Wild Vegetation
From Art to Nature

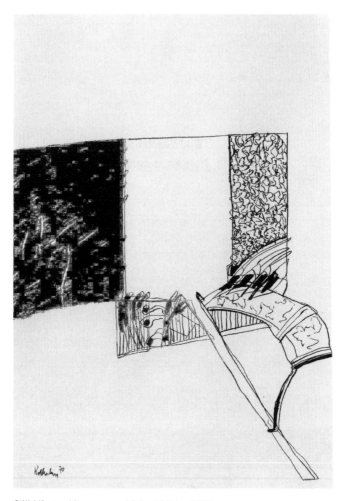

Still Life, graphite on paper, 19.5 x 13.8 in., 1970

Paul Zwietnig Rotterdam

WILD VEGETATION

FROM ART TO NATURE

HIRMER

Contents

Introduction

Helotes, Texas, 2012
North Blenheim, 2014

The following texts are a collection of loose papers in two languages. While selecting, I have concentrated on lectures. Oral statements, limited by time, express thoughts with simplicity. Analytical extrapolations belong to another medium. Most texts came into being shortly before being delivered. My painting led to invitations for speeches accompanied by slide material, as is usual in this country. Thoughts are often repeated or clarified —an indication that we walk in the world with baggage.

In artistic production, the existence of what is older always accounts for the newness of what is new. The old and the new make a connection between past and future, serving as material for reflection about our present location in history. Today's neo-modern art history has to deal with an unprecedented diversity of styles and can no longer rely on foundations of ideology from where to estimate the importance and aesthetic value of artistic phenomena. Rather, phenomena appear spontaneously, seemingly out of nowhere, and often disappear as soon as they have arrived. This is a different state than only a few decades ago. Modern art developed comparatively monolithically and allowed progress with regard to the logic of previous waves, which pushed the present into the future. Today, there is no collective model of thought which would impress itself as historically necessary or significant.

Even though philosophy joined the visual arts, it was not able to establish teleological models of imagination other than a painful ontology for the purpose of separating profane objects from the realm of art.

We must deal with individual works, far removed from a *zeitgeist* which would consume phenomena from an Archimedean center. There is no modern art today, because there are no plausible parameters of expression able to claim newness in substance or universal significance. New forms are not more modern than old forms. Interest does not gravitate toward newness or modernity but toward otherness.

The concentration on single works has the advantage of leading to an expansion of aesthetic consciousness liberated from constraints of tradition and local fashion. Now we can equally appreciate phenomena of non-Western cultures which report the movement and expansion of the human spirit. Each work has to prove itself within all of art. One can assume that this is a healthier situation than when apperception of art was influenced by stylistic norms and aesthetic dogmas retarding progress. Our present culture displays sudden changes or lapses in development due to the absence of characteristic ideas and unifying principles in politics and in art. It came to hybridization and the appropriation of old ideas in the face of the new—the old was made new, the new was made old—as if there had never been the element of time, watching with gleeful eyes over the truth developing in the present. What remains are single works, swept to the top by the waves of an ocean, remaining there or sinking, depending on the climate of political and cultural circumstances.

It is astonishing that time present is more difficult to comprehend, while past events can easily be assembled by a busy mind operating between fact and fiction. What is aesthetic in this world comes to lie in the forefront of historical awareness. Old columns tell old stories. Philosophy and art are visible witnesses to how the

attitude of mankind toward itself is changing. The ups and downs of cultural predilections are symbols for the movement of the spirit seeking completeness and infinity.

Zeitgeist in the first decade of the 20th century was a spirit of departure into zones of consciousness that had been prepared like an enticement by 19th-century philosophy and art. The work of future-oriented painters in the second half of the 19th century, together with the development of a contemplative philosophy, made it impossible not to continue what had started. One could no longer paint haystacks which provided limited forms. The privilege had to be extended to a movement of freely invented configurations, visual structures creating an atmosphere that refers exclusively to itself and can only be apprehended by contemplation. The occurrence of new, objective configurations demanded a change in the process of cognition, which could no longer rely on the monopoly of mechanical apprehension but demanded a more creative participation on the part of the beholder. 19th-century concepts like *disinterested attitude* and *sensuous depravity*, point already to a method of cognition which seeks the reality of art not in depicted subject matter but in the structural properties of the work. That the change in the method of aesthetic cognition is still fraught with difficulty today, a hundred years after the inception of non-representational art, results from the imposition in our mind of a Greek tradition that the art of the West needs to be involved with visible reality, regardless at what level of abstraction. The greatness of Western art, in comparison with other cultures, was said to derive its unsurpassed glory from concerns with a world as it presents itself. At the same time, however, this glory found itself in a third degree position behind hard reality and the spirit of philosophy. The painter was viewed as a worm crawling behind the *elephant of reality*. It was difficult to depart from visual presentations which could be read like a book. The art of the 20th century is a challenge for the participation of the beholder who can no longer rely on a

pictorial presentation that provides material for simple rationality and logic. Now we must deal with autonomous configurations which exhibit nothing else but themselves and find effectiveness in a feeling contained in thinking. The lack of representational images does not compromise aesthetic sensations because imagination has no limits when liberated from the chains of empirical data. Without constraint it can go its own way.

Empathy and *contemplation* became the most important epistemological concepts. They drastically changed aesthetic perception. It became impossible to look at artistic phenomena, particularly at abstract art, with eyes used to looking at imitated objects. Empathy and contemplation stirred the emotional base of perception and created a new attitude, not only in the perception of art but in viewing the visible world. Through empathy the will of the self surrenders to the other. The feeling of the sublime breaks the rules of rational thinking by not concentrating on outer appearances but on what is contained invisibly in the object. Artistic innovations mostly often occur through unreasonable risk-taking rather than through rational planning.

Contemplative philosophy does not involve in contrasting aspects of existence. It deals with the totality of appearances devoid of ideas expected in an object. By not obeying its willfulness the self becomes one with the nature inherent in the object. Properties we seek and expect build a barrier between the subject and object and limit the freedom of the spirit, which only in selfless surrender to the totality of the appearance can experience enlargement of consciousness. It is senseless to approach a work of art with rational expectations, trying to find something we already know. In contemplation, the spirit is embedded in the feeling of truth regardless of what this truth or this feeling may be. The feeling of truth in art transfers to the perception of the world in daily life. Through feelings obtained by contemplation the subject experiences an expansion of character.

Now we can ask for the ontological character of art. The answer can already be found at the beginning of the 20th century when Abstraction and Realism were torn apart and all kinds of pictorial elements were granted entrance into the realm of art, from a two-dimensional abstract line to hard, three-dimensional objects like a train ticket, a table or a spiral in a lake. Empathy and contemplation encompass not only products of art but include the entire visual field of life which has become richer now, full with the myth of inner properties.

Abstract art, demanding empathy and contemplation for its apprehension, created a focus on what historically had always been necessary in the experience of art. Abstraction aims at the core of where the true reality of art is located. Here we see a division of spirits: those who refuse to abandon rationality and continue to load the canvas with pre-existing elements, even if the result is an empty surface or an amalgam of empirical data, and those spirits who abandon studious planning with freely invented forms and provide other sounds than those from the general base of existing reality. The neo-modern period is characterized by the exploitation of the entire width and height of abstraction, from the hard Realism of found objects to a non-representational painting which shows something without depicting it, closing the traditional circle from nature to art and art to nature. What has changed is not the making of a painting but the method of perception and the intensity of imagination in the creation of an art as autonomous as nature.

The following texts could only see the light of day through the patience, help, encouragement, and love of my friends.

Paul Zwietnig Rotterdam

Why Science
Has Nothing To Do With Art

Lecture for a Faculty Seminar, Visual Arts Center,
Harvard University, Cambridge, December 1970

With science alone we do not understand the world. Science provides knowledge about the world. While knowing precedes understanding, knowing and understanding are not identical. We obtain understanding by integrating knowledge into the wholeness of a universe to which our individual existence belongs. Understanding is ordering known empirical data to a meaning within the wholeness of life. I know a man but for that reason I don't need to understand him. However, I understand him if his actions and thoughts mirror my own. Scientists collect samples from the moon but understanding the moon within the wholeness of life is something else; perhaps it is to be left to poets.

Scientific research has achieved rich knowledge about physical facts and causal relations of existence, giving us security within the uncertainty and turbulence in the world. But knowledge of facts alone cannot unveil the enigma of reality; it cannot create a truly integrated understanding of the world. Integration is possible if we transcend physical facts and advance to a metaphysical realm of feeling and thinking. Science is not allowed to be metaphysical because its method is directed to achieving cognitive knowledge applicable to physical facts. Art is not allowed not to be metaphysical because its results must transcend physical connections and become symbols for the wholeness of life. Pro-

fessor Arnheim explains that a work of art is always symbolic, because the forces stirred up in us when experiencing art: "… are only individual examples of the same forces acting throughout the universe. We are thus enabled to sense our place in the whole and the inner unity of that whole."

I believe that all knowledge about reality might become possible through science, the only knowledge, however, an individual can obtain that is more than a cognitive knowledge is the relation to his own existence. The ethical situation, as a result of an individual's confrontation with reality, finds its concretization in art and religion. The only science that deals with ethics is philosophy. Pascal realized that scientific knowledge could not bring him to an understanding of the world in the sense of revelation and he retreated to religious exercises in a monastery. Similar motivations might have guided the old Japanese painters who dedicated themselves to painting after having experienced the limits of fields they had been working in: science, economy, politics, etc. Artistic creation allows the individual to experience results in immediate relation to his innermost being. As artists, we have the possibility to show our attitude toward existence, toward the manifold events in life with our artistic reactions resulting in style. Style is the unchanging *how* of expression in a series of works rather than the *what* of expression which belongs to science. Originality of style is a sign of general maturity for life and therefore the highest education. All experiences in human exposure to the world contribute to the message of style. An artist is able to reveal his attitude toward existence, make concrete his perception and interpretation of the visible world and reveal the emotions resulting from events in life. Originality of artistic style is a sign of general maturity; it is a sign of education and experience. The *how* of expression is an essential part of the integral message of art.

Science, in contrast, relies on *what* is accomplished and not on beautiful procedures that might bring no results. The scientific

method is always a tool to achieve results without, however, the tool being an integral part of the result. The scientist needs rules to order the manifold appearances in his research into a logical system with principles of thinking that prevent continuously new decisions in the pursuit of results. If one method doesn't work, he will try another. The goal to be accomplished is always clear in his mind.

The artist, by contrast, needs freedom from preconceived notions about the particular appearance of the work. The act of creation, while directed by general aesthetic intentions, has freedom to continuously change direction in choosing possibilities for arriving at a particular appearance. Instead of a given procedure in art, we have only a mode of behaving in the act of creation. It is a behavior toward sensuous stimuli. Such behavior cannot be learned or taught. It is an internal substance, a personal, spiritual attitude.

Both science and art create manifestations of truth. But while the sciences observe the processes of nature and apprehend the laws which underlie all changes of existence, the arts do not apprehend or observe but reveal physical existence. Works of art are creations of realities which have not been before and will not be again. Heidegger points to the Greek word for truth, *aletheia*, which means revelation, expressing that truth is a process of revelation regarding the substance of an individual who reveals his wishes, feelings, thoughts, yet his entire state of being when bringing the work to its state of existence. The nature of science does not reveal but apprehends and arrests truth within the changes of nature. The Latin word *scientia* denotes a mental possession rather than a process, and *veritas* is taken to be fundamentally and permanently true. If art is a process of revelation then its goal is understanding and wisdom, if science is apprehending and knowing its goal is mastery—a distinction Panofsky makes between the humanities and natural sciences. Scientific mastery aims at abstract structures

of thought to grasp the plenitude of empirical phenomena in concepts. Anatomists cut the human body, plant physiologists dissect flowers, mineralogists break stones, etc. The concept behind scientific activity is a mental image which, because of its intellectual universality, is raised beyond intuition and beyond immediate perception. Artistic working is not conceptual work in the sense of logical analysis but a perceptual, simultaneous total grasping of a given object.The truth of art is not in analytical rightness but in subjective intuition. I feel sorry for artists who get stuck in concepts and repeat forms in their work as if they sprang from a formula. After all, van Gogh's shoes are not cleansed by a shoe formula which prescribes how to paint shoes, they are art because the painting presents a new aesthetic reality that emanates mood, involves distortion and exaggeration of forms that symbolize emotions and life. The creation of truth in art is an original, creative event comparable to the original creation of the world. The truth of art is the revelation of truth in its physical existence. Emphasis is on truth as a physical existence and not on a truth in the sense of substituting an event in nature. The stronger the work deviates from everything we know or expect within the sphere of the communicable, the stronger it exerts its existence. To achieve such an outstanding originality we allow the infiltration of all possible means of visual presentation, the craziest ideas can contribute to the creation of a new reality. Yet only by virtue of its difference from everything familiar can the work force the beholder into a state of perceptual contemplation in which we experience its symbolic radiance.

Nothing I have said about art applies to science. We are faced with two completely different systems of communication. Science uses a system of signs to describe objective situations (descriptive symbol system), while art uses a non-descriptive symbol system attached to immediate sensuous experience. The scientific description of a poem is something entirely different from the immediate experience of a poem. Analytical description can never substitute

perceptual experience. The tool of science is thought, the tool of art is perception. Thought is the only reliable tool to order the appearances of the world and it provides a security which perception does not offer, for perception is always conditioned by attitudes. But thought is slow while perception is fast. The mood of a person, says Brunswik, can be understood by a single glance at the face, while scientific description would take a long time and would probably never reach its goal.

We have to realize that some objects can be attained by thought only, for instance all the constructs of pure theory while other objects can only be grasped perceptually because they would be destroyed through analysis. This is the difference between the world of conceptual knowledge (science) and the world of intuitive, perceptual knowledge (art). We should never mix up science with art. Ernst Cassirer, the master of the philosophy of symbolic forms stated in this context that, although conceptual knowledge is based on intuition and perception, conceptual knowledge distinguishes itself once and for all from perception and intuition by being content with mere representative signs, while perception and intuition have always a direct contact with their object. "To question this dividing line between the immediacy of perception and the mediacy of logical-discursive thinking," he says, "would be to disregard one of the securest insights of epistemology and to abandon a truly classical distinction, growing out of a centuries old tradition."

The difference between the immediacy of expression and the cognitive logic of thought makes the difference between the world of science and the world of art. Phenomena of expression cannot be entrusted to the service of theoretical analysis because, in art, we face a formation independent of objectification. In art we do not have boundaries between real and the unreal, between physical existence and pure apparition, boundaries, a theoretical objectification would have to draw. The substance of a work does

not recede behind its appearance but substance is contained in the appearance itself. Artistic phenomena, unlike scientific facts, are not broken into fragments which constitute the whole but the whole is always present as an inevitable unity. Science dissects phenomena backward to their condition and follows them forward to their effect.

The reason I have to show tonight why art has little to do with science lies in a tradition of thinking which claims that art should also adopt the scientific mode of dissecting phenomena backward to their condition. This is the structuralist approach, whose founder Leonardo da Vinci determined the way of art education at academies since the Renaissance, and it is still the source for concepts about the goal of art and education in art. Structuralist ideas deal with the shape of an object being the result of many structural elements inside the object. Structure is understood as a meshwork of elements which are organically connected and build more or less automatically an overall form. Structuralists speak about *organic form* allegedly being tantamount to *good form*. Attention of structuralists is always directed toward the inside of a form and toward the systems responsible for connecting the elements in the right way. These are mostly systems of symmetry. There is no formal expression in the sense of risking statements of form but everything is bound to proper construction. Aesthetic judgments are reduced to technical judgments of *right* or *wrong*. The structuralist method differs principally from the artistic method in defining form. The structuralist says "form is determined by structure," the artist says "form is the result of imaginative power."

The structuralist attitude found entrance especially in modern architecture and sculpture, where it results in visually boring constructions, translations of a mathematical system into the third dimension. Oswald Spengler called this "the liberation of geometry from the visual." We see buildings that no longer sym-

bolize a mode of life, as good architecture should, but autonomous and indifferent constructions which can be anything—a glass house, a concert hall, a pavilion, etc. Structuralist conceptions derive from the findings in various fields in the belief that the development of art must parallel the development of civilization. In the 19th century, professors of medicine used to give lectures in academy courses of nude drawing to tell students what is inside the body so they could reconstruct the outside in a proper way. Academies today bring scientists from various fields to lecture on the inside of stones, bones or plants and designers pretend to be eyewitnesses of intricate circumstances in nature. They explain their designs by saying that also a plant or a crystal can have such and such a constellation of elements inside the form. These are rational concepts of a primitive naturalism; it is nothing other than the instinct of photo reporters hunting for sensations and excitement to offer amusement through extraordinary phenomena. It is a typical feature of common taste art. How a painting of common taste art can serve the purpose of sensation—showing the painter as an eyewitness of intricate circumstances—is demonstrated in the title of a picture by Delaroche from 1829: "The moribund cardinal Richelieu, coming from Tarasquon, travels in a boat on the Rhone and in a small boat, towed by his own larger one, he has the Cinque Mars and the de Thou whom he wants to have decapitated in Lyon."

Structural arrangements cannot appeal to the observer who wants to obtain conviction about form but only to the observer who wants to satisfy his curiosity. It is typical that structural arrangements operate with sensationally new materials. The more academic fields become involved, the larger the possibilities to exploit various scientific information for visual purposes (a molecule becomes a restaurant, etc.). It is symptomatic that the products of such sensationalism can be found at world fairs where the findings from different fields are mixed together.

It is the task of art education to free the student from the rational concepts of other fields so he can enter the intuitive sphere of visual expression. If the findings from various academic fields are mixed together, so called *totalities* result with a low degree of articulation. However, we must realize that we live in an extremely articulated world which demands that we live in it with differentiated orientations. Intuitive perception and religion are differentiations as important as the rational concepts required for science. The universities of today need education programs including all aspects of human existence—not only science but also art and religion—to make man capable of changing his attitude according to the situation, thus truly integrating him into his environment.

As far as the structuralist approach is concerned, I believe that structure is one of the most important means of visual expression but only under the condition that it transcends the character of simple arrangement, I mean the simple ordering of geometrical elements, and become a form of intuitive expression.

Writers who claim a link between science and art, accompany their essays with juxtapositions of scientific photos and works of art. Such comparisons are wrong and misleading for they neglect the fact that the physical and the mental worlds are governed by different laws. The visual comparison of a picture by Jackson Pollock and the micro-structure of a metal, for instance, intermingles two different aspects of beauty. And furthermore, although it is quite enjoyable for a painter to look at books of medicine or crystallography, it remains doubtful that he can establish a connection between such photos and his work. A quotation from Naum Gabo: "The new scientific vision of the world may affect and enhance the vision of the artist as a human being but from there on the artist goes his own way and his art remains independent from science. It would be a relapse into the naïve naturalism if the contemporary artist should start to reproduce the new forms of nature which the scientist is unfolding, taking

for granted the scientist's vision as he, the scientist, is representing them. That would amount to nothing more than a waste of energy and be of no account since it would only repeat what the scientists have already done. The artist's task consists in bringing forth an image which is in a language of its own, acceptable to all men, and is imparting his message without the help of anything other than his own pictorial and plastic means."

I spoke about the perceptual expression in a work of art which constitutes the intuitive world of myth. To regard this aspect alone would seem to see the entire information of the work in its sensuous expression only. No, beyond perceptual expression the work establishes a meaning which originates from the relation to other works of art. It is wrong to believe that art aims only at *expressive feelings*. Rather the direction of our creative activity is directed by motivations; we have to apprehend the principles of art, the language with which we make ourselves understandable and we have to obtain knowledge about art to apprehend a historical situation from which we make our own contribution.

It is important for art education that the student is made aware of the context of projects within contemporary art. A program in visual studies not related to art is in danger of being a purely formalistic exercise. The excitement of an art program can only be maintained if the student has the feeling that, at any moment, he can make an unforeseen discovery with importance in contemporary art.

The Bauhaus was the first institution that succeeded to isolate and define elements of art by means of analytical methods and the systematization of findings. Yet its members were also aware of not pushing aesthetic analysis too far. Paul Klee, who was an excellent theorist, was always ready to break or bend the most rigid rules and surrender to personal fantasy.

Although the artist is highly aware of what he is doing, although his method of gaining knowledge about art is cognitive

and perhaps scientific, despite his involvement in the conceptual and rational side, we cannot conclude that the act of creation itself has become doubtful on the intuitive side. The act of creation has to be conceived as a unity of thinking, feeling, and wishing. It is not the pursuit of a single goal but an event in which the whole person becomes activated. We surrender to the immediacy of stimuli we establish in the work. There is nothing like a will superimposed on matter but rather "intended wishing as the result of our knowing (Schopenhauer)." Intended wishing means that, although conceptual knowledge is part of our consciousness, it never reaches the dominance of rationality but merely remains a wishing that influences the direction of our doing.

Writers who claim a link between science and art base their arguments on this unity of concept and intuition, a unity we can find in the origin of science as well as of art. They overlook however the principle that two effects, though being the result of the same cause, might very well be of a different nature. Cassirer explains in this context that the source for mathematical numbers was a magical-mythical view of the Pythagorean number and an intuitive link to the objects whose quantity and relationships it enumerated. But when numbers became independent of objects and their arithmetical or geometrical relationships, they became independent entities which dwelled merely in a form of knowledge separate from sense perception and intuition. Only by virtue of its independence from the intuitive world can number be a genuine expression of the underlying principle and the truth of the physical world. It is a peculiar property of theoretical knowledge that its success depends on placing a distance between itself and reality.

The representation of the universality of form in its relational character can only succeed if thinking is not determined by the manifold of reality. Thinking creates its own norms, it imposes upon reality. The symbols of abstract thinking are the product of thought. They represent a new mode of objective relations based

merely on their own standard, completely different from empirical intuition.

Artistic creation begins, like scientific creation, in empirical intuition by having sensuous contact with reality. But art never detaches itself from reality despite the meaning of a work being within the system of art. The intrinsic value of the work remains in the concrete experience of its reality. Intuitive perception combined with knowledge results in a mode of experience we call intuitive knowledge. Conceptual knowledge of science and intuitive knowledge of art have, although coming from the same source of intuitive perception, nothing to do with each other.

Conclusion
It would be a wrong formulation of a question to ask whether science is superior to art or whether art is superior to science. Rather, the dividing line is a completely different aspect of human spiritual activity in regard to the reality of the world. In order to grasp the manifold appearances of reality, science has to operate with a theoretical construct of abstract images applied and proven on reality. Cognitive theoretical thinking functions the better the more it is removed from the immediate sensuous confrontation with reality. It is my belief that science will be able to grasp everything, from the identification of microstructures to events in the universe. Art, in contrast, will continue to hover above reality and provide clues about the recesses of man's innermost being.

Wild Vegetation
Van Gogh and the Advent of Modernism

Lecture at the Benedictine monastery Seckau, 1995

In late June or early July 1889, Vincent van Gogh created a pen-and-ink drawing which is markedly different from his earlier work. It shows a remarkable thrust into unknown regions of abstraction, far removed from the expectations of his style and from Impressionist painting at the time. The image develops an unexpected distance from recognizable subject matter and reaches a degree of visual autonomy which makes its title *Wild Vegetation in the Hills* questionable, probably invented by van Gogh's oeuvre cataloger, Baart de la Faille. One is tempted to place the work in Kandinsky's period around 1910 or into the oeuvre of an artist of our time. From a contemporary perspective the drawing has a timeless modernity no longer comparable with the efforts of an Impressionist working in front of nature, attaching himself to visible subject matter, even if the depicted objects serve no other purpose than as material for artistic innovation and abstract manipulation of form.

Wild Vegetation (fig. p. 226) is not the re-creation or the abstraction of a phenomenon of nature. It is the presentation of an autonomous object whose content is contained within its own nature. The character of the drawing resides in short, curvilinear scribbles which follow neither an identifiable shape nor serve a traditional landscape space. The linear marks act as structural

elements for the articulation of the picture plane. Applied evenly, with little distance from one another, these elements create an energetic pattern not dissimilar to the "all-over painting" practiced half a century later. The drawing evolved from an activity that concentrated solely on the sensuous material, as if the playful spirit of the artist had observed from the outside, or from a distance, how the scribbles assembled almost automatically to create a mesh of lines totally at ease, completely immersed in its own making. The result is certainly not the product of a strict intention, nor is it the reproduction of objects imagined or re-created from memory.

Six months earlier, in the autumn of 1888, *memoir* was a hotly discussed topic when Paul Gauguin visited van Gogh in Arles. Gauguin insisted that a higher degree of abstraction and a more truthful display of stylistic features could be accomplished only if the artist kept his distance from outer appearances. In a letter to his brother Theo, Vincent wrote in December 1888: "Gauguin, in spite of himself, and in spite of me, has more or less proved to me that it is time I was varying my work a little. I am beginning to compose from memory, and all my studies will still be useful for that sort of work, recalling to me things I have seen I am going to set myself to work from memory often, and the canvases from memory are always less awkward, and have a more artistic look than studies from nature, especially when one works in mistral weather."

Wild Vegetation is not only a variation of van Gogh's drawing style, but the clear proof of his ability to push abstraction with the audacity of a genius to the highest peak at a time when no one expected an artist to allow his fantasies to erupt spontaneously, apply an almost automatic working method, and force the beholder to come up with his own conclusions about what he sees and what the perceived is supposed to mean. The aesthetic idea in *Wild Vegetation* is no longer in conflict with or dependent on empirical data, seen or imagined. Van Gogh's style emerges from the action of

drawing as a raw force that distributes pictorial elements almost randomly and allows the entirety of the work to come into being as if automatic. Liberated from the often uncertain and hazy connections to past experiences, the aesthetic idea is now situated in the physical existence of the work itself. In this respect *Wild Vegetation* can be distinguished from the aesthetic ideology of the late 19th century, which envisioned the essential character of artistic production in the symbiotic relationship between artistic principles and the measure of nature.

Cypresses in a Starry Night (fig. p. 227), by comparison, completed two weeks before *Wild Vegetation* in June 1889, is still indebted to interactions between the memory of a landscape and the impulse to make a rendering according to traditional notions of how objects should be depicted and located in a pictorial space. *Cypresses in a Starry Night* evolves from short, linear marks which follow the contours of objects in an imagined space. A shallow illusion is created by gradually diminishing sizes of depicted images from the foreground into a deeper space of the sky. Invented constellations of linear structures and marks of the pen derive from the representation of something existing. Despite the presence of visible subject matter, the artist pursues the abstract quality of the work by carefully controlling the application of strokes. He avoids overlapping and merging linear marks which easily occur when working with pen and ink. The pictorial space is invigorated by texture and dynamic elements as if they had erupted from an inner boiling, as if a celestial command had opened the pores of reality and allowed initially separate elements to construe themselves in a newly found world. A fantastic illusion lies in front of our astonished eyes.

Despite the high degree of abstraction that encompasses every element, *Cypresses in a Starry Night* still depicts reality. Van Gogh succeeds in overcoming the tight brushstroke articulation of the Impressionists by tearing pictorial elements apart, shaking them

up, making them float while holding them together by a magnetic force before releasing them into space and establishing a fluent transition between tangible objects on earth and intangible events in the sky. Invention of form is carried to its limit as if there were no other purpose to art than to open distant sites of the mind where repressed and dormant images have been waiting.

Wild Vegetation, in contrast, allows pictorial elements to emerge from a vague idea and come to clarity solely in the concrete existence of the visual structure itself. Something is depicted without having depicted it. It is a modern work even one-hundred years after its creation. The drawing reflects issues much discussed in 20th-century aesthetics and particularly in recent years when the advent of Post-modernism forced a reconsideration of aesthetic values for works on various levels between Realism and Abstraction. Post-modernist manifestations promote a laissez-faire attitude toward the implementation of realistic subject matter, while simultaneously engaging abstract elements as if it were most natural to employ images of the visible world in conjunction with invented forms. Images come into being almost automatically, guided only by the energy of the artist and by conditions at the time of creation. While shapes associated with the visible world may be brought into the work according to subjective impulses, the presence of abstract shapes provides physical immediacy and visual autonomy.

Wild Vegetation is van Gogh's most abstract work. At the moment of its completion the artist had to decide whether to push his work further into purely abstract expression or to continue the tradition of formal exploration of identifiable subject matter. He asked himself how far an artist is allowed to distance himself from outer appearances of reality. Today, by comparison, ambitious artists must consider how far to distance themselves from pure abstraction.

Five months after he drew *Wild Vegetation*, van Gogh wrote in November 1889 that the problem with Gauguin and Émile

Bernard is that they had let themselves go too far into abstraction. "If you work diligently from nature without saying to yourself beforehand—'I want to do this or that'—if you work as if you were making a pair of shoes, without artistic preoccupation, you will not always do well, but on days you at least anticipate it you find a subject which holds its own with the work of those who have gone before us." "Artistic preoccupation" with preconceived concepts allows an artist to go too far into a conceptual enterprise. Van Gogh's enterprise was solidly grounded in the beauty of the world. *Wild Vegetation* was created in an aesthetic experiment that transported the artist far beyond his time.

Working from memory and imagination was an important issue for ambitious artists at the end of the 19th century. They tried to overcome the Platonic accusation that simple imitation creates an ontological barrier between the ideal of art and the captured forms of nature. According to Plato, imitated objects find themselves on a teleological inferior level, because nothing can transcend the truth of actual reality. The parasitic position behind the forms of nature, assigned by Plato to representational painting and sculpture, places the visual arts behind the truth of existence and the clarity of ideas. Products of mimesis slavishly follow the outer appearance of imagined or perceived things and seduce the beholder to mistake the depicted for the real. The history of art evinces, however, that the craft of imitation has always had opposition from artists who conceive of beauty not only as it is found in the visible world, but beauty as it is located in the physical properties of the work. Impressionists liberated pictorial material from its service to illusion. Van Gogh added physical marks to the surface of the support. He developed a pictorial language more radical than anything Western painting had seen when trying to overcome the Platonic stigma.

Van Gogh operated in the wake of an aesthetic and philosophical climate which would bring the traditional synthesis between

representation and abstraction to an end. Avant-garde movements at the beginning of the 20th century provided ample fuel for critical dialogue by either adapting, interpreting or challenging not only traditional values of art, but ultimately interrogating the traditional synthesis between feeling and thinking. Free invention of form was meant to evoke a universal understanding of art and create emotional states never experienced before. Today, critics ask whether the promises of early abstraction were fulfilled or whether abstract art has become increasingly useless.

The tradition of 20th-century art concerned itself with objecthood. Anything narrative or associative was forced out of the work. Form and formal invention were reduced to the presentation of pre-existing geometrical shapes synchronized with the geometry of the support. The traditional conflict between the shape of the canvas and pictorial elements placed within its delineated area disappeared. A pictorial space emerged, unbroken by subjective decisions or idiosyncrasies of expression. This minimalist approach led to the perception of the work as an actual object hanging on the wall like a Persian carpet. Cleansed of any involvement with the emotional, the psychological, the personal, the irrational, abstract art inclined to become a rational enterprise for creating good designs. The phenomenological purism of Minimalism regarded the multiplicity of sensations and the pluralism of meaning, attached to freely invented form, as something vague and exchangeable. Ambitious artists limited their parameters of execution and the horizon of expression to arrive at an aesthetic perception which focused on a synthesis between appearance and its understanding of how and why it had come into being. The myth of spirituality and the formal freedom from which early non-representational painting drew its inspiration transformed into the logic of construction. Formalist works are concretions of an aesthetic ideal and represent the liberation of Western Art from the detested Platonic curse. Today, a painting exists in the same

three-dimensional space as any other object in the world. We ask ourselves what to do with the accomplishments of Modernism and what territories of aesthetic consciousness are waiting to be explored and at what expense.

In the visual arts, content manifests itself as a feeling. The elimination of subject matter at the beginning of the 20th century promised a universal understanding, connected with the emotional experience of formal constellations. Yet, the short history of abstract art produced results quite to the contrary. The "black hand" of materialism and decoration, feared by Kandinsky, took theoretical issues more seriously than expressive necessity. At the end of Classical Modernism, in the late1970s, we saw a lot of stripes and decorative patterns placed on the canvas like a disease of the skin. Critical voices questioned the aesthetic virility of the enterprise of abstraction. New impulses were expected from a new figuration. Already the first signs of Neo-Expressionism produced enormous interest, because the new movement promised relief from the rational sterility and deafening silence of reductive abstractions. Attention was directed at subjective handwriting, at the irrational, the intuitive, the raw, the unfinished, and spontaneous, at the here and now of creative manifestation. After a period of philosophical stringency the Post-modern epoch may be praised for an absence of theoretical dogma, for the lack of overt aesthetic purpose, for the freedom to work at any height of abstraction, the rejection of a consistency of style, and finally, for the repudiation of style itself as an art-making feature.

Parallel to the rejection of critical norms, the 1980s produced a sociologically interesting situation. An enormous apparatus of financially motivated collectors and powerful art dealers pushed artists almost at random into the limelight of attention. Capital gain and short term speculation infiltrated the realm of art. Unprecedented competition arose amongst dealers who saw their purpose in life becoming and acting as conceptual artists them-

selves. They gained control of contemporary ideology and the course of history. What an artist produced was less important than the galleries exhibiting the work.

In an essay entitled "Bad Aesthetic Times in the USA," Arthur Danto reasoned that nobody was prepared for the advent of Neo-Expressionism, and that even ten years later we still have no clue what it actually intended. Other critics deplored the loss of contemplation and silent apperception. They wondered what is the matter with our society. What is the matter with those who spend enormous sums of money on works produced only yesterday? Who is responsible for the diffused period and who delights in the aesthetics of an incomplete experiment rather than in truly new parameters of expression? The aesthetic basis of Neo-Expressionism was said to be no more than an extended phase of the expressionist impulse in the first half of the 20th century. Such an impulse brought to fruition the provocative adventure for raw form and raw execution started by van Gogh, who replaced intellectual control with instinct and sensuous delight.

On the other side of contemporary discourse are the protagonists of a new figuration. They denounce abstract art as a fiction without effect, an exhausted style which indulges in stale concepts, a phantom of absence, and reduction of energy, a phenomenon without critical challenge, without psychic energy, without confrontation with the visible world, solely directed at itself and its perverted principles of operation—a symbol of what we miss in art. Abstract art, critics argue, has become so commonplace one may suspect the loss of its ontological foundation. Critical dialogue has become obsolete and we yearn for something else, for something either not contained in abstraction or for attainment made possible only by the challenge of its innate laws of operation. A new figuration is said to be the avant-garde movement of the day because its content makes us self-conscious and self-critical.

On my part, I see no purpose in either discarding figuration as something unimportant, nor would I admonish abstract art for lost territory. On the contrary, the virtue of figuration as a branch within the ramifications of post-modern pluralism resides in stimulating non-figurative artists for a renewed contact with the visible world and for more sensuous and subjective modes of expression. The last stages of a purist abstraction known as Minimalism, seen by many as the culmination of an aesthetic theology of sublime nothingness, could proceed in no other direction than into further nothingness. Paranoia of pictorial articulation produced redundant geometry and monochromatic empty canvases supported only by philosophy. Of course, the holy abstinence of Minimalism, leading to intellectual and emotional exhaustion, was in need of change. Painting was in need of exploding into a wild collection of styles on various levels of abstraction. Painting should conquer the vast and almost uninhabited territory stretching from the spiritual Abstraction of the North to the beguiling Realism of the South, from the concepts of art in the East to the hard reality of the West. All styles and all cultures have gained access and are available as a context for contemporary aesthetics.

At the end of the 20th century a new freedom of creation and variation of feeling has come home to the visual arts. The traditional linear development of artistic movements has been replaced by a coexistence of multiple meanings on the same historical plane. Painting gained freedom to show content without depicting it. The visible world is involved again without asserting itself as the exclusive source for the imagination or creation of form. In this context, *WildVegetation* is still a wild work of art, because it breaks the traditional distinction between subject matter and aesthetic reality. Van Gogh created an image of beauty, a piece of paper driving imagination to its limits.

We live in a hopeful period for art. A new concentration on aesthetic quality has replaced the formal doctrines of Modernism.

Distinctions between Realism and Abstraction have become irrelevant. We neither apologize for abstraction nor avoid references to nature. We avoid nothing for ideological reasons. Theoretical, political and aesthetic dogmas have been replaced by ethical considerations. Emergent styles encompass the general presentation of autonomous form while enjoying a new freedom to engage the visible world. While no specific content may hold our attention, we stand in front of art as if we were in the presence of nature. The shift from art to reality and from reality to art has come full circle.

Notes
The Letters of Vincent van Gogh,
edited and with an introduction by
Mark Roskill, New York 1974

Gustav Klimt: *The Kiss*
(A Kiss To Art)

Lecture Notes for *European Nations Introduce Themselves*,
Corcoran Museum of Art, Washington, D.C., 1995

In 1907–08, 45-year-old Gustav Klimt worked on a 6 x 6-foot canvas entitled *The Kiss* (fig. p. 229), now one of the best known images of 20th century art. Reproductions are found in student dormitories, on the walls of airports, hotels, scarves, T-shirts, napkins, and paraphernalia of all sorts. My excursion to *The Kiss* comes at a time when I am a bit tired of looking at this image in bad reproductions or listening to commentaries by prejudiced critics. Aesthetic reflection is necessary to appreciate the beauty and importance of a painting. Through reflection I hope to recuperate what could easily turn into the superficial viewing of an alienated phenomenon.

While intuitive liking or disliking determines our personal relationship with a work, it is critical interest that contributes to the appreciation of the sensuous material in connection with intellectual propositions introduced to the tradition of painting. Artistic invention of form is the result of a critical thinking which participates in the birth of the work as an implicit principle.

We cannot assume that thinking about *The Kiss* a hundred years after its creation can reveal the ideas or feelings which gave its creator the irresistible urge to liberate himself from the tradition of 19th-century art and create a work which exemplifies, for the rest of history, the momentous changes at the turn of the 20th

century. We observe a work which has ordered itself into the consciousness of modern art.

Klimt's early work was indebted to a tradition of painting derived from Hans Makart, who at the time was probably the most famous painter in Europe for successfully competing with the aesthetic ideology of the Renaissance. But right at the beginning of the 20th century, Klimt starts to go his own ways. His vocabulary deals increasingly with abstract organizations of space and the employment of geometrical elements. The concentration on line, plane, ornamental structure, and particularly the flatness and immediacy of pictorial space changes the usual way of looking at a painting by leading observation away from the narrative meaning of depicted objects and concentrating on the trans-empirical properties of visual elements on the surface of the canvas. Thus, Klimt abandoned the 19th-century desire for imitation and substituted external relations of depicted objects with the internal dimensions of the creative action. The new impulses of form can no longer be deducted from the visible world but from the search for a self-articulating consciousness. The sensuous components of the work appear in a physical state as material applied to the surface of the canvas and not related to anything outside itself; it occupies a place between rationality and sensuality, so that the sensuous material becomes spiritual and the spiritual turns into sensuality.

The 3D space of imagined and depicted objects is shifted to the flatness of the picture plane and the corporeality of depicted objects turns into flat geometrical elements. The distribution of these elements obeys a rigid architecture of planes in lateral space.

While the new methods employed by Klimt are reminiscent of the ornamental formality in Byzantine art and objecthood in the Middle Ages, his aesthetic propositions come as a surprise at the end of the 19th century. Like anything avant-garde, his work challenged the limits of art itself.[1]

Aesthetic progress occurs in times when the traditional allows little freedom for critical thinking. The neo-classical painting of mythological and historical scenes developed at the end of the 19th century into a boundless illusionism which seduced the eye with manifold concepts and stories while offering little in terms of the purely aesthetic. Progressive painters were aware that the window of illusionism needed to be closed to provide painting with new means of creating aesthetic reality. The motives and the content of the new art is the *conversion of form into content* as Hegel expressed it.[2] The essence of the work is thereby not behind depicted subject matter but it has become existence itself.

The formal motives practiced in *The Kiss* are an early testimony to the theoretical concerns of Classical Modernism which followed; they point toward a future that will divide Abstraction and Realism as two parallel developments indebted either to the free invention of form or the extrapolation of formally non-manipulated, actual objects.

Klimt's juxtaposition of realistic and abstract elements is the most prominent feature of his style. The *tromp l'oeil* of depicted faces and hands, paired with the abstraction of neighboring structural elements, is a play with the ontological vacillation between illusionist images and physical elements, between sensuality and rational concepts. Both directions, Abstraction and Realism, developed in the course of the 20th century into the presentation of an autonomous work of art, free from external obligations, creating its own laws, become concrete as an aesthetic and spiritual material. After having witnessed the development of Classical Modernism, we look at *The Kiss* as a key work of the 20th century.

Autonomy

What immediately strikes us in *The Kiss* is a timeless modernity manifest in formal simplicity. Two large forms are placed on the canvas. One of them occupies the largest portion of the space in

the center. It is a vertical golden form resting on top of a green area that has come into the picture from below. The edges of these forms are sharp like the edges of stencils cut out with scissors. The spatial flatness of the design is surely the flattest version of Western art in the beginning of the 20th century. It must have irritated the eyes of a society that expected painting to cast empirical facts in accordance with a tradition of looking at art no differently than looking at the visible world. Flatness is related to the articulation of the picture plane and a perception directly involved with the physical conditions of the painting.

Pioneers of this development of painting toward pictorial autonomy were the Impressionists who succeeded in creating the flattest version of depiction in the 19th century. They applied pigments on a canvas that directly put itself in the middle of actual reality. A shallow space, independent of volumes or the depth of a landscape, expands evenly throughout the pictorial plane and makes the contours of things disappear in the network of an even articulation of brushstrokes. Impressionists sought artistic truth in the direct existence of an art object in reality. Now, we encounter an object that transforms manifold appearances in nature into the autonomous nature of a work that guarantees a pre-conceptual experience expressing mood and atmosphere.

The flatness of Impressionist painting, most beautifully accomplished in Monet's cathedrals and haystacks, found its clearest radicalization in the geometry of Cézanne, who made the direction of pictorial elements correspond with the horizontal and vertical edges of the canvas so that pictorial subject matter is arrested in the matrix of a geometrical structure. Cézanne is often quoted as having created the flattest version of pictorial space since the Middle Ages.

His effort to structure the picture rectangle with small facet planes always encountered the difficulty of maintaining flatness while dealing with the depiction of round objects like nudes or

fruits. In Klimt's *Kiss* the pictorial elements are flat as if pressed onto the canvas by a steamroller. Illusion is reserved only for a few body parts—arm, face, feet—which intermingle with the abstract environment as if coming from another world. The result is a pictorial totality which presents itself as sublime.

Around 1905, Klimt was in full possession of his stylistic means. Today, it appears that the stage was ready for the development of Modern Art.

The New Space

The transition from the Middle Ages to Renaissance art was marked by the development of an illusionist space in painting which would govern Western Art until the end of the 19th century. At that point, the loss of interest in faithfully reproducing the forms of nature, illusionist space, the favored instrument of mimesis, lost its dominant role as a pictorial parameter. Impressionism, Fauvism, and Abstraction concentrated on the physical existence of autonomous forms and colors, making the refutation of 3D illusion the most visible sign of artistic progress in the first decades of the 20th century.

It is no coincidence that such pictorial elements dominate the repertoire of abstract painting which corresponds with the pre-existing geometry of the support and makes an object out of the painting, whose lateral space ends exactly there, where the canvas ends. The unification of pictorial material with its support makes an object out of the painting that exists in real space. Pictorial forms find themselves on the same level of reality as the canvas and its edges. The painter cannot allow forms to be cut off by the edges of the canvas. A situation must be avoided—inherent in illusionist painting—where the picture window is just a segment of a larger reality.

The inclusion of the picture edges in the distribution of pictorial elements allowed Klimt to create an autonomous actual

space. Such a space was not available for contemporary artists at the time, not even for Picasso and Braque, who developed the same attitude of placing physical elements on the surface of a painting only around 1912 when creating collage. It is a re-orientation of the eye from the modeling of volumes in an imagined space to the employment of actual material in real space like relief or sculpture. Even though Picasso and Braque pushed the pictorial events without pity to the surface of the painting and created an immediacy of aesthetic reality, never found previously in the history of western art, the little abstract facet planes which structure Cubist painting always appear in connection with illusionist means like shading, shadows, and the variation of color and proportion. Inspired by the compositional principles of Cézanne, the Cubists succeeded in creating a formal and ontological unification of the canvas rectangle with pictorial elements either painted or physically applied.

Around 1912, Picasso and Braque worked on a series of *papiers collés* using available material like wallpaper, newspaper and cloth. Drawing lines are integrated as something made by hand. While early Cubism is still indebted to the traditional notion of pictorial space, *papier collé* is able to re-orient the eye toward actual material in actual space. The demarcation between painting, relief, and sculpture has become fluid and aesthetic truth is embedded in physical existence. The use of a metallic substance like gold allowed Klimt to attach it like a 3D element to the surface of the canvas and introduce already at the turn of the century a collage-like way of treating pictorial space. The homogeneous texture in the background of *The Kiss* is like a hard material, like a solid wall without meaning beyond itself. Klimt's formal flatness is not the byproduct of perhaps creating an ornament or a superficial decoration. It is the result of an ambitious artistic endeavor to create an abstraction that stands like a stepping stone for the advent of a new age.

In the same year as Klimt worked on *The Kiss,* Picasso painted *Les Demoiselles d'Avignon* (1906–07) which is still indebted to an interior space as we know it from illusionist painting. Even though Picasso defines the contours of bodies with hard edges and condenses corporeality into flat shapes removed from direct association with empirical objects, *Les Demoiselles* is indebted to a tradition of painting that allows the eye to look into the illusion of space, distinguish empirical data and sink into the interstices between depicted figures.

Structural Identity

Structural identity is the abstract character of a pictorial configuration in its totality. Abstract painters place aesthetic reality in the middle of actual reality. They create a structural identity that proclaims its individuality within all other objects in the world. Pictorial elements like lines, color fields, points etc. are not only visible components of structure but they are the basic essence of an aesthetic idea organized in style. An abstract painting is first of all a surface with details which approach the beholder as something really existing, making it possible to capture the sensuous appearance in a *coupe d'oeil* in the first instance of encounter. Structural identity is the Absolute of an aesthetic idea. It is the actual content of the work. The structure of connected elements allows the beholder an imaginative entrance, a direct impression and emotional contact with the presented scene. The outer appearance is content and content turns into Idea.

Inspired by the ideas of Plotinus, the Impressionists saw the entrance of an image into the soul not in the mimetic transposition of an outer appearance but through unspecific impressions. Around 260 A.D., in the fourth book of his *Ennead,* Plotinus writes that "when we receive impressions from what we see, then it is not possible to look at the actual thing, but we see the shapes and the shadows of objects, so that the objects them-

selves are different from what we actually perceive [...] one has to be removed from the object so that we can transpose it onto the soul."[3]

Radical changes do not occur in empty spaces but in a climate of critical discourse concerning artistic parameters which prevailed in the past and needed to be changed or replaced to make progress possible. Artistic ambitions are not based on a single truth applicable to all ages but they emerge from a melting together of past, present and future aspirations, always different, making a living organism out of works like the world itself which grows with the laws imposed by the change of time.

The Kiss and Kissing

The vertical form in the center of *The Kiss* is not associated with any empirical concept. It is an autonomous abstract form that rises like a rock glowing in a setting sun, covered with flowers, flat like a shape cut out of wallpaper and glued to the canvas. The left side of this central form is articulated by black rectangles. They create a ceremonial and festive atmosphere. They are beyond any description of empirical data. Their only function is articulation of the pictorial plane. Three, somewhat larger rectangles, also painted black, are more pronounced. They establish a parallelism with the edges of the picture and keep the whole situation in a rigidly static position. A mosaic of circles articulates a form bending over the back of a male head adorned with the wreath of Dionysus. He is drawn to the face of a woman, whose expression is none other than that of complete surrender. Both figures find themselves in a monumental silence as if frozen in this position for the rest of eternity. Never will they return to normal life, particularly not to the life of Impressionist lovers who frolic in flowering meadows and in the shade of green trees. Klimt's lovers are suspended in space and time, cast into a hard form that does not represent kissing but is the *kiss* itself.

But what kiss is it? There are no lips that touch, no eyes searching for the other's soul, no movement, no action, just embracing and holding as if an invisible power had provided rest and peace from the turbulence of the world.

Surely, it is not the kiss of Toulouse-Lautrec's *Au lit: le baiser* of 1892 in which two high school sweethearts spend Monday morning in bed; it is not the kiss in the film *Color of Night* in which Bruce Willis succumbs to the erotic web of Jane March; it is not the kiss on the Aretinian vase from the period of Augustus (27 BC–14 AD), which shows a lover holding the naked body of his pride; it has little to do with Munch's *Kiss* in which bodies melt in an illusionist space; it is not Rodin's *Kiss* of 1896 with its lively modeling of naked bodies; it is not the intensity of desire displayed in Camille Claudel's bronze eight years earlier; it is not the archaic formality of Brancusi's *Kiss* (1908) or the sarcasm of Duchamp, who in 1968 showed where the hand of Rodin's lover needs to be.

Klimt's *Kiss* has abandoned all anecdotal description belonging to an earlier age and put itself in front of an aesthetic movement, which in the 20th century will deal with the medium of painting, silent and static objects leaving the narrative behind like a broken toy.

Realism and Abstraction

An enormous dialectic exists between the realistic plasticity of the face, shoulder, hand and feet, and the flat abstraction in the rest of the painting. Short brushstrokes molding illusionist elements adopt the same static character that pervades the rest of the painting: a holy silence of gold. Both figures are cast as a shiny statuette, mysterious yet alert in rigid immobility. Eyes are fixated and forlorn in meditation. They find themselves in a heaven of eternal peace.

The synthesis between Realism and Abstraction determined aesthetic taste until the end of the 19th century. Klimt's *Kiss* broke

this fusion of form and content and presented diametrically opposed principles—Realism and Abstraction—as if they could embrace only in opposition. We do not look at the depiction of a kiss, but witness the rendez-vous of two totally different aspects of art: one regulates with Apollonian clarity the life of pictorial form, the other flirts with reality and the beauty of pre-existing form with Dionysian lust. The realist elements of the body, painted in *tromp l'oeil*, show nothing subjective, neither in form nor in presentation, and melt into the same objectivity as the neighboring geometry of abstract elements. Both geometric and realistic elements are "ready mades." They are not invented form but found forms. They turn the familiar into the unfamiliar and mysterious; they give life to the trivial, turn the process of selection into a creative act, distance and alienate the beholder while inviting him to unravel a complex mystique.

First and Second Versions of *The Kiss*

The Kiss as it exists today is the second and final state of a canvas initially conceived as *Liebespaar*, documented in a black-and-white photograph (fig. p. 228). It was finished toward the end of 1907, exhibited in the summer of 1908 at the Wiener Kunstschau, and purchased by the Ministry of Culture for 25,000 guilders, with the stipulation that the left, lower corner, the area of the meadow, had to be finished.[4] Nobody expected that the renewed involvement with the meadow in Klimt's studio would lead to decisive changes to the rest of the painting. Changes to the meadow demanded a re-examination of all other elements. Klimt was forced to concentrate once again on the entire image.

The rather clumsy articulation of the meadow with round elements in *Liebespaar* changed into a homogenous distribution of flowers. But altogether the project demanded a reduction of visual information and a quieter composition through simplification of spatial events. In the first version of the painting, black

rectangles float on top of the male figure as if to decorate a morning coat. This impression is evident in the left lower corner, where the coat bends backward like a sculptural volume. The elimination of this corner in *The Kiss* creates an elliptic shape which, together with slender black rectangles, provides a static and convincing rigidity in the whole arrangement of form.

Reduction of visual information, which starts with re-working the meadow, continues in the central vertical form. The small rectangles of the first version articulate only the coat of the male figure but provide little hold for the whole vertical form. By structuring the whole form of the male figure with slender rectangles a static and unified form could be created, built as if using brick. The multiplication of rectangles led to a reduction of spatial events.

The realistic parts of the first version were also the subject of new inspection. The naked arm of the woman received an elbow which stands like a "V" in the center of the painting. Klimt accomplished simplification by adding elements. The female feet deserve particular attention. In the first version they are hardly visible because they were embedded in the central, vertical shape. Now they emerge as clearly defined forms, acting like a nail that holds the surrounding elements in perfect balance. The horizontal contour of the meadow is now connected from left to right with the contour of the feet. Together with two larger rectangles a base is created so that the vertical, central form is no longer inclined to tumble over, either forward or backward.

The changes from the first to the second version provide an interesting insight into the artistic will of a painter who sees in the totality of sensuous appearance the absolute of aesthetic value. The reduction of narrative information increases contemplative concentration.

When Kandinsky liberated pictorial elements from their traditional tutelage to carry images of representation (1910), he not only opened the limitless territory of formal invention but paved

the way for realistic elements obtaining freedom from the involvement in subjective manipulation of form. Duchamp's ready mades found their way into the realm of art without the burden of narrative meanings. Nietzsche's idea that objects of reality would one day escape from the slavery of artistic manipulation became concrete both in Realism and Abstraction. Both reject outer meanings for the sake of autonomous aesthetic objects.

Kandinsky and Duchamp engaged in a process of tension reduction between different strata of reality—reality as form and form as reality. They repudiate outer concepts in deference to autonomous entities. In *total amnesia*[5] Duchamp chooses objects from the household of reality and liberates them from their original meaning. Kandinsky follows his *inner necessity*[6] with forms and formal constellations independent of outer concepts. Since 1914, Realism and Abstraction have developed independently, each pursuing the ultimate possibility of their inherent character. Abstract artists enjoy the search for the deepest recesses of the soul; Realists penetrate the inner life of objects with situations and constellations possible only in art.

Klimt's synthetic style between Realism and Abstraction is a concentration on the immediacy of form and physicality of execution. His development is not only the result of a future oriented spirit but also of the cultural circumstances in his time.

History

Gustav Klimt was born in 1862 at a time when the Austrian monarchy ruled over a massive block in the heart of Europe. Its borders reached from Herzegovina in the South to the borders of Poland in the North, from the Swiss border in the West to Transylvania in the East. Austria had the only multinational army since the Roman Empire. The country's languages included German, Hungarian, Czech, Slovenian, and Italian. Vienna was the third largest city in Europe. Under the leadership of Emperor Franz

Joseph, the Habsburg monarchy was expected to reign in peace for the next thousand years. As an expression of the monarchy's well-being, Franz Joseph began the largest architectural undertaking in Europe. On Christmas Eve 1857, as a gift to the people of Austria, he ordered the demolition of Vienna's defensive fortifications which surrounded the inner city, and the construction of a grandiose replacement for the dilapidated buildings where antagonist worker unions were often barricaded. Over the next fifty years he erected a number of magnificent buildings along the Ringstrasse encircling the 1st District. The project was conceived as a *gesamtkunstwerk* embracing all disciplines of the visual arts. The largest building erected was the Neue Hofburg, residence and offices of the Emperor, designed by Gottfried Semper (1803–79) and Karl Hasenauer (1833–94), who also designed the Burgtheater, a major theater in the German-speaking world. Theophil Hansen (1813–91) was the architect of the Vienna Stock Exchange, the Rossauer Barracks and the Academy of Fine Arts; Heinrich Ferstl (1828–83) designed the Museum of Applied Arts. The Parliament with Carl Kundmann's *Athena Fountain* and the new Opera House were built by August Siccard von Siccardsburg (1813–68) and Eduard van der Null (1812–68). Null committed suicide due to the criticism he received before the opening of the opera for not having met the Greek standard which would have raised the building from street level with a broad flight of stairs leading upward to its entrance.

Today the Ringstrasse is a museum to the architectural taste of the 19th century. The monarchy started to dissolve in 1914 when a nationalist Serb shot the heir to the Austro-Hungarian throne, Crown Prince Franz Ferdinand, in Sarajevo, initiating the First World War. Austria emerged from this war only a fragment of its former size. Grand architectural splendor no longer signified the mood of a country that needed to come to terms with the loss of a glorious past. The dominant style of these buildings is the re-

juvenation of a historicism derived from Roman and Greek sources. Allegorical frescoes, reliefs, and sculptures decorate facades and continue in lobbies and staircases. Whatever value one attributes to this architectural style, the buildings have obtained a majestic appearance and beautiful aroma over time, particularly after the 2nd World War when Austria became a neutral nation in the heart of Europe.

Around the date of Klimt's birth, the Austrian painter Hans Makart stood at the peak of a brilliant career His subjects included allegorical scenes mostly from Greek history, portraits of opera stars and actors. Klimt's early artistic training was in keeping with the tradition of Makart.

With his brother Ernst and his friend Franz Matsch, Klimt established the "Künstler Compagnie." Their first commission was the decoration of the staircase ceilings in the Burgtheater. Out of the various arrangements of works each artist selected, there are two dialectically opposed paintings by Gustav Klimt: *The Altar of Apollo* and *The Altar of Dionysus.* The symbolic polarity of these images is a reminder of Nietzsche's *Birth of Tragedy.* Two distinct aesthetic impulses govern art: the Apollonian constraint of form for clarity and the Dionysian flight into the irrational. Nietzsche refers to the necessity of establishing a synthesis between two opposing forces in the creative process: intellectual control and inner necessity. Admiration for Nietzsche's philosophy guided Klimt's theoretical concerns and accelerated his expansion of stylistic parameters. Similar to the interest of the French Impressionists in Schopenhauer, Kant, and Plotinus, Klimt received philosophical support for his stylistic parameters, for the opposition and unification of Apollonian clarity and Dionysian sensuality.

The commission at the Burgtheater brought Klimt great reputation. The picture of 1888 which shows the theater audience with many important personalities brought many people to his studio. He could have become *the* painter of Viennese society—

like Franz Matsch, who after the dissolution of the Künstler Compagnie involved in traditional portrait painting—but Klimt's curiosity for the new in art prevailed over economic ambitions.

The wonderful portrait of 1890 of the pianist Joseph Pembauer is an outstanding example of an artistic will to transcend the limitations of simple imitation. The flatness of the picture frame, decorated with symbols from Greek antiquity, stands in contrast to the almost photographic representation of the face. The opposition between volumetric and flat elements continues to the center of the painting where the abstract form of a kithara articulates the flat background.

The connection between abstract geometry and the lifelike depiction of the face and hands appears in the portrait of Emilie Flöge (1891), who would later become Klimt's lifelong companion. Klimt painted Emilie a second time in 1902. This time she is wearing a wonderfully decorated garment. Flöge directed a successful fashion studio, designed by Josef Hoffmann, with connections to Paris, London, and Moscow. From here we understand Klimt's employment of ornamental patterns and abstract elements when painting garments of his female sitters. He was inspired by a fashion world which produced exquisite forms and color combinations.

At one point the rumor developed that the couple in *The Kiss* is the master himself with Emilie Flöge, even though no such indices can be found. The head of the male figure is every man's head and the face of the female is every woman's face. Klimt never painted a self-portrait and the woman could equally well be Alma Mahler.

In a 1960 autobiography, Alma blames her mother for destroying the great love of her life when forbidding her to speak to the thirty-five year old Klimt, after it was found out that he had secretly followed her and her parents on a trip to Genoa and Venice to observe her from a distance.

In 1898, Klimt became the founder of the Secession, an artist organization independent of the Künstlerhaus, the official art institution of Vienna dedicated to allegory, historical painting, and monumental portrait sculpture. The spirit of Makart, who died in 1884 at the age of 44, still set standards for official art in the manner of the Renaissance. Dissidents, discontent with the conservative Künstlerhaus and its neglect of new art movements abroad, raised funds for a building of their own, the Secession, greatly supported by the Mautner and Wittgenstein families. It was designed by the then 30-year-old Josef Olbrich. Particularly striking is the golden roof, a cupola consisting of 3,000 gilded, cast iron leaves. Above the entrance is the inscription: "To every era its art, to art its freedom." The building contrasts markedly with the appropriated style of the Ringstrasse. The interior of the Secession building comprises a single open space which required the invention of moveable partitions for exhibitions. Between 1898 and 1910 a number of important shows, national and international, were organized. The cultural climate of the city and the aesthetic impetus artists received from their immediate environment changed drastically. The Secession became the center for what was new in Vienna. Klimt became its first president. Members included Carl Moll, Joseph Engelhardt, Theodor Hoerman, Wilhelm List, Ferdinand Andre, Max Kurzweil, Kolo Moser, and the architects Josef Hoffmann and Otto Wagner.

In 1903, Josef Hoffmann founded the Wiener Werkstätte to encompass designs from architecture to kitchen utensils. Its motto declared that one well-made object produced in a week is better than the production of a hundred inferior objects a day. Its style ranged from strict geometrical pattern to the linear flourish we know as Jugendstil. Both features are found in the architecture of Otto Wagner, who had great influence shaping the city. His contributions include the Vienna subway stations, the main post office building with its futuristic features, and the psychiatric

clinic at Steinhof, consisting of a dozen buildings and a large chapel on a hill overlooking the city.

Gustav Klimt found himself in an atmosphere of intense aesthetic discourse and cultural development. He was in the midst of painters, architects, and philosophers: Sigmund Freud, Otto Weininger, Gustav Mahler, Arnold Schoenberg, Anton von Webern, Alban Berg, Hugo von Hofmannsthal, Robert Musil, Franz Werfel, Rudolf Carnap, Moritz Schlick, Ernst Mach, Ludwig Boltzman, and Ludwig Wittgenstein, to name but a few. The Secession became a showplace for international art.

In 1905 Klimt broke with the Secession because the participation with Galerie Miethke resulted in the same commercialization that brought criticism to the Künstlerhaus.

Josef Hoffmann, Otto Wagner, Carl Moll, Max Kurzweil, and Adolph Böhm amongst others, became part of the newly founded "Klimt Gruppe." In 1908 they created the Wiener Kunstschau, an exhibition taking place in the summer months on the site of the later Konzerthaus. The pavilions designed by Hoffmann showed the newest in art ranging from theater designs to posters, crafts, and paintings. Here, Klimt showed the portraits of Fritza Riedler, Adele Bloch-Bauer, Margarete Wittgenstein-Stoneborough and the first version of *The Kiss*.

Pure Form

The contrast between the flatness of gold and illusionist rendering became apparent in Klimt's *Judith* of 1901. This work is of particular importance because the frame is incorporated in the composition. A newspaper article described the intentions of the Secession as *a* "modern art movement that finally makes some progress in an otherwise slow going city; young painters are convinced that a frame should be designed in harmony with the picture."[7]

The involvement of the frame in pictorial events had already been proposed by Karl Friedrich Moritz in 1785. In his *Aesthetics*,

Moritz speaks of a work of art as a thing in itself before it exhibits illusionist subject matter. He developed a definition of form as contour. As an expressive element the contour is separate from depicted subject matter and it makes itself felt as an independent visual force. The ornament of the picture frame is a member of the entire constellation of pictorial elements. In an essay on ornament he claims that the beauty of the frame and the beauty of the rest of the painting derive from the same principle: both are free of mental associations.[8] The autonomy of form is the highest principle of aesthetic consciousness. Klimt's employment of small, geometrical elements like squares, triangles, and circles in conjunction with the frame is a text book example of Moritz's theories.

In the early years of the 20th century, Klimt produced a number of paintings that operate with an astonishing degree of abstractness. His influences derive from older art like Velázquez's portraits with their elaborate concentration on the pattern of garments, and also from the golden mosaics in Ravenna and St. Mark's in Venice. The theories of Viennese art historians and philosophers, who drew attention to Kant's aesthetics that point to pure abstraction and the distinction between pure form and narrative representation, must have been of particular importance.

Concentration on geometrical elements and the employment of gold as a color is the most prominent feature of Klimt's work between 1903 and 1907. Klimt's ideas were reinforced by the theories of Pater Desiderius Lenz (1832–1928), who published a book in Vienna *Zur Aesthetik der Beuroner Schule*[9] in 1898, in which he advocates that academic naturalism and its perverted illusionism must be replaced by ideal typical forms, the basic forms of nature. The formal imprecision of Realist art must make room for the truth of basic geometry inherent in natural objects. The Greeks and Egyptians reached beauty through clarity and simplicity by reducing natural forms to a canon of geometry In an exhibition of the Beuron School in the Secession in 1905, critics com-

pared their works to the efforts of the Klimt Gruppe, which also connected modern art with principles of the Classical past and approached visible reality with fundamental data of geometry.

In his *Aesthetics*[10] of 1865, Robert Zimmermann proposed that a philosophical discourse should investigate why certain shapes and formal constellations are aesthetically more effective than others. He sees the appearance of an object separate from the concept it represents. Form and formal constellations are the essence of aesthetic content. This somewhat exaggerated meaning of form led to intense discussions at the end of the 19th century about the role of an empirical Formalism over the romantic idea that the beauty of subject matter can equally serve metaphysical aspirations.[11]

In 1902 Alois Riegl (1858–1905) published *Spätroemische Kunstindustrie*.[12] He re-evaluates the massive architecture, sculpture and frescoes of the late Roman period, which is often associated with the decay of Roman culture (*Verfallszeit*). Riegl's linear view of history sees changes of taste in the changing *Kunstwollen* of artists expressing aesthetic volition through form and color on a plane or in space. He separates the purely aesthetic from narrative content. Riegl distinguishes the *objective reality* or the palpable existence of the work, and the *optical qualities* that reflect subjective interpretations of visible things. He introduces the concepts of attentiveness and vigilance as psychological criteria for the expressiveness of form and formal relationships. The physical presence of the work carries a greater truth and demands greater attentiveness than contents of representation which are never part of a universal language of perception. A few years later Kandinsky would ascribe universality to the language of abstract form because it addresses not individual concepts but emotional strata of consciousness.

Riegl's emphasis on the physical existence of the work has precedence in the theory of Conrad Fiedler (1841–95). In his *Über*

die Beurteilung von Werken der Kunst[13] Fiedler refutes the ideal of Classicist Art that saw beauty only in a synthesis between ordinary and aesthetic reality, a synthesis between depicted subject matter and forms serving composition. Instead he sees art as part of a larger and still evolving creation. For Fiedler, aesthetic forms are first of all autonomous realities before signifying anything else.

An aesthetics that points to the immediacy of pictorial elements poses a key question in 20th century art: if the formal content can appear independent of associations, can one assume that it appears also independent of feelings? This question is of particular importance at the end of Classical Modernism when the purism of Minimal Art shunned the confusion of subjective taste, a confusion created by works accessible to multiple and conflicting interpretations Similarly, at the end of the 19th century, there is a conscious search for invention and aesthetic rejuvenation. The result is a progressive re-orientation toward aesthetic concepts within the complex field of artistic possibilities.

In 1902, the architect Henry van de Velde (1863–1957) proposed that within all visual means the line deserves the highest attention. A line can communicate and set into motion vibrations of the soul and arouse aesthetic feelings more than other components of visual expression. Van de Velde's theory of line is an early manifesto for the developing Jugendstil, which creates emotive content by linear movements and concentration on the contour of depicted forms.

Around 1910 Kandinsky start his experiment with abstract lines he saw inside and places them in his paintings out of *inner necessity*. He translates the closed and rigid lines of Jugendstil into freely developing and internally corresponding linear elements, which create movement and float in space. They are not boundaries of forms but free agents creating a colorful space, spontaneous and improvised as if the result of automatic handwriting.

Kandinsky's linear autonomy is historically the culmination of a long process of liberating pictorial material from the service of representing empirical data.

Very different is the approach of Klimt and the Constructivist line of abstract painting with its focus on controlling clearly defined elements within the quadrangle of the painting.

Malevich, Mondrian, and other Constructivists use rectangles and squares to eliminate the traditional dialectic between figure and ground. They create paintings to be viewed as objects devoid of inner events or conflicts while straining to control the pictorial field to the minutest detail. The creative act no longer engages in random improvisations and deviations from imagined subject matter; now the painter is in continuous contact with the laws of art imposed by the physical constitution of the picture plane.

Of great importance for Klimt's aesthetic thinking were the theories of William Morris (1834–1896) who founded a company for arts and craft 1861 in London. Wallpaper, glassware, carpets and furniture were produced with high standards of craftsmanship. Morris united different disciplines of artistic activity in a single creative enterprise. His idols were in the Middle Ages when no difference existed between the ugly and the beautiful because craftsmen tried to make everything beautiful. Morris rejects the exaggerated luxury of the Renaissance as an enemy of art because it doesn't fulfill any function in everyday life. Equally the manifesto of the Secession proclaimed in 1897 that "there is no difference between High Art and Craft, between art for the rich and art for the poor, art is for everybody."[14]

In his opening speech for the Kunstschau (1908), Klimt quoted Morris saying that "even the most unimportant thing, when it is executed with excellence, will add to the beauty of this world and solely in the progressive penetration of all of life with artistic intentions will the progress of culture be founded."

Stoclet

The highest degree of abstraction attained by Klimt is his mosaic frieze (1905–11) for the intimate breakfast room in Stoclet Palais in Brussels. Josef Hoffmann was given the important architectural commission by the young Belgian industrialist Adolphe Stoclet. A *gesamtkunstwerk* including every detail of the building, together with its furniture, walls, and carpets would be elements of an all-encompassing design. The mosaics were executed by the Wiener Mosaik Werkstätte in colored faience, white marble plates, copper sheathing, and silver plate.

The designs for the Stoclet frieze, which was started in 1905, are also stylistic and thematic preparations for *The Kiss* (1907–08). While no preparatory sketches exist for *The Kiss*, there are many cartoons and detailed drawings in pencil and tempera on card which were used by the Viennese mosaic studios to cut the pieces of marble for the frieze. Photographs show the creation of the frieze and preparatory drawings pinned to the wall of the dining room. The drawings and cartoons provide an understanding of Klimt's stylistic efforts. We see a dressed couple, the man from behind, the woman melting into the male figure, her face only visible from the side (fig. p. 230). The structuration of form with geometrical elements[15] shows Klimt's concern for a flat and exclusively lateral composition. The mosaics have a vivid surface. Marble elements sometimes protrude from the otherwise flat surface. A *Kiss*, called *Erfüllung* (fulfillment), is on the right wall of the dining room. Klimt's talent for abstraction and apollonian control finds its ultimate expression here. Already in the preparatory drawings, which were finished between 1906–07,[16] we can see a clear shift from an involvement with representational content to the inherent properties of geometrical elements and the logic of distribution on a pictorial plane. The title *Erfüllung* is the proper name for a work which pushes abstraction to the ultimate limits of representation on its way to pure abstraction. *Erfüllung* is

articulated by clearly defined, eliptical elements, which adapt to the roundness of winding branches from the tree of life, which in turn is distributed over the entire right wall of the dining room. The result is a fluid integration of figure and ground.

The face of the woman, her hand, and the head of the male figure act as participatory elements of an abstract composition rather than as signifiers of associations to representational content.

Klimt shows half of the female face while the head of the male figure is visible only from behind. These realistic elements have no firmer hold in conveying subject matter than the birds and fish in the center of the oval shapes held in a static position.

The woman's hand exhibits a similar holding function. As a small vertical rectangle, it acts like a signal within the turbulence of neighboring elements. In no other passage of the image occurs a greater turbulence than in the vicinity of this hand. It evokes the symbolic gestures of figures from Antiquity. The way it visually holds the male figure in an erect position is reminiscent of the myth of Isis and Osiris[17]—the Stoclet collection of Egyptian artifacts was kept in a side room off the dining room. The motive of the tree of life, which is a reminder of the waves on the Nile, shows Klimt's talent at illustrating a long story with the minimalism of constructive intelligence. The white rectangle at the bottom of the image in particular is like the weight of a base for the rising forms of the figures. It conveys a premonition of Mondrian and other Constructivists, who rely on clear geometry to establish solid and static compositions.

The Height of Abstraction

Of particular interest is the small rectangular frieze on the narrow wall at the end of the dining room (fig. p. 231). The mosaic frieze is the most abstract work in Klimt's oeuvre. It shows the bold experiment of leaving representation completely behind. It was to take a number of years for other artists to accomplish the same

degree of abstraction. In this *Abstract Composition* (1905–09) Klimt is indebted to ornament, symmetry, and the logic of geometrical arrangement. The mosaic (194 x 91 cm) is divided into three vertical bands. The left and the right band are covered with an even pattern of circles and triangles that build a background for the vertical form held in the middle of the composition by two slender rectangles framing the flower pattern. The principle of polarization and the juxtaposition of emotionally distinguished elements—a distinction between male and female forms—appears here at a high level of abstraction as a demonstration of the objective laws of nature. At the bottom of the image we see the tree of life contained in a square that is less a mandala than a small oriental carpet.

Josef Hoffmann designed the supraporte relief for a niche above a door in the Secession as early as in 1902 (fig. p. 232). It consists of vertically shifted cubes of various widths creating the impression of a utopian city scape. This abstract plaster relief became a symbol of his style.

The articulation of aesthetic space with cubes, rectangles, etc., as we find it throughout the 20th century, is the desire to reach an Absolute of aesthetic content through the purity of universal elements. Geometry intensified in De Stijl, founded in 1917 in Holland, propagating vertical and horizontal directions as an answer to subjective handwriting and free invention of form. The axial orientation of Mondrian's compositions, the reduction of pictorial incidence in the rectangles of Rietvelt, Vantangerloo, and van Doesburg are expressions of a metaphysics of reality, a metaphysics connecting the artistic enterprise with universal laws of a morally founded aesthetics. These artists doubt subjectivity and arbitrary events in life. They pursue objectivity and purity, extending the laws of geometry into the sphere of living.

Geometry was also an important issue at the Bauhaus, founded in 1919 by Walter Gropius (1883–1969) in Weimar. It ex-

erted influence even after its closure in 1932. Paul Klee, Wassily Kandinsky, Marcel Breuer, Walter Gropius, László Moholy-Nagy, Ludwig Mies van der Rohe, Max Bill, Hans Albers, Johannes Itten, Lyonel Feininger, Herbert Bayer, and others, worked with *Urformen*—squares, triangles, and circles—as pictorial elements and architectural volumes. The Constructivist ideology embraced not only all areas of design but influenced life and was also to explain the workings of the universe. The second law of thermodynamics, which Rudolf Julius Clausius (1822–88) placed like an omen in the path of stars, claims that the material world is in a process of dissolving and that the present order of things will turn into chaos.

The concentration on geometrical elements, which determined the work of Bauhaus artists, was meant to establish peace, at least in art, amongst the otherwise vanishing forms of reality and test the capricious invention of form with objective laws of geometry, while still leaving room for creative freedom.

Rectangle

The most prominent formal motive in *The Kiss* is the employment of a sequence of rectangles which account for a degree of abstraction totally unexpected in the beginning of the 20th century. Klimt's *Kiss* finds itself at the advent of a Constructivist tradition that will dominate Classical Modernism during most of the 20th century, at least until the end of Classical Modernism around 1980.

The motive of the rectangle appeared in 1913 in Mondrian's, Kupka's, and Malevich's compositions, and exerted its influence particularly on Formalism in the 1960s and '70s with its Minimalist reduction of aesthetic incidence in objects with little or no internal articulation The reduction of pictorial events to vertical and horizontal directions can be seen in the work of Barnett Newman, the meditative black paintings of Ad Reinhardt, the stripe paintings of Kenneth Noland, the monochrome surfaces of Ellsworth Kelly, Yves Klein, Robert Ryman, and painters who prefer objec-

tive matter and concentration of visual information over the often vague and confusing results of uncontrolled forms derived from the free invention of form The Minimalist emptiness, as it occurred between 1970 and 1980,comes from a tradition in Western painting which sees excellence in the order of form, first in the fixed lines of a central perspective, later in the geometrical units of Cézanne and the Cubists, in the calculated constructions of Mondrian, and finally in the dissolution of form in monochrome canvases

However, it would be deplorable if the search for compositional order were to end in emptiness or in a vacuum, as is the case in many works of the 1970s, particularly if one expects from the visual arts that their products have not only meaning within the network of aesthetic concepts but also address the inner movement of consciousness by varied degrees of order or disorder in a living aesthetic structure, which only in pathological cases is fully ordered or absolute chaotic.

In modern sculpture the rectangle operates like a salvation from the arbitrary extensions of matter in space. Georges Vantangerloo's *Wood* (1921), Kurt Schwerdtfeger's *Bauplastik* (1922), and Kurt Schwitters's *Monument for the Father* (1922–23) are creations of a will to reveal the inner nature and inherent laws in the act of creation. In 1924 El Lissitzky commented in *Nasci*, a co-publication with Kurt Schwitters on Constructivist ideas, that aesthetic forms are petrified moments in a state of becoming. Crystals, cylinders, circles, columns, planes, stripes, and spirals are the seven constituents of everything which exists. These forms guarantee an optimal working of the universe: "They are found in architecture, technology, mineralogy, chemistry, geography, and astronomy, in art, in crafts, and in the whole world."[18]

The rectangle and the cube found their strongest expression in David Smith's 1960s "Cubi" series of, hollow cubes, boxes, and pillow forms in polished steel, often connected only at the edge—

weightless, like particles escaping into space (fig. p. 233). The traditional monolith with its unitary mass and limitation for formal articulation is replaced by the expressive theatricality of formal exclamations.

The motive of open construction and the loose distribution of cubes, rectangles, circles, and squares became the most prominent feature of Western sculpture at the end of the 20th century. Donald Judd orders boxes vertically on the wall, Richard Serra bends oversized rectangles of steel. Eva Hesse, the bright star of the Art Povera movement in the 1960s, uses art-alien material like rubber and plastic to endow rectangles with the strength of an inner life and a beauty as if they had arrived from another world (fig. p. 234). Christopher Wilmarth takes rectangles of glass to create the impression of an abstract, transparent landscape, Tony Smith creates a black oversized cube as if it were a home of silence and repose, Robert Smithson reigns over the garden of a wide landscape with the geometry of a gigantic spiral, and Richard Long places stones in the shape of a circle.

The evolution of the rectangle at the beginning of the 20th century shows Klimt at the outset of a Constructivist tradition. A future-oriented spirit controls pictorial space with ceremonial discipline, creating an immediacy of form and a physical presence of the aesthetic object only found fully developed years later in modern art. There is something futuristic about these rectangles in *The Kiss* and the way they control the pictorial space. Even the natural body parts, which in Klimt's oeuvre appear only sparingly, are treated objectively like found objects lost in a geometrical environment.

Apollonian

The competition between objective Realism and objective Abstraction proves Klimt to be a rational Constructivist who controls from a distance how the painting orders itself, always accompa-

nied by an awareness of the inherent properties and aesthetic forces of both Realism and Abstraction.

The three, life-size portraits of female collectors, *Margarete Stoneborough-Wittgenstein* (1905), the more decorative *Adele Bloch-Bauer* (1907), and the poetic *Fritza Riedler* (1906), show rectangles in various sizes structuring the background in vertical and horizontal directions, while overtly pronouncing the vitality of contours belonging to the familiar appearance of a person. Klimt's portraits represent the noblest aspects of Western portraiture. The abstract composition and its color scheme affect the emotional state of the beholder while being invited to apprehend emotions in the depicted face. The geometrical background determines the flatness of pictorial space. Puffy garments turn into flat forms. Their vital contours melt with the background and establish equilibrium different from the traditional distinction between figure and ground. The rectangular architecture of the painting allows perception to vacillate between formal composition and familiar associations to imagined reality.

Of particular interest is the treatment of the 3D furniture in *Fritza Riedler*. The mussel-shaped patterns are turned into 2D elements through Cubist shifts along vertical axes. Similar to the method used by Vermeer and Whistler, the head of the depicted person is placed in the vicinity of geometrical shapes, windows, pictures or maps. In Klimt's paintings a melting of originally different concepts into a conceptual and formal equilibrium occurs. The half round mosaic laid at the back of Fritza Riedler's head is like a stained glass window which creates an opening and allows the eye to move forward and backward between a deeper space and the sitter's face. Our glance wanders between the spatial distance in the window and the closeness of a modeled face without halting on one or the other.

The principle of unification of initially separate elements of reality is radicalized in *The Kiss*.

Non-representational elements on the surface of the support pull the Realism of depicted parts of the body into their own realm of abstractness. In this respect *The Kiss* is different from earlier portraits because, here, the elements of representation participate in the formal logic of the abstract composition. The painter succeeds in liberating representational elements from their conceptual meaning. He concentrates exclusively on the totality and immediacy of the aesthetic object.

In 1923, José Ortega y Gasset (1883–1955) deplores the expulsion of the human face from art. He points to the lack of pathos in modern art, the lack of feelings which determined the artistic expression of the Romantic period. He mentions Mallarmé (1842–98) as the first poet of the 19th century to avoid pathos and emotion, the natural material of poetry. His poetry can no longer be felt with emotions, there is nothing human and no feeling. When a woman appears, it is Mrs. Nobody and when the clock rings it is the hour absent from the dial. A sum of piled-on negations in the poetry of Mallarmé refuses emotive resonance and develops outer worldly characters which can only be observed from a distance.[19] The acoustic substrate of the verse is the actual voice of the poet. His stylistic attitude has become the foremost element of literary content.

The flight of the modern artist from depicting something human in favor of pictorial self-manifestation, far removed from traditional emotions, purely phenomenological, alienated for human purposes, is just a symptom of art coming back to itself, becoming aware of its freedom to pursue manifold ontological conditions. Formalist painters assert that their paintings are no more than objects, devoid of emotions and associations, simply there like any other thing in the world. The result is an ontological confusion between aesthetic and normal reality. Abstract objects behave like remnants of a forgotten construction site.

"Why is the contemporary artist afraid of the vital lines of a

living body?" asked Ortega y Gasset. Why must the artist substitute the vitality of a realistic depiction for the rigor of geometrical elements? The answer is simple when we view the course of history as changing between periods of involvement with nature and periods of abstraction. Prehistoric periods show a change from the Paleolithic vitality and sensibility for living form into the Neolithic attitude of composing the natural forms of animals into an allotted space on the walls of a cave, incorporating symbols and stylized signs.

The formalist period of Classical Modernism seems to have followed the dictum of Porphyrius: *omne corpus fugiendum est*. The problem points to the position of the artist who cannot be ignorant of historical circumstances but employs his creative energy according to what is necessary at the time. Either he follows the canon of traditional form or he is leery of history and struggles to come up with parameters most appropriate to his inner being. The alleged dehumanization of art in the beginning of the 20th century derived from the rejection of the romantic idea that visible nature is the only source for creative impulses. Future-oriented artists like Klimt changed from the depiction of existing nature to the demonstration of aesthetic ideas bound into the nature of aesthetic manifestations.

Klimt's *Kiss* could have been a simple illustration of people kissing, had a disciplined spirit not pushed the work to a level of newness within historical circumstances. Kissing is for Klimt the threshold on which the sensuous and the spiritual come together in the unification of abstract elements and depicted subject matter. Of particular importance to Klimt's development was the exhibition at the Secession of Impressionist Art, representing Renoir, Manet, Eva Gonzales, Cézanne, Metardo Rosso, Rodin, Monet, and van Gogh. Klimt started to use he Impressionist method of small brushstrokes to gain control over representational elements. His distrust in losing control over form is clearly at odds with the

vital forms of landscape painting. The Impressionists painted landscapes with a gusto for atmosphere and painterly looseness. Klimt's concern for design makes him a calculating Constructivist. A sunny afternoon at Attersee, a garden of blooming flowers, an *allée* leading to a castle are the subjects of Klimt's rigor of form.

Dionysian

The Apollonian constraint was torn apart in Vienna by the exhibitions of Oskar Kokoschka (1886–1980) and Egon Schiele (1890–1918) in 1908. Both painters pursued the expressivity of line by shading along the contours of depicted bodies, creating abstractions from natural forms, and concentrating on the immediacy of the pictorial space. This development was no threat for Klimt. He saw the ideal of art in continuous change. Even though the expressive figuration of the younger generation contrasted with his own work, it was Klimt who managed the first exhibition of Kokoschka and Schiele at the 1908–09 *Kunstschau*. Responding to warning voices not to incite the public with wild gestures, Klimt is said to have answered: "It is our duty to give a great talent a chance. Kokoschka is the greatest talent of the young generation. Even if we demolish our Kunstschau, we have done our duty."[20] In his *Windsbraut* of 1914, Kokoschka, toward the end of a stormy affair with Alma Mahler (Gustav Mahler's widow and the future wife of Gropius and later Franz Werfel), turns painting away from planar geometry and allows large brushstrokes in a space devoid of compositional regularity. The lovers find themselves on a bed of clouds. The upper parts of their bodies are naked while their lower halves are covered by a blanket. They are surrounded by a stormy world. They have little in common with each other. Alma is absorbed in a dream, while Kokoschka's eyes are awake and wide open as if lost in thought. Hefty brushstrokes dig into his upper body as if to dissolve it into something painful. Half-formed elements float like pieces of lost matter in an empty space. The

lovers have come together in an unstable and unformed world which speaks in dark and muddy colors of the loneliness of man and his exposure to unpredictable circumstances.

A similar approach was taken by Egon Schiele, who in his short career created an astonishing oeuvre of watercolors, drawings, and paintings dealing with a limitless manipulation of natural form comparable only with the formal exaggerations of van Gogh and the German Expressionists. Schiele never left the security of contour and closed form because the outlines of depicted subject matter could develop into vibrating lines, sensitive and fragile, precise in description, yet autonomous as pictorial elements. An almost narcissist concentration on his own appearance accounts for the great number of self-portraits, often in contorted poses as if his body were held with strings like the frozen poses in a puppet shows. Many of his nude- drawings, while not as fluid as those of Klimt, are expressive, often cruel concentrations on the flow of line which now exists not as a description but as an autonomous pictorial reality. Nothing could be more a contradiction of the truth than the assumption that these drawings derived from erotic impulses. Today we look at them not as erotic signals but as moody, often angry outbursts of an aesthetic will to penetrate the inner life of pictorial elements, endow them with emotion, and incite the pictorial space with an unexpected placement of form. Schiele has not pursued the visible world but used its material to create the forms and formal constellations he had seen and felt inside.

Kokoschka and Schiele are natural antidotes to the rectangular style of the Wiener Werkstätte and Klimt's Constructivist style. From the general progress of history, it can be assumed that a period of formal reduction is followed by an expressionist period which has *furore dell'arte,* the uncontrolled and the primitive, as an idol. With freely articulated brushstrokes and an explosive energy in the act of creation, the artist accomplishes spontaneity

and liberation from all constraints. Nietzsche's *Urge for Vision* and *Urge for the Orgiastic* have established themselves as two opposing forces of nature. Silence, simplicity, and concentration on beauty gave way to the feeling of the power of an artist, who saw moral duty and truthful behavior in an act of creation, removed from the moralizing attitude of *l'art pour l'art*. Nietzsche's *Urge for the Orgiastic* increases in expressionist works through the emancipation of creative input from the driving force of emotion. Beauty is therefore not the result of a teleological order but, as Nietzsche wants it, the highest sign of expressive power.

Expressionist works often appear as light, hardly begun results of an aesthetic will unable to spoil anything because the spoiled is a desirable condition. Line and contour are not limitations of a clearly defined form, but are autonomous forces following the unorganized principle of spreading over the pictorial plane without hindrance by narrative content.

A similar change of taste occurred at the end of Classical Modernism, around 1980, when the geometrical reduction of Minimalism turned into a Neo-Expressionism that returned to the subjective, the irrational, the unexpected, to pure intuition, to formal exaggeration, and the relentless plowing of the picture surface. The dialectic between these extremes in the creative action appears like an inherent property of man's soul. Art is the barometer of these highs and lows of human feeling on the pedestal of time, which holds equilibrium until it dissolves into dissonance, until the smooth flow of line separates in many directions, until rigor and discipline sink into the polymorphism of the empirical world.

When Minimalism was replaced by Neo-Expressionism, painting returned to the uncontrolled and often renegade exaggerations of form and disturbances of the pictorial field. Minimalist and Expressionist approaches seem to be irreconcilable aspects of the human condition. We witness their ups and downs on the

pendulum of time, often holding a fragile balance until dissonance supplants consonance, until the smooth flow of line is released in many directions, until rigor and discipline surrender to the polymorphism of either the empirical world or the turbulence of artistic temperament.

Conclusion

It is an astonishing accomplishment on the part of Klimt to have confronted two theoretical propositions in *The Kiss*, the abstract and the realistic, and that these would become distinct traditions in the course of 20th-century art.

Abstract artists look at nature's basket as if it were not to contain enough forms to provide material for inner expression. They replace the depiction of reality with autonomous non-representational forms. From Kandinsky's early abstractions of 1910 until the end of Classical Modernism around 1980 two morphologically separate branches develop in non-representational art. One is bound to the apollonian order of geometrical forms, the other ventures in the territory of free invention. Both tendencies pursue a purism which rejects an obvious engagement with the visible world. The abstract quality of the work is different from superfluous appearances of reality and their changing interpretations in time. Now the artist is concerned with the purity of a conceptual enterprise which is platonic in nature.

Modern pictures and sculptures have abandoned an aesthetic tradition which located each work on historical city plazas or the walls of interior spaces, and placed them in galleries and museums where their autonomous forms are appreciated as concepts within the hierarchy of art history. The 20th century is a time of galleries and museums. The changing disposition of aesthetic objects accounts for a renewed estimation of what constitutes aesthetic value. It is no longer the emotional connection to a particular object but the intellectual esteem of a phenomenon

within the established discourse of history. Appropriation and hybridization have become significant signs of a post-modern period which rejects the search for purity of the medium, as evinced by Modernism, as something unnecessary and antiquated.

A prominent characteristic of post-modern art is the search for reality, not to turn Abstraction into Realism but to find content in art which is there without being depicted, a sublime content transcending ornament and principles of design. An atmosphere is created which is more than sheer physical existence. The purity of abstract sign language which governed abstraction until the end of the 20th century was replaced in today's post-modern period by a multitude of meanings, intermodal relationships, vitality, and the inclusion of parameters of expression larger and more varied than the singularity of ideas in formalist abstraction.

Like all avant-garde art, Klimt's *Kiss* emerges from crises. *The Kiss* was created in a period when not only the depiction of reality, but reality itself had become problematic. It promotes the notion that painting has at its disposal a greater variety of forms than those found in the visible world. *The Kiss* contains references to older epochs in art, and like a post-modern work displays historical continuity while pointing to its relative synchronization with time: It looks at the distant past of Byzantine gold, Egyption and Greek mythology, relevant philosophy, romantic art, contemporary painting, and the open spaces for inventing new strata of aesthetic consciousness.

The discourse between pure Abstraction and Realism concerns the world of aesthetic objects vis-à-vis the real objects of the world. Pointing to their separate virtues, Abstract art has access to the purely artistic, while Realism exposes the formal and semantic values of objects. Klimt, like no other artist of his time, employed both, as if it were most natural for the abstract and the real to appear in union. In this respect *The Kiss* has enormous meaning in the development of Modern art.

1 Hermann Bahr, "Rede auf Klimt" in *Gustav Klimt: Die goldene Pforte*, Salzburg 1978, p. 79
2 Friedrich Hegel, *Enzyklopädie der philosophischen Wissenschaften im Grundrisse*, Hamburg 1959, p. 135
3 Plotinus, *Enneads*, IV.6, Cambridge, MA. 1984, p.323
4 Fritz Novotny, Johannes Dobai, *Gustav Klimt*, Vienna 1967, p. 343
5 In an interview Duchamp speaks about the choice of his ready-mades: "You can choose many objects if you want, but the thing was to choose one that you were not attracted to for its shape or anything you see." John D. Schiff, "Some late thoughts of Marcel Duchamp" in Jeanne Siegel (ed.), *Artwords*, New York 1992, p.17
6 Wassily Kandinsky, *Über das Geistige in der Kunst*, Munich 1912, p. 60
The concept of "inner necessity" was first used by Alois Riegl in *Spätrömische Kunstindustrie*, 1901, in connection with "Kunstwollen" (the will to art). Inner necessity became a central concept in Kandinsky's writing to justify the invention of abstract form.
7 W. S., "The Studio, Vienna 1898" in Nicolas Powell, *The Sacred Spring*, London 1974, p. 115
8 Karl Philipp Moritz, *Schriften zur Ästhetik und Poetik*, published by Hans Joachim Schrimpf and Max Niedermeyer, Tübingen 1962, p. 116
9 Desiderius Lenz, "Zur Ästhetik der Beuroner Schule", Beuron 1898, pp. 6–60 reprinted in M.E. Warlick, "Mythic rebirth in Gustav Klimt's Stoclet Frieze; new considerations of its Egyptianizing form and content", The Art Bulletin, New York 1992, vol. LXXIV, no.1, p.121
10 Robert Zimmermann, *Allgemeine Ästhetik als Formwissenschaft*, Vienna 1865
11 The dispute between form and content has not subsided. Today, in the post-modern period, we ask how the pragmatic Formalism of the second half of the 20th century could deal with aesthetic values when formalist painting pursued abstract ornaments and presented a capricious play with patterns and the overt rejection of inner motives of expression. Formalism with its stripes, squares, and monochrome areas tried to avoid anything personal, psychological, emotional or irrational to communicate nothing else than the structural constitution of the work. The concentration on the purely phenomenological was an attempt to create a spiritual value which should result from the co-existence of an empirical phenomenon with the understanding of its ontological propositions. Such a puritanical pursuit of art for art's sake refused to admit that perception orders a great variety of spiritual content in an uninterrupted stream of consciousness, which manifests itself as an aesthetic feeling. Immanuel Kant, often accused of having paved the way for speculative formalism, was always concerned with an aesthetic consciousness which unites a wide horizon of rational concepts with innermost emotions.
12 Alois Riegl, *Die spätrömische Kunstindustrie*, Vienna 1901
13 Conrad Fiedler, *Schriften über Kunst*, edited by Hans Marbach, 1896
14 William Morris, *Collected Works*, vol. 22, London 1914, cited in Werner Hofmann, *Grundlagen der modernen Kunst*, Stuttgart 1966, p. 352
15 Eduard Sekler, Josef Hoffmann, *Das architektonische Werk*, Salzburg 1982, p. 507
16 Novotny-Dobay, ibid. p. 341
17 Plutarch, *Moralia*, cited in Warlick (op. cit.), p.129. Plutarch's compendium of the essential elements of the myth of Isis and Osiris paints a picture of continuous division and renewal. Isis and Osiris, born from the body of their mother as lovers, encounter the jealousy of their brother Seth, who claims the birthright for himself. He designs a wonderfully decorated corset which he gives to the person it fits at a party with friends. When Osiris tries on the corset, Seth nails it together and drowns his

brother in the Nile. Searching for her lover Isis travels through all of Egypt and finds Osiris, whose body has been grown over by an Erica tree, and takes him back. One day, when Seth finds the corset unguarded, he dismembers his brother in 14 pieces and distributes them over the whole country. But Isis finds everything again with the exception of the penis a fish had swallowed.

18 El Lissitzky, in John Elderfield, *Kurt Schwitters*, New York 1985, p. 139
19 José Ortega y Gasset, *La deshumanización del Arte e Ideas sobre la novela* (The Dehumanization of Art and Ideas about the Novel), 1925, n.p.
20 Berta Zuckerkandl, "Als die Klimt Gruppe sich selbständig machte", Neues Wiener Journal, Vienna 06/10/1927, cited in Nebehay, op. cit., p. 397

Myth and Art

Lecture at the international conference
on the presence of myth in contemporary life,
Cooper Union School of Art and New School
for Social Research, New York City, 1984

May 29, 1945, at six o'clock in the morning. It was raining in
Amsterdam. Two police officers knocked at the door of Han van
Meegeren, a painter, to arrest him for high treason against the
state. His name had been found in connection with papers show-
ing the sale of paintings by Dutch Masters to the Nazis during the
war. It was especially the sale of a Vermeer painting to Hermann
Göring that put van Meegeren under suspicion of collaboration
with the enemy. After weeks of denial, van Meegeren confessed
to the crime, but with the inclusion of a statement that stunned
the world even in those hectic postwar times: the painting in ques-
tion was not a Vermeer, it had been painted by van Meegeren him-
self and he claimed to have created other newly discovered works
by Pieter de Hooch and Frans Hals. The greatest nightmare of all,
however, was his assertion that it was him, who had painted Ver-
meer's famous *Christ at Emmaus* (fig. p. 236), which had already
been hanging for seven years in the Museum Boijmans Van Be-
uningen in Rotterdam. When this canvas appeared on the market
in 1937, its authenticity certified by the most outstanding experts
in the world, numerous publications spoke of Vermeer's ultimate
masterpiece. It sold to the museum for the incredible price of
550,000 guilders. The painting became the centerpiece of the 1938
exhibition of 450 Dutch Masters. Enormous crowds of visitors

were led to a separate room with carpets on the floor so as not to disturb the silence of contemplation and the feeling of mystical serenity emanating from the work as if from an altar, as critics described it. It became the most popular painting in Holland, said to contain all the elements of the holy, the mystical, and the spiritual which convert the viewing of art into a pilgrimage to a sacred shrine. wherein man's inner state is liberated of worldly anxieties, healed by a wondrous, religious spirit.

The assertion by van Meegeren to have painted *Christ at Emmaus* was received by the world and particularly by Vermeer experts as a joke. They said that van Meegeren came up with such lies only to get off the accusation of having sold national treasures to another country. After all, when the painting came on the market in 1937, it had been investigated for its authenticity by a number of high ranking institutions and the most famous Vermeer experts in the world. These included the University of Amsterdam, the national bureau of art-historical research, the central laboratories for Belgian museums in Bruxelles, experts for painting at the museum in The Hague, and laboratories for British museums in London. All of them testified that *Christ at Emmaus* was an original Vermeer. The judge at van Meegeren's trial ordered canvas and paint to be sent to the prison so the artist could prove he could paint like Vermeer. The large canvas depicts Christ amongst biblical scholars. It was finished in eight weeks and even though it does not have the quality of his work in the studio, it served its purpose. Experts praised the oversized heads, the masterly paint application with indigo and lapis lazuli, etc. Now it was then said: "We have lost Vermeer but we have found van Meegeren."[1] Still in prison, he received hundreds of portrait commissions and he signed a book illustration contract with an American publishing house. Freed from the accusation of having sold Dutch treasures, he was convicted of forgery and jailed for one year. However, as a result of the stress of the trial, he died six weeks later in December 1947.

The story is not only the story of a skillful forger who knew how to put old paint on old canvases, but more importantly, it calls into question the concept of spirituality in art and the changing climate of aesthetic appreciation.

Today, sixty years after van Meegeren's painting was demoted to the museum corridor, we might say that it represents the false pathos of a childish illustration. The heads of the depicted persons are like decorated balls floating over the canvas, the fingers are dead sausages with fingernails stuck on them, the hair is wet and hangs down in strands as if they had just come out of the rain, the shadows are arbitrary, the whole arrangement of form is dull and unrelated to the demands of structuring pictorial space.

And what about the holy, the wondrous, the spiritual? Did it suddenly evaporate in the sun of truth that rose as soon as the clouds of pretense lifted? Altogether, the example of van Meegeren reveals an unstable weather condition with a low pressure area surrounding the phenomenological conditions of a work of art and what viewers denote as the spiritual forces contained within.

If the spiritual is one day contained in a phenomenon and the next day escapes through the introduction of hitherto un-known facts, the spiritual is either not contained in the phenom-enon or the effect of transcendence is only imagined as a result of expectations of spirituality. But why would we talk about the spiritual, the mystical, the transcendent, if we did not assume that it can be found in art and that certain works contain more than others? In fact, the whole question of quality centers around the spiritual; individual works are criticized in terms of formal features and essential emotions which rescue the work from its existence as empty visual matter.

Since the spiritual can be either present or absent in a phe-nomenon, we can assume that the spiritual is not something like a ghost or a vapor in front of every painting that contains certain formal features. It must be attached to both the painting and the

beholder in a mutually inclusive manner. In that sense, *Christ at Emmaus* carries values, esteemed at the time as something spiritual, namely a post-nineteenth-century Realist style that mistakes sentimentalism for the heroic and the spiritual. And because it resembles nothing that Vermeer had ever done, it was supposed to be his greatest work ever. The master was said to have made the ultimate push into a style of silent pathos, widely appreciated in the 1930s as official High Art, not only by dictatorial regimes but by most of European society.

A work is sometimes this, sometimes that, depending on the forces which take possession of it. The question concerning the essence of art must, therefore, be concerned with the synthesis of forces already in possession of the object and the forces that struggle for its possession. There is something tragic in this because nothing would suit us better than to know the essential characteristics of art which enable us to bring order to the multiplicity of appearances. However, if we could see the absolute in a single work, it would be unnecessary to look at others.

The myth of art, keeping our interest alive, is the trend of interpretation of reality manifest in the kind of working and the particularity of feeling expressed by individual artists. In that sense, the visual characteristics of a work are not its essence but only a possibility of appreciation. Immanuel Kant tells us that a loving couple seated in the early evening hours in a meadow is blessed when, in addition to the beauty of the landscape, a nightingale starts to sing. However, when they turn around and discover that the sound of the bird had actually been produced by a mischievous boy hiding in a tree, the whole situation is destroyed.[2] One and the same stimulus can provide different strata of appreciation. Once the Emmaus painting was discovered to be a product pretending a history of production requisite to paintings of an earlier age, its value changed. Our indignation comes from the displayed characteristics not being genuinely derived from historical or subjective

necessity but from the re-creation of an Old Master look. Our appreciation suddenly shifted into the realm of a conceptual enterprise. Awareness of a painting's existence for a purpose extraneous to art hampers our willingness to re-create it in terms of an emotional necessity. Masterworks conceal their intellectual propositions by the intensity of a feeling condensed into the autonomous reality of the art object itself. Artworks are not billboards for the illustration of ideas, but three-dimensional objects leading into their internal necessity of existence. The Emmaus painting is an example of the unstable nature of aesthetic interpretation. Visible properties are the foundation on which various interpretations and aesthetic predilections can be built. The forces of propaganda have laid themselves over the properties of the Emmaus painting and prevented us from receiving what we expected to receive from Vermeer. The Emmaus painting pretends to have a history of production which places it into an earlier century. Our indignation derives from its sick effort to look like older art. Now it is a conceptual enterprise which does notn't teach anything. In the garment of a sentimental Realism it seeks expression in the facial features of depicted persons. We are supposed to read their emotional state and concomitant spirituality of the work by looking at sunken eyelids. And what if the Emmaus painting, discovered as a fake by sheer coincidence, were still hanging in the museum? Has our eyesight improved? Can we now apprehend its identity in contrast to the work of Vermeer? (fig. p. 235)

Vermeer, the painter of pure expression, finds deep emotion in the abstract formation of pictorial elements. He sinks his feeling into the structural totality of the work as if it were a single and autonomous reality with which he participates in the creation of the world. Catharina, weighing pearls, finds herself on a wonderful scale of art. A sublime silence surrounds the pregnant woman who silently weighs pearls in the house of a patrician. Silence is in every object. They hold each other without overt intention, cor-

respond as pictorial forms with the edges of the canvas and always serve the totality of the composition. Even the folds on Catharina's blue cape structure the lateral picture plane parallel to its edges. The white of the fur flows onto the plane like a silent waterfall. It is the whitest white in the work and it determines a center on which the rest of the painting hangs. Here we feel the impulse of an artist to escape narrative illusion and give the painting its existence in real space. Altogether it is an abstract composition that holds together in all its details. The depicted light is not wasted for illusion—as in the Emmaus painting whose figures are lit as if sitting on a stage—but light becomes the property of the painted areas themselves. Light does not shine onto a wall but it is found in the transition from light to dark on a painted form.

A reality is created which demands little from the objects of representation because the painting is an object itself in which form and content embrace each other as equal values of aesthetic appreciation.

The confusion between master and forger appears today as an incomprehensible error that resulted from the superficial perception of structural qualities in the work of two totally different painters. Without concentration on the structural identity, we experience nothing but an enumeration of narrative and mostly banal objects. What is essentially artistic will get lost when perception exhausts itself in finding similitude between known and depicted objects. Aesthetic circumference will not be established by the concentration on individual elements but solely in the apprehension of the entire nature of a work. The structural identity of a work is a nature all of its own. It creates an emotion found nowhere else but in this work. Ultimately, the feeling we experience is the essential message of art. However, aesthetic feeling does not derive from a naïve surrendering to visual stimuli alone, but from the inclusion of all components of consciousness. Kant speaks of *Denkgefühl* as a feeling when thinking.

Since the truth of an aesthetic object does not emerge through appearance alone, there must be something contained and yet concealed in the object which is the same and yet different from the exhibited characteristics. The example of van Meegeren shows that aesthetics cannot be a branch of psychology that measures how excitedly Wittgenstein's dog wags his tail in front of his master, or how much pleasure we get in front of our masters. Aesthetics is a branch of philosophy concerned with the value system in the back of your head when standing in front of a painting.

There is a difference between the judgments: "This painting is beautiful" and "this painting is art." The first is a theoretical judgment based on sensuous attributes, the second is a critical judgment supported by values. Values are assembled by contextual relationships with the same or similar classes of objects. While both judgments are independent of each other, they are connected in aesthetic apperception: the appreciation of sensuous beauty and the imagination of aesthetic ideas. Neither one can claim to be the final determination of aesthetic value.

It does not make sense for an artist to work outside the linear development of history. We should not forget that van Meegeren's work came at a time in European art history when Modernism was in full swing. Abstraction, Cubism, Dadaism, Expressionism, Surrealism, Constructivism had already seen major accomplishments in the 1930s. Looking back at his work, we can say that he understood how to put oil on canvas but his products are totally outside art. They pretend a history of production that places them in an earlier century. While we admire the skill of an artist, his products are nothing but stale repetitions if he follows a mode of working unconcerned with the aesthetic issues of his time. Nevertheless, the scientific intelligence necessary to arrive at new regions of consciousness is just one of the many and complex components of creating art.

At this point of my reflection I need to say something about style because the confusion between the Emmaus painting and Vermeer's work is a confusion of style. Style is an excellent tool to differentiate painters. Style is the visible expression of inner necessity that creates motives in their full development from subjective emotions to aesthetic intentions on a continuous basis in examples of art. Style is the foundation of the spiritual which lays itself like a concept over a series of artistic events. Style is not only a theoretical principle the artist can decide upon as a goal. It is not a manner in which to work but an emotional necessity. Style is the underlying basis for various phenomena and a unifying principle. Even though there is always a definite intellectual directive for the creation of a certain type of work within historical circumstances, there is no reasoning as to the why of style; reason always finds its way back to inner necessity. Of course, not everything is possible at all times. Inner necessity determines the choice of forms at a particular time in history and marks the demarcations of the territory from which artistic creations come. Even though formal relationships or techniques are pursued consciously and working strategies are consolidated for the future, the artist is bound by his singular energy expressed in a singular emotion maintained throughout his approach to art. In that sense, style is an elementary proposition which cannot be further analyzed. The emotion represented by a sequence of works is on a relatively simple and more condensed level than in individual examples. When we think of paintings by masters we know or love, we do not have a clear idea of depicted images, but we connect a name with the imagination of a style which created a particular emotion. The myth of art is the myth which each artist creates through feeling. It does not make sense for an artist to work only on paintings. An artist has to work on himself.

Among the many propositions available to painting, the artist chooses those which transport his feelings with greatest

clarity. A painter who continues to work throughout his life is not adding more and more work of the same kind into the already existing household of reality, but he subtracts from the possibilities of interpretation.

A single example is more complex than a whole proposition. A series of works, while simpler, is also stronger because it shapes a more precise vision of aesthetic reality. Value in the visual arts does not derive from the introduction of a multiplicity of separate meanings as in literature, but power in the visual arts resides in the condensation of the visually presented into one single uninterrupted stream of consciousness operating as fine emotion. Aesthetic strength in the visual arts is synonymous with simplicity. The aesthetic value of a painting does not derive from a multiplicity of narrative details but from the condensation of the depicted in a single stream of consciousness. The visual arts are the only arts in which recognition manifests itself as an emotion. This emotion is recognized only within the context of what we have recognized in the past in either normal reality or in works of art. We cannot grow tired of looking at more and more works of the masters because the more clearly their singular energy emerges, the more appetite we have for them.

The first encounter with the Emmaus painting was full of the expectations of high art from Vermeer. The fake had succeeded to sneak into the "Vermeer family" with whom it had nothing in common. In the interval between its appearance in 1937 and its demise seven years later, Vermeer's reputation suffered badly. If I had seen this as my first Vermeer painting, I could well have lost an appetite for more. One single parasite is enough to bring the whole "family" into disrepute.

The Emmaus painting is a rather arbitrary arrangement of bodies who share no more than bread, freshly baked, and the table around which they sit. Mary Magdalene's roughly painted face appears not to have found its proper place within the pictorial space.

The soft face of Christ with its swollen lips beats the plane brutally in coloration. The clothing of the figures is all the same, rough blankets sewn together with thick seams. Christ wears a morning coat, freshly ironed as if he were wearing it for the first time. The objects on the table are dead matter without aesthetic life, boring, freshly polished utensils that make the onlooker believe that there is a place for eating. The wall of the room, modeled from light to dark, gives the impression that the room had not been painted for a while or that the figures are placed on a dirty stage. A light rectangle à la Vermeer pushes from the left into the picture as if it were an afterthought. Instead of bringing light, it is a dirty area. Figures and other objects are isolated phenomena that meet like in a blind rendez-vous of foreign elements. They do not allow the eye to rest in contemplation of the totality of the work but point to the division of objects in the world; their separate existence, like a snapshot which allows an only momentary view of a vanishing scene, similar to the first sentence of an unfinished story.

While the superficial viewing of a painting I found in my grandmother's attic is exposed to various misinterpretations, its inclusion into the oeuvre of an artist or in the style of a period may clarify its aesthetic message. The spiritual that condenses in feeling is the driving force between works of art. Family resemblance, as Wittgenstein calls it, is an elementary proposition which cannot be further analyzed. However, style is not the only criterion to allow a work to be part of art. A shoemaker who produces the same type of boot may also speak of style or at least of fashion as a limited style in time.

The rational effort for style leads many painters into a routine of producing the same type of work. They become craftsmen of their own propositions. The works of masters cannot be explored through analytic analysis of visual components alone. Their inner being cannot be extrapolated by forms which the painter has laid upon the canvas like a shoemaker. Formal properties never crys-

tallize into laws that determine the future of an oeuvre. An artist lives from his present energy which overcomes the path of the past and invites new challenges and formal risks. Academic painters, in comparison, beat the same forms until they are dead. They glue a visual label on their works so they may be recognized from a hundred yards away. They propagate their individuality with a company logo. Once you have seen one painting, you know them all. The employment of redundant elements leads the onlooker into the formal mechanism like a planned exercise, instead of allowing a new visual experience beyond conceptual parameters. It is certainly admirable when an artist is aware of his means of expression, but petty diligence in arresting aesthetic dogmas should not place itself in front of discovery. The work of masters can also be recognized at first sight, but not because of already established forms, but because of feelings invested in the conquest of art. Masters resist analytical extrapolation of the elements of their style because what constituted the formal properties of their work in the past is not a guaranteed end for the future. They live out of their energy which they trust more than past accomplishments. They expose themselves to ever new challenges in their approach to painting when coming to grips with their imagination.

Feelings in art do not reside or come from the phenomenon alone, but are similar to the space between laundry hanging between poles. The emotional, the spiritual, the transcendent manifest contextually in the empty space between works or on a pre-aesthetic level in the space between created image and reality itself.

The myth in art is the singularity of expression an individual has created for himself, set apart from all other examples in the history of art. Singularity manifests itself in the newness of style because it means particularity of emotion. All great names in the history of art have separated themselves by opening avenues of innovation for a new state of consciousness. All innovations can be appreciated in the context of what is older in art. Artists have

insight into art because their innovations are not superficial reactions to the works of other artists, but derive from a careful analysis of the premises on which art as a whole is based. And since the emotions in art operate out of real life, the masters must have had a great insight into life, for it is life which contains the inspirational emotions condensed in a style that advances a single, uninterrupted stream of consciousness. The feelings expressed through the artist's stylistic decisions represent the myth in which he senses the world. He rediscovers this myth in works he has substituted for reality.

The enterprise of art has its origin in the longing for transcendence of reality. Works of art affect us in the context of real life and in the context of emotions from other art. The energy displayed by a master is not exposed; as a structure it can be felt only in the context of an assimilation of past and present experience. Someone who is not in touch with himself, or who has never had previous experience with art, might stare in astonishment or bewilderment.

Works of art liberate us from the here and now of reality, and while they are physical bodies they represent only what is not physical, the general, the absolute, which beyond all individual appearance has made room for itself in the spiritual. Aesthetic motives return in their concreteness to the idea of art. Without an idea for art an artist will get stuck in the accomplishments of masters or in the individual appearances of nature.

Hegel saw the truth and the absolute of art, whose place was postulated by Plato only in the idea, as only existing in the concrete existence of the aesthetic object. The Platonic idea is not really concrete because only in its concreteness is the idea really true.[3] And since a concept is not actually true without its manifestation in reality, so is an idea not really an idea without concreteness. An aesthetic idea must progress to its physical manifestation and only in its phenomenological existence can it be an

example of how individual subjectivity has become an aesthetic idea. Thus, the limitations of subjectivity have been lifted in the limitlessness of the idea.

The more we understand about art and life, the sharper our sensitivity to differentiate similarities or differences of emotions evoked by works of art. The energy of an artist reveals itself not only on the surface of the canvas, but as a spiritual attitude within the panorama of aesthetic possibilities. The structural identity of a work derives from an assimilation of past and present experience. The significance of an aesthetic experience results for the beholder from a contact with himself and the phenomena of art.

While it is true that the contemplation of a thing for its own sake is possible and how pleasantly or unpleasantly we are affected by it, the apprehension of a fuller value is the complete development and consummation of an act of looking for the creation of a consciousness that includes all facets of past experience with the world as well as with art. But the rational comprehension of art does not guarantee the recognition of the finest feelings because intellect and emotion are two different strata of consciousness. Intellectually, we are ready for any master at any time but emotionally it is a different matter. We are not ready for any art at any time. We sense the message of art only if our emotional channels are prepared for being opened by art. We may understand the teleological aspects of a work and its historical significance and yet not comprehend its full significance when practical thinking prevents intuitive appreciation. The structure of the perceived must persuade us in all its aspects as a totality beyond its concepts and ideas outside the work.

Intuition orders knowledge into a persuasion about truth. Art does not contribute to the basket of analytical knowledge. It leads us to a particular feeling. One may understand everything about the formal constituents and the history of art and yet not get the feeling. One gets it only if persuaded.

To make this point more tangible, I would like to tell a story I have told before. A few years ago, I lived in a tiny village in Texas very close to what they call the hill country desert. After some time, I noticed that every day at almost the same hour in the early evening the distinctive sound of an animal could be heard. I thought it might be a frog or perhaps a small, rare animal. A woman in the country store told me that it was the green stone-eater, an animal measuring a little more than a foot, all green, living two feet underground and that it eats stones. Every evening the animal comes to the surface and makes its distinctive sound. The people on the East Coast would not believe this, the woman said, because they believe only what they read in books. But there are natural phenomena, the woman said, not explained in any book of natural history.

I accepted her explanation and from then on listened to the sound of the green stone-eater.

Now, I need to tell another story. Imagine drilling a hole in the ground where you happen to stand. You continue drilling to the middle of the globe and then even further until you reach the other side of the earth. Now you take a stone and let it fall into the shaft. How deep will it fall? To the center of earth? Will it appear on the other side of the globe? A professor of physics may explain everything about fall and gravity, but I tell you that the stone will fall only two feet before it is eaten by the green stone-eater.

Even though I just told you there is an animal two feet underground eating stones, you were unable to make a connection between the first and the second story. I am not trying to convince you, I persuade you to believe what I say.

The Ancient Romans made a difference between *persuadere* and *convincere*. *Convincere* is to conquer, to overcome doubt. *Persuadere* is to induce belief, to urge, implying the fuller notion of changing a person in the direction of a new belief system. Aesthetic judgments are synthetic judgments adding nothing to our knowledge but rather amplifying it. Intuition leads to content.

No intuition is necessary with works that approximate or synthesize the accomplishments of earlier art. They cannot change us because greater works have already changed us. An enlargement of consciousness occurs with the experience of artistic inventions having an effect on the number of emotional channels available to us as responses to the world. What we call the spiritual in art is the never ending change in our innermost condition. Of course, the more sensitive we are, the more varied feelings we have. Not only is art not for everyone, but a particular type of art may be appreciated only by few at a time. The capacity to integrate new emotional information into the established household of our existence depends on flexibility and the willingness to take risks. The ratio of familiar emotions combined with a driving curiosity for change delimits the amount of new aesthetic information available to us at a particular time. Radical changes from unexpected appearances of art liberate psychic energy and nourish the vividness of consciousness by allowing new phenomena into the household of established ideas and predilections. Such aesthetic forces come into being through works which do not slavishly adopt or synthesize the parameters of older art. The spiritual in art is a message about the continuously changing inner condition of mankind.

The concept of newness in art, traditionally viewed by society with suspicion and often met with resistance, has turned today into a fanatic search for extravagant phenomena. New art is brought on the market as if the visual arts were a branch of the entertainment industry. The visual arts are jeopardized by what is sensational instead of providing inner rejuvenation and interrogation of existing parameters of expression. It is symptomatic that works receive great applause when appropriating older ideas and employing them as superficial newness. Synthetic artists live through the heads of other people. Original artists, by comparison, manifest their substance through new means of art making.

I doubt that one can speak of a linear development of art which would allow us to predict the future of artistic phenomena. A forecast of art must take into consideration the unpredictability of the human condition which always operates with the most varied energies to assert its position in the world.

Returning to van Meegeren, we can say that his attitude is a synthetic layering of already known and superficial properties inherent in Old Masters. Even though he developed a style, his style is only the product of a spirit that lives through the spirit of other artists. This is the only thing we learn about the painter. The Emmaus painting is a piece of Italian laundry (the painting was said to be so great because it carried Italian influences—Vermeer was said to have finally succumbed to Italian influences), which found itself hanging on the same line with linens made in Holland. How could it be possible that the inferior quality of the Italian linen was mistaken when so much was known about Dutch linens and particularly the brand used by Vermeer?

A work of art exists in relation to style, to its time, and most of all to reality itself. At the time when the Emmaus painting surfaced, expectations distracted from the visual characteristics contemplated earlier in Vermeer. The beholder suffered from the spell of a myth created by the applause of the world. Even though van Meegeren's style contained characteristics admired by millions of people, its value totally changed. We do not look at the work today as if it were the exponent of pleasant or admirable properties, but we look for aesthetic values that assemble in a more fully developed act of looking. While the first encounter with the Emmaus painting was tainted by the imagination that it belonged into the "family of Vermeer," we now contemplate the work in its inner structure and realize that there is nothing to be looked at. The beholder was fascinated by a myth the world had built around the work, instead of searching for an expression, which so clearly had been presented in Vermeer's art.

Some philosophers claim today that an object, any object, becomes a work of art as long as the art world has elevated it into the status of art. The paintings of the chimpanzee Betsy in Chicago Zoo would be art as long as the curator of the Chicago Art Institute is willing to christen them as art and display them on the walls of his museum. Such arguments confuse the ontological status of a phenomenon with its social or monetary status. It has become a desire of Wealthy collectors to concentrate on world famous works. They claim to have an understanding of art when doing often no more than enumerating famous works. Yet, real understanding of art, it seems to me, is the concentration on the inner structure of an aesthetic object. The value of a work should not depend upon worldly myth—even though we enjoy standing in front of a popular work—but aesthetic value must ontologically be contained in it as an objective necessity equal to a truth which is super-individual, universal, and eternal. In that sense it should make no difference whether we look at old or already known phenomena or whether we see new structures which have had no previous place in the consciousness. While we have predilections for aesthetic movements, we love art as a whole because it provides the continuously changing substance of the human spirit. The spiritual objectifies in the stylistic features of a work, in its formal qualities which show its position within the hierarchy of other art. That the style of an artist is original and powerful does not depend on the subjective disposition of an onlooking individual; it manifests itself through the objective characteristics of the work itself like a thing of nature, which you either see or do not see.

Experts were unable to identify a painting as not belonging to an artist they supposedly loved. They took their intellectual convictions more seriously than the truth out of which they should have operated. They failed because they did not invest enough emotion, not enough empathy, and no contemplation. Contemplation eliminates the functional apprehension of an ob-

ject and arrives at what lies beyond the visible thing and causes it to be. A liberation from common material states transfers loyalty from intellectual reasoning to innermost feelings. Contemplation refers to the holistic perception of an object. In contemplation an array of sensuous stimuli is ordered into an uninterrupted intuition. The concept of the uninterrupted is important here, because we are one with the entirety of the work only if visible details lose their name.

A Vermeer painting is different from any other painting by any other artist. I can establish how he paints and what formal devices he maintains throughout his oeuvre, but nothing I say about Vermeer may hold true for Rembrandt or for any other painter. It is more likely that everything I say for the art of Vermeer may be terrible if applied to somebody else.

The history of art cannot be considered a history of actual values—there is no reason to believe that the best survives—but rather, it is a basket full of myth, the myth of individual artists who have created a vision for themselves and for the glory of man.

1 Sepp Schüller, *Falsch oder Echt*,
Bonn 1953, p.18
2 Immanuel Kant, *Kritik der Urteilskraft*,
Hamburg 1954, p. 154
3 G.W. Friedrich Hegel, *Ästhetik I*,
Berlin 1984, p. 146

Realism and Abstraction

Lecture at the Benedictine monastery Seckau, 2001

A perennial concern in art criticism is the problem how far a painter can remove himself from depicting empirical subject matter without creating empty objects or decorative patterns. The advent of abstraction in the beginning of the 20th century made it necessary to start an investigation of the inner motives that liberate the visual arts from their tutelage to visible reality. Descriptive art criticism, dealing with allegorical or mythological meanings, had to be replaced by formal and ontological investigations concerning the logic and meaning of non-representational plastic organizations. It makes sense to ask whether the representational is superior to the non-representational.[1] After all, we live in a world that continuously forces the identification of objects, establishes concepts and comes to terms with manifold appearances and events in modern society. While grounded in reality, we also seek the transcendence of thoughts, words, and actions. Science and art are disciplines which order reality, organize the inside and the outside, and set no limits to the expansion of the spiritual.

Today, one speaks about the spiritual as if it were clearly in front of us. However, nobody can say what it is. The spiritual in art cannot be captured by applications of doctrine, principles or opinions about what is possible. The presence or absence of empirical images is not responsible for the presence or absence

of spiritual content. The appreciation of beauty is different from the recognition of depicted subject matter. Aesthetic theories with their claims to universality are always bound to problems and debates of their time. Today, one even speaks of an end of art because artistic practice is no longer integrated into life as in earlier times. It demands rational thinking and requires philosophy to figure out what artistic appearances mean or what art is supposed to be.

Aesthetics begins with Plato and Aristotle and their search for universal values. Plato ranked the representational arts behind ideas and the truth of reality. Plato is an early symptom of the continuous mistrust of contemporary phenomena. Looking back into history, doubters of contemporary art dwell on archeological findings and cultural remnants. They develop the wishful thinking of a golden age with harmony amongst various aspects of life and the integration of art and religion as spiritual forces of culture. From the Middle Ages until the end of the 19th century, there was a clear notion about the physical make-up of a painting. A painting is a flat plane which cuts out the illusion of space and contains depicted subject matter. Patrons commissioned the representation of a scene or a story, let's say the battle in the clouds between Zeus and Gorech. The artist had the freedom to concentrate on the *how* of depiction and how he wanted his work to be seen. Avant-garde practice has always been viewed with suspicion, as if the artist had too little proficiency to adhere to traditional rules and regulations.

Reflection on the essence of art would be unnecessary if aesthetic phenomena were not subject to change, if they stayed with us like a familiar habit, if we could admire them with a *disinterested attitude* and not ask didactic questions about value and historical context. Today, in the post-modern era, there is no avant-garde. The present pluralism of aesthetic phenomena does anything but provoke discourse on newness, not only because we naturally expect art to be new, but art itself appears subjective and

obsolete vis-à-vis an ever increasing bombardment of sensational events in the daily media. Older art sometimes appears newer than contemporary work. The post-modern multiplicity of appearances intermingles with the old, blurs boundaries between different disciplines of art production, and makes it impossible to predict how the battle between Zeus and Gorech will end.

Since the inception of non-representational art at the beginning of the 20th century, it has become necessary to replace the belletristic rhetoric of aesthetic description with a depth analysis of formal constellations. We like to make sense of new forms and discover a certain logic in the various changes of art. Formalist critics consider depicted subject matter secondary to the purely aesthetic which expresses itself through abstract forms and their various effects. This anti-realistic attitude is nothing new. It spans from Antiquity to the formalist theories of the present, which determine aesthetic value by the existence of registered properties: flatness, spatial unity, integrated picture edges, homogeneity in the degree of abstraction, etc. Formalist criticism deconstructs the work, reveals its structural genealogy and describes what design alternatives have been deleted or suppressed. Avant-garde art has a history of suppressing or supplanting existing parameters and replacing them with forms that demand a new way of seeing and thinking.

The superficial comparison of a painting that depicts objects of reality with a painting that operates with self-presentational elements may show that we prefer the painting with recognizable subject matter over a painting that is non-representational. Depicted objects provide a hold that keeps attention directly on depicted events. While having a base in empirical images we look for the artistic, the formal inventions. In representational art the empirical content functions as an axiom for the difference between emotive reactions in daily life and their occurrence in art. If depicted images are absent, the beholder loses hold and

what remains is the perception of a more or less decorative arrangement of lines or color fields.

While we acknowledge that recognizable subject matter introduces pleasant concepts and meanings, we cannot postulate that the depiction of horses or naked women make principally better paintings than those that operate with non-representational forms. From experience we learned that aesthetic value does not derive from the accumulation of all kinds of association in a work, but that value is sought in the intensity with which pictorial structures, real or abstract, effect consciousness. There are no a priori dogmas about what is possible or impossible or what kind of art is superior to another. With this statement, I started a tune which makes the question whether the quality of a painting depends on the presence of depicted images unimportant. Now, the work is a carrier of aesthetic ideas within the overall framework of art.

It is astonishing to what degree Western culture has sought aesthetic value in the competition and comparison with actual reality. With *disinterested attitude* and *empathy* the beholder was expected to apprehend the *expression, significant form* or the *vital import* in a work. The value of art was said to be superior to sentiments had from normal reality. As the *flower of life,*[2] aesthetic reality was said to transcend everything existing and its value was measured with how much stronger or how different from normal reality it could arouse the sentiments of the beholder. Art alone was granted the privilege to order depicted objects in a medium accessible to contemplation. Depicted objects became visible symbols of an otherwise invisible beauty. The distance between beauty in nature and beauty in art accounted for the degree in which the artist subjectively treated the content of perception, whether he simply imitated what he saw, whether he surrendered to an already established manner of working, or whether he developed a style that brought new feelings to the experience of art.

Blenheim, graphite on paper, 46 x 30 in., 2006

Technical virtuosity is an essential element not only in art but in many areas of life. We admire simple imitation when a painting delivers a photographic similitude of a face. We admire accomplishments recorded in the almanac of world records. The intensity of technique is an essential element of aesthetic enjoyment. From here the dictum evolved that art comes from skill. In fact, we can expect goose bumps or tears when listening to Glenn Gould on the piano, Pablo Casals interpreting Bach, the breath-

taking dance of a ballerina or the reactions of a goal keeper at the penalty kick. All human activities are measured with their extremes.

Free invention of form is the movement of the spirit into unknown regions of consciousness. Western Art is distinguished from cultures that follow the signature style of their country or tribe. Western avant-garde searches for new phenomena free from the impediments of regional expectations. Free invention of form is romantic. It allows unexpected variations of expression and replaces classical neutrality with coincidence, the personal and the irrational. Hegel maintains that the fine arts are not the proper subject for scientific examination because beauty is bound to sensuous experience and demands another organ than rational thinking. In the immediacy of perception there are no rules. The source of art cannot be found in the shadow of ideas, but in the free activity of a fantasy which is more abundant than nature.

It is not possible to ascertain the sentiments created by a work of art and how they differ from the feelings created by objects of normal reality. One cannot determine formal components that would make it possible to speak of a constant and defined quality in the history of art. All formal criteria, elicited from artistic styles, are not only subject to change but can also apply to normal reality. When I say that a Raphael painting is a great work of art because the depicted figures are composed harmoniously, because they possess a high degree of imitative likeness, because shapes and lines are clearly defined, because the development of an illusionist space creates a convincing distance between objects, etc., I apply seemingly objective concepts whose application on another *great work of art* might be different or wrong and could also be true for regular objects. In various segments of history one can attribute much value to certain visual conditions, particularly if they reveal how much a work is indebted to a preferred tradition or whether it has escaped into a new territory of expression. Aesthetic appre-

ciation is not based on objective criteria—even though we tend to assume that everybody sees the same—but on subjective predilections in the selection of seemingly objective criteria born by the individual experience of the beholder. It does not make sense to discuss subjective predilections. Attempts to convert subjectivity into objectivity and expose something essential or applicable to the rest of art must necessarily end in an arbitrary fallacy.

To say that a van Gogh painting is good and of high quality is the same as saying that a horse is a good horse. In order to establish the quality of a work I must have alternatives in mind which I introduce critically. To say that a van Gogh painting is better than a Kandinsky is to say that a horse is better than a camel. In each case the distinction is not based on a logical hierarchy of values. The evaluation of aesthetic properties makes sense only in connection with a purpose. As the owner of a horse racing stable, I will decide on horses that run the mile in a good time; as the owner of beer delivery I decide on strong draft horses. When the value of a horse is based on a preferred purpose it stands to reason that the appreciation of a painting is also based on the same. In judging, the purpose is not a fixed and *a priori* condition I impose on the work. The purpose is visible in the inner structure of the appearance. As such, preferred ideas are embedded in the visual structure and how successful an artist has pursued his own propositions.

When visiting a room in the Louvre where van Gogh's palette is exhibited in a glass case opposite his paintings, we might find that at first inspection there is little difference between the palette and the paintings. We cannot say that the pictures are better because we see houses and trees in them. If I want to see houses and trees I could look out the window of the Louvre. And still I say the pictures are better because I have a deeper experience. With this statement I speak only about my experience and say nothing objectively about the objects to be differentiated. My experience

is different from the determination of visual components responsible for my experience.

The reason for my experience is imagined after the experience has occurred. What we denote as a reason for aesthetic experience is a sequence of imagined works within a continuity of time. Therefore, van Gogh's paintings are no longer in competition with houses, trees or palettes, but are elements of the historical continuation of aesthetic objects. Our thoughts sink into a substructure of empirical knowledge which no longer depends on sensuous data but makes order within past aesthetic experience. It is no longer a question whether houses, trees or palettes are more beautiful than the paintings, but how the master was able to evoke a vista of nature and an imagination of art through his method of working that developed a new way of looking at the visible world. We love art because we love masters who show how the inner and the outer are united in a vision of reality.

The experience of a work is different from the understanding of its logical structure. It is interesting to see van Gogh's palette because we imagine the brushstroke activity which mixes and distributes paint, yet it misses the continuity of existence which in all elements postulates the necessity of time. In the imagination of time, an endless chain of elements enriches the content of present experience and determines its location. An aesthetic experience can only subjectively be applied to art. I said that my interest or my participation goes more into the paintings than into the palette. I made a subjective statement. By contrast, objective values derive from the discursive ordering of phenomena into a system of observation.

A thesis of higher experiences in art is as futile as a thesis of transcendence through formal beauty. In each case there is a lack of objective criteria which would allow a comparison between formal components in art and the forms of nature. We conclude that there is no difference between the perception and the experience

of a work of art and the perception and experience of normal reality. Art and reality are on the same level of existence. No matter in what garment a work may appear, as a canvas covered with a coat of paint hanging parallel to the wall, no matter whether a painting operates with illusionistic or abstract means, its position as a physical object can only be transcended by the presentation of an aesthetic idea that has meaning and purpose within the context of art. In that sense a painting is the metaphorical expression of a permanent connection between past and present aesthetic phenomena.

It is unimportant to ask whether I see houses or faces in a painting or whether it solely displays non-representational elements. When deciding whether on object is art or whether, like the palette, it belongs into normal reality, I must have a meaning in mind which transforms the appearance into an idea of art, changes the vista of pictorial possibilities, and unites feeling and thinking.

People with little experience in the visual arts substitute aesthetic contemplation with the observation of nature. The sublime appears in instances of nature as well as in art. Knowledge or rational thinking does not guarantee aesthetic experience either in art or in nature. Sometimes, the most intelligent art lovers cannot comprehend or enjoy the newest art because their vision is tainted by the impenetrable cloud of the past. We must also take the intention behind creative actions into consideration. A situation is imagined in which the artist had more than one possible mode of procedure. A work of art is the product of continuity and the differentiation of aesthetic ideas which determine the objective value of a plastic configuration.

The distinction between art and reality, which had always been taken for granted, collapsed when, in 1910, Kandinsky declared in *Über das Geistige in der Kunst* (On the Spiritual in Art) that contemporary art has at its disposal the entire arsenal of phys-

ical material, from the hardest to the simply two-dimensional.[3] It is astonishing that the *spiritual* found its way into the storeroom of physical material. Pictorial elements, when not depicting anything beyond themselves, are on the same level as a table or any other 3D object. The distinction between normal and aesthetic reality has become blurred and the painter obtained freedom to conceive formal elements as hard objects. This recognition opened a wide range of formal possibilities and affected a new attitude toward the ontological makeup of a painting. The picture plane is no longer the place to get an illusion of space or concomitant segments of imagined reality but has become a physical substructure for lines and color fields. A non-representational painting is a physical totality whose space ends exactly there where the physical edges of the canvas end.

The identity of abstract elements with normal reality demanded from Kandinsky and from the rest of abstract art a particular logic of pictorial construction which takes the edges of the canvas into account by not allowing them to impose arbitrarily on the extension of the lateral picture space. The painter has to avoid that pictorial elements are cut by the edges of the canvas in order to avoid the kind of space which fundamentally determines the nature of illusionist panel painting and its character of showing only a segment of depicted reality like a window with limited view. Now the edges are included as active components of the composition.

Kandinsky abandoned his Expressionist period, reminiscent of landscape painting, to create a classically controlled style with geometrical elements which float in a transparent space like fish in an aquarium. His geometrical paintings are containers, closed on all sides, their surfaces defined by physical elements parallel with the vertical and horizontal directions of the picture plane. Regardless of what you think about this change of style, he opened new and logical avenues for non-representational painting. We

understand that his artistic accomplishment is so marvelous because the introduction of new parameters challenged the authority of conventional panel painting and opened a multitude of new possibilities for visual expression. All great names in the history of art are distinguished by accomplishments on a historically contextual basis, inventions we call great art, which opened new avenues for the future. While acknowledging that we attribute the highest value to newness and the individuality of style, we also apply criteria of logic to the course of history. Each work of art, regardless how old or new, can display good or a bad qualities depending on how successfully it pursued the logic of its own propositions. It does not make sense for an artist to search for innovations which make no sense to the rest of art.

Today, we make a distinction between ontological, epistemological, and formal inventions.

Ontological newness concerns the physical properties of a work, a painting as a flat panel that opens the illusion of space, a panel on which three-dimensional elements are placed, a stretcher frame on which pieces of canvas are hung, etc. Epistemological concerns deal with various painting techniques for structuring pictorial space or articulating surfaces with either flatness or texture, etc. Formal inventions extend the inventory of form for new emotive content from the discipline of geometry to freely invented forms and provide a broad territory of expression.

What is new in art always reflects what is renewed. Inventions do not occur in a vacuum or from the superficial reactions to works of other artists. Newness is the result of a careful analysis of the premises prevalent at a time. History shows that revolutionary works are created in a climate of cultural exchange in which artists and critics build a mutually fruitful front. New works arrive through the analysis of conventions that govern the taste of a time. It is the opposite of synthesizing elements created by other artists at other times.

The newness of Renaissance painting, compared with the art of the Middle Ages, resides not only in a more worldly subject matter but in the invention of a perspective which makes the physical properties of the canvas invisible in favor of an illusion, which accounts for depicted bodies having the greatest intimacy or the furthest distance, in which the tangible on earth and the intangible events in heaven are in close proximity, in which things in space start to live, move from light to dark, and exude a beauty, as if brought as a celestial gift. The newness of Cézanne and Vrubel consists in the way round objects are flattened into disks of paint, how facet planes create a firm homogeneity not matched by previous art. The newness of Impressionism is in brushstrokes and small patches of pigment, heaped beside each other, uniting the pictorial field into a territory of loaded tension, full of inner energy and unencumbered by rules of mimesis. The newness of Pop Art cannot be seen in the selection of profane subject matter but in the way the century-old discrepancy between the picture surface and what is painted and depicted on it is overcome. The painting, despite images, is turned into a unified 3D object.

The ontological questioning of the Cubists made the traditional distinction between painting, sculpture, and normal reality questionable so that it became increasingly difficult to distinguish a painting or a sculpture from everyday reality. This process starts with the implementation of 3D objects into the art of painting. Physical elements convert all other elements into their own physicality. The surface of the painting as surface and the space as space become part of its constitution. Everything imagined in traditional painting as an illusion can now be imagined in the spatial continuum of the world. Looking at older art we assumed that atmosphere can be created and emotions evoked exclusively by aesthetic means. Now, atmosphere and emotions can also come from objects outside art. Hard objects, liberated from their original function, become sensuous signs and sensuous signals.

The inclusion of profane objects in the realm of art changed the idea of sculpture being monolithic and employing the human body as a measure for beauty and formal invention. Bottle racks have traditionally no aesthetic value; their occurrence in art produces a lot of thought about the medium of sculpture and concomitant expectations concerning beauty, expression, originality, skill, and emotion. Duchamp's *Fountain* should have an honorable place on a pedestal in the Bibliothèque nationale. As a condensed book it is better preserved in a library than in a vitrine of the Centre Georges Pompidou, where it would slowly rot. Demarcations between art and philosophy have become fluent. Sometimes a work makes ingenious exclamations while being aesthetically insignificant. Never before has art been in such a precarious position. When individual works split from the family of art and seek refuge in philosophy, it is the duty of philosophy to investigate what is the matter with the rest of art. While formal progress in the course of history has changed taste and aesthetic ideals, a painting or a sculpture was never jeopardized by being mistaken for trash.

When I find a painting or a sculpture in my grandmother's attic there is initially no doubt that it is a painting or a sculpture. A painting depicts images on a flat surface; from traditional sculpture we expect the depiction of a human body or an animal figure. At this point we ask axiological questions. Have we found a Rembrandt or an unimportant work? The proximity of modern art to normal reality does not guarantee the identification of a plastic configuration as a work of art. The proximity of modern art to normal reality makes identifications difficult and often impossible. A row of bricks can be a sculpture, an empty canvas a painting. We realize what the extreme forms of Realism have done to the esteem of art. Philosophical pathologists find great pleasure dwelling on the borderline between healthy and malignant objects.

What are the properties that transport an object of Art Povera into High Art? It has been claimed that it suffices for an

object to appear in the context of an art world, in a gallery or a museum. The paint smears of the chimpanzee, Betsy, in Baltimore Zoo would be art if the curator of the Chicago Art Institute suggested this idea to the public. But what idea is it? As discussed already, the value of a work can only be ascertained objectively within the value structure of ideas in art. The idea is manifest in the structure of sensuous material because only in concreteness is the idea a truth and of significance for art. Purely narrative or allegorical works contribute little to the truth of aesthetic cognition. The less art one gets from the formation of a work, the more help it will need from philosophy. A minimalist work, a monochrome surface, a black cube, an empty canvas, all tell romantic stories of theory in sensuous deprivation. What in former times was a story or an allegory, is theoretical rhetoric today. Hegel complains that the content of beauty becomes irrelevant if aesthetic principles are the purpose of depiction because only in concrete singularity is the work true and real, not in abstract generalizations.

Of course, I need to understand something about the ideas of art to properly apprehend the meaning of a work. The unification of idea and visual appearance accounts for a total visual experience. The work of art turns into an object of continuity of time. Every element has significance within the particular propositions of the work itself and within the larger context of the work in its time. Aesthetic judgments need distance from immediate sensuous input. Apperception seeks objectivity, independent of momentary sensations, to establish a logical and universal connection between subject and object. The significance of a work results from the imagined connection with other aesthetic experiences. An initially simple work of Art Povera may be liberated from its sensuous deprivation and attain the status of a symbol for an inner wealth of other data. Every work of art suggests and represents another work of art.

An artist's aesthetic intentions are most clearly manifest in stylistic propositions which exist through related examples. In connection with stylistic continuity Wittgenstein speaks of family resemblance, a connecting idea or unchanging attitude connected to a concept.[4] Family resemblance, however, does not guarantee art. A stereotypical activity also applies to craftsmen who produce the same thing every day. Even though style is a necessary feature of art, it cannot be employed as a defining concept for eliciting necessary and sufficient conditions applicable to an essence of art. A painter who appropriates the geometry of, let's say, Mondrian, could create a style and achieve the same quality as the originals but contribute nothing to art. His works recall the Constructivist period at the beginning of the 20th century but remain solidly within the realm of craftsmanship. The originality of the Appropianists, who are fashionable today, is solely contained in the skill of imitating the work of masters, yet the idea is too small to justify the content (a definition allegedly derived from Bertolt Brecht). Strangely enough, such works enjoy great success because the less invention the easier one can handle them. They repeat a formal principle and create a logo, similar to the logo of industrial companies, a signature style without much freedom. By contrast, avant-garde artists practice the extension of consciousness by continuously moving into unexpected areas of visual expression without denying the original source of emotion from which their inventions spring. Jackson Pollock moved from his all-over paintings into a period of risky compositions with figurative elements. The even distribution of lines over a surface, characteristic of his work, gets deeper meaning from this risky development into a semi-figurative style.

The possibilities for new art are limited. At least since Wölfflin, it is known that not everything is possible at all times, and also, what is new today may be forgotten tomorrow. One needs to determine what rooms have been closed by former

accomplishments and which rooms in the hotel of art are waiting to be occupied. All new art carries in itself the elements of older art, even if the old is not overtly visible in the new. Inspiration and aesthetic content are found in the rejuvenation and renewal of expressive means which lead to new aesthetic experiences. While recognizing the strategy of working and accepting the authority of given means of expression within the context of art, we also change our way of looking at the visible world. In looking at van Gogh's paintings, we are not captivated by a subject matter we could find in another painter, but how his brushstroke articulation and freedom in manipulating unexpected forms and colors has turned the picture plane into a field of inner vibration which forces us to invest psychic energy and change the conventional way of looking at the world and art. Artists do not paint what they see but the art they imagine.

In the course of the 20th century it became fashionable to challenge the boundaries of artistic disciplines. The loss of an apparent difference between an object of art and an object of reality forced questions of motives and led to an often painful conflict between the eye and the mind. The story of the emperor's new clothes comes into being when new aesthetic directions are born. In such times it is difficult for the eye to work in conjunction with the mind because the eye is not able to grasp the intellectual system which creates the difference between art and normal reality. The conflict must be decided for an aesthetic experience which, in all elements of imagination, creates a firm hold in the mind while liberating a stream of emotions. The finest art deals with the finest feelings.

1 Clement Greenberg, "Abstract, Representational, and so forth" in *Art and Culture*, Boston 1961, p.133.
2 Arthur Schopenhauer, *The World as Will and Idea*, translated by R.B. Haldane and J. Kemp, New York 1961, p. 278.
3 Wasssily Kandinsky, "Über die Form-frage," 1911, in Klaus Lankheit (ed.), *Der Blaue Reiter*, Munich,1965, p. 143. Also quoted in Werner Hofmann, *Turning Points in Twentieth Century Art: 1890–1917*, translated by Charles Kessler, New York 1969, p. 105.
4 Ludwig Wittgenstein, *Philosophical Investigations*, translated by G. E. M. Anscombe, Oxford 1953. The idea of family resemblance appeared in the Berlin lectures of G. F. Hegel, 1835. See also *Ästhetik*, Friedrich Bassenge (ed.), Berlin / Weimar 1984, p. 153

Concerning Beauty

Lecture at the Symposium on Beauty,
University of Graz, 1987

The meaning of beauty in art is important when the nature of art has become problematic. Today, the way art is supposed to affect us has become a problem and consequently the concept of art itself. From the recognition of something beautiful within the chaotic multiplicity of appearances, we expect elementary conclusions about the driving forces in the making of art, as well as in ourselves, as if to arrive at a constant substance, at something eternal and universally true. The pluralism of contemporary phenomena forces continuous reconsiderations of aesthetic ideals and the circumference of possibilities we grant art to remain as art and not become something else. The psychological energy necessary to keep in touch with artistic phenomena is particularly stressed in times of stylistic changes, when the monolithic development of a linear course of history suddenly divides in many directions and allows phenomena, of often questionable origin, to enter the realm of art.

Concerning the concept of beauty, we must admit that it is astonishing to connect it with contemporary phenomena when modernist art in general shows that beauty, or what is visually pleasing, is no longer a central concern but rather a peripheral by-product of the production of art. Beauty is not a goal and there is no guarantee for its existence in contemporary works. In fact, it is questionable how far the concept of beauty has ever reigned or

had any influence in the history of art, even though we speak of "fine art" and trust academic institutions to determine methods for the creation of beautiful objects or at least of things that can be included in the fine arts. The different interests and diverse goals of contemporary art show themselves in the curriculum of academic institutions. There are photos of classrooms in academies showing students sitting around a nude model while the professor in a white coat speaks about aesthetic affection, proportion, distribution of light and dark, plastic volumes, flatness and space, foreground and background, etc., all concepts of imitation, as if young artists could not see for themselves and distinguish elements of visual quality. We speak of a long period in Western Art indebted to the ideals of a Greek tradition which followed the appearances of nature in order to rescue them from the chaos of reality, endow them with a higher beauty and subject them to the order of art. Today, it is difficult to understand why a depicted object should be more beautiful than an un-manipulated thing, and also why art must be involved with existing reality at all.

It has long been established that the concept of beauty is an open concept that continuously changes and corrects itself in different periods of history. There is a difference whether I ask if an object is beautiful or whether it is art. Learning institutions of today no longer prescribe formal parameters which should lead to established notions of art, but rather involve with the world of ideas opening a radius for new possibilities. The concept of beauty describes both negative and positive aspects of a thing. "This is pretty good"; "this painting is pretty bad," etc. Good art doesn't need to be beautiful; one assumes that minimum standards of taste are observed. Still, a good painting fulfills other criteria than those deriving from a pure judgment of taste because a work exists in a continuum of time beyond purely sensuous appearance. While beauty remains with the object, the spiritual is hoped to represent a truth which is objective and universally applicable.

Sometimes one can hear that art is the free operation of emotions and the unfettered field of imagination, while the singing of the nightingale comes from instinct and natural laws. But if we look closer, we must admit that the painter does not operate out of pure freedom either. He paints because he needs to paint, because he cannot find another direction in life, because he needs to create what is possible within the circumference of his being. Whatever you call this freedom, which is an inborn necessity, it is not liberated from the substance out of which it lives and with which it is identical. The painter, like the nightingale, is bound to his inner being, his substance. Products of art are expected to reveal the singularity of an individual and demonstrate his love. We love art because we love the masters. The greatness of humanity rises in front of us like something mysterious. Art is both rational and irrational and bound to the personal. While hiding rational intentions, art moves into the realm of the metaphysical, is transcendent and only obliged to the substance from which it comes. This principle encompasses all of art and is beyond the reach of logical thinking.

Intuition comes from an unlimited freedom, yet its particular direction is a conscious choice, the product of directed energy. Manifold intuitions order themselves into an aesthetic direction. What does not belong to it is eliminated. A painter does not pursue beauty as a goal. He selects the true and right in the state of becoming. Pictorial material is pushed around until it reaches a finality from which he can no longer separate himself. Because the unconscious and the fortuitous prevail in the act of creation, the artist cannot fully anticipate the success of his efforts or bring his actions under complete control. Ultimately he does not feel completely responsible for the product because it has come to him like something not engineered, perhaps more like a gift from above. The secret of art resides between the visible and the invisible, the rational will and the purity of feeling, the reality of the here and now and its evanescent objective truth. Because the work

Blenheim, graphite on paper, 19.7 x 11.9 in., 2006

does not exhibit the reason for its createdness, does not explicate beginning and end, it remains a singularity inaccessible to exhaustive analysis and finds its ultimate determination only in emotion.

A successful work is sublime because it unites all elements of construction into an undivided totality. The interest in narrative or formal elements turns into *disinterested pleasure,* a perception which, devoid of interest in details or intellectual relations, turns into the contemplation of pictorial totality.

By contrast there is kitsch (today, one even speaks of Kitsch Art) that appears in galleries and museums, often under the predicate of avant-garde. It is a simulacrum of the classical 20th-century avant-garde, which, in its time, assumed the risk of provoking the new, the otherness and the individual. Kitsch imitates the character of the avant-garde with phenomena which pretend feelings of art. Creators of kitsch cannot be cured because the cause of illness is bad character. It is easier to tolerate realistic than abstract kitsch, because the exaggerated labor on realistic elements shows at least craftsmanship. Abstract kitsch, by comparison, is original deception because the realm of abstraction has no room for painters, who, because they have nothing to say, hide behind geometrical elements (stripes, squares, rectangles, circles, etc.) which provide objectivity and universality. Realistic as well as abstract kitsch artists lose themselves in the exaggeration of narrative or formal elements. The thick gets thicker, the thin thinner, the geometrical becomes a blown up pattern, etc. From Artistotle we learned that a work of art is complete in itself; one cannot take away or add anything, while with kitsch the temptation exists to change something or dismiss it.

There is a curse of geometry in modern art. Modern society associates geometry with modernity. While geometry is a necessary tool for the production of mechanical devices and architecture, its employment in the visual arts is a convenient tool for decorators. They structure the surface of a painting with pre-existing elements. Such an action is a pitiful display of limited creativity. To live within the confines of geometry must be a miserable life indeed, for then it is not an artist who invents but a craftsman who produces more or less decorative wall decorations for motels, banks, and unsuspecting curators of provincial museums.

I want to make sure that I am not speaking of painters like Velázquez, Cézanne, Klimt, Cubist Picasso, and Braque, or the early Constructivists, who used geometrical elements in conjunc-

tion with invented forms, but rather, I am thinking of contemporary phenomena that approach the condition of pattern painting.

It is amazing that in 1792 Immanuel Kant already pointed out that geometrically regular figures like stripes, squares, rectangles, etc., which are commonly regarded as indisputable examples of beauty, are mere presentations of concepts prescribing the rule for the configuration and the operation within which they appear. Satisfaction does not rest in the aspect of the figure – as compared to a scrawled outline which is irregular and deformed – but on its purposiveness for all kinds of design. Regularity, like in pattern painting, belongs to cognition and contradicts the free play of imagination. It is repugnant to taste; contemplation is the grasping of an object in a single representation and not divided into the cognition of operations which account for the result. Rather than investigate cognitive faculties and depend on theoretical judgments, beauty occurs when precepts and rules are neglected and form alone constitutes the beauty of an object. Beautiful art, although it is designed must not look designed but must look like nature although it is in agreement with rules which are not painfully apparent and have not fettered mental powers.[1]

Abstract painters without imagination follow their taste in arranging geometrical elements toward the production of objects (usually oversized because they try to convince through material quantity), that please only mechanically like a Lego mosaic. At the advent of abstract art it was already feared that non-representational presentment would open up space for decorative impulses. Kandinsky spoke of the *black hand of materialism* devoid of inner necessity. Regularity in the sequence of elements calls to mind the practical purpose; it produces boredom through empirical predicates inherent in objects of use. Pattern painting is kitsch because the effort is too big to justify the content. On the other hand, the transcendence of reality is accomplished by an unstudied manner, always new to us and never tired of looking at them.

Kant quotes the businessman, Marsden, who tired of the vital flow of nature in Sumatra while being intrigued by the regularity of a pepper garden he found in the middle of a forest. The parallel stakes on which pepper plants twine themselves are the opposite of the wild beauty in exotic trees and plants. Kant counters this by asking Marsden to spend a day in the pepper garden so he becomes convinced that the regularity of its design will not hold his attention for long and actually will impose a burdensome constraint upon his imagination. Nature, in contrast, will supply constant food for taste because it is free of artificial rules or patterns imposed as laws of procedure. Nature is exciting in its unexpected fancy and it entertains the eye with a continuous variety of form.

Facing products of imagination is more demanding than the perception of repetitive patterns as it occurs in single image painting by painters who dwell on the same or a limited number of images throughout their careers. Painterly configurations and beautiful designs are not the result of a program but result from mental powers of imagination. We like painters who come up with renegade solutions. Isn't the risk of failing an implement of creation? Isn't incompleteness the essence of reality? Reality, in the process of being created, is continuously trying to complete itself.

Originality is the opposite of following a canon of established rules. Originality is more like an eruption that does not show nor know where it came from and will not provide strategies for others to accomplish the same. An aesthetic idea is the presentment of something imagined and can, therefore, not adequately be captured by the rationality of language or made intelligible as a necessity. Resulting from the free play of imagination and liberated from the restraints of cognition, the work is not a billboard of ideas but a holistic phenomenon which lends itself to intuition and transcends simple experience through an animating spirit. An original work may encompass everything that has been created before without, however, being deductible from any particu-

lar example. As such it is an object which never existed and will never exist again. Its truth is sealed forever in the particularity of its being and only as such can it be an example for other art.

...

The present period in art is complete with artistic phenomena which have nothing to do with each other and cannot be measured with overt principles of judgment. My previous remarks about good or bad art, about Kitsch and High Art appear like old-fashioned rhetoric. Questions concerning Beauty, Good, and Truth, which should be answered by the particularity of an aesthetic appearance, have shifted to the question of what position an artistic product can claim on the capitalist art market. It does not make sense for philosophers to search for the *end of art* within the discipline of art history by talking about the end of narration or the dissipation of uniting formal parameters, when the market itself shows that value is not sought in the visual but in a monetary hierarchy. The *decay of the West* is an amalgam of unfounded reactions to unfounded phenomena. Nobody knows what it is and nobody wants to know because nobody believes in the absolute of universal or eternal values.

Konrad Paul Liessmann (b. 1953) refers to the writing of Friedrich Schlegel (1772–1829) who substitutes the concept of beauty with the concept of *Interesting*.[2] What evokes interest in the *Interesting* is according to Schlegel its *lack of universality*. The *Interesting* does not obey a connecting aesthetic norm, it does not represent anything objective, it does not strive for completeness or harmony but fascinates solely through an excessive display of its peculiar particularity. It belongs to the mannered, the characteristic and the individual. What is interesting breaks the boundaries of the common, it is excessive in appearance, must make itself visible in the industry of information. Liessmann remarks that the interesting can be substituted by something that is equally or

even more interesting. The merely interesting exhausts itself in sensuality without reaching a spiritual plane.

The post-modern movie industry is probably the most striking discipline in creating shocking events and manipulated stimuli without inner content. Schlegel defined shock as *the last convulsion of a vanishing taste.* Contemporary movies without linearity of narration make visual effects more important than tales about situations in life. Thereby the movie is granted visual autonomy and what you remember are images without narrative context. It has become fashionable to watch two or three movies simultaneously whereby the areas of projection are stacked on top each other and attention can vacillate between, let's say, a winter in the Alps, a love scene on the beach, car racing in Les Mans and boxing in Las Vegas.

A similar situation exists in post-modern painting. We cannot follow the stylistic development of an artist but look at an art world that presents the short flickering of personalities which, in the wild vegetation of things, suddenly turn up without making it possible to judge or comprehend their accomplishments within a hierarchy of aesthetic endeavors.

What stands opposite the turmoil of post-modern forms is the stasis of nature, which in the present period of art becomes increasingly prominent and involved in the magical driving of imagination. The new concern for nature in art has nothing to do with the imitation of outer appearances but is more the creation of a pictorial atmosphere, strong enough to create content without clues to a concrete reality or particular situation. A sublime content stands like a miracle in front of our eyes. Something is created without depicting it.

...

Very different from the comparatively straight development of Modern Art, the last twenty years have seen an unprecedented

plurality of forms and styles. Even the most liberal philosophers have problems accepting that everything should be possible, that the lack of a hierarchy of form should allow phenomena to enter the realm of art which claim to examine the discipline from within while often coming from purely cynical sources and contributing nothing but upheaval concerning the ontological condition of art. Plurality shows itself on various levels between Realism and Abstraction. In single works it may manifest itself as the freedom to simultaneously operate with realistic and abstract forms and the variation between illusion and physical self-presentation. The traditional method of operating on a homogenous level of abstraction, which encompasses every element of depiction, has been replaced by an often arbitrary rendering of elements on various levels between Realism and Abstraction.

The basic problem in contemporary aesthetics is the establishment of visual categories which would create the intellectual and emotional foundation for an ideologically flexible apperception of art. We make a difference between the judgments "this painting is beautiful" and "this painting is art," because from art we expect an elementary model of reality that evokes new strata of feeling, condenses consciousness about our position in the world, enriches our position toward aesthetic phenomena, and reinforces what we already know.

It is astonishing that the protagonists of post-modern aesthetics carry the dialogue between Realism and Abstraction into judging contemporary art, when we find ourselves at the advent of an epoch in which this dialogue is without consequence and ends in sophistry. On the one hand there are critics who see contemporary Realism as an outdated phenomenon, and on the other hand there are critics who look at abstract art as something that has lost newness and the element of surprise. Jean-François Lyotard sees Realism in opposition to the experimental avant-garde because its only definition is to avoid a reality which is

directly implicated in the reality of art; he sees Realism dwelling between academicism and kitsch. As an alternative he proposes abstract art "because it is in the aesthetics of the sublime in which modern art finds its impetus and the logic of avant-garde its axiom."[3] In the opposing camp we see Donald Kuspit with his assertion that abstraction comes to us with such plausibility that it has lost belief in itself as the *ontological foundation of art*. He proposes painterly figuration which is critically more significant.[4]

Both philosophers operate with the idea of a particular degree of abstraction or realism contained in a work as preconditions for what one could call *the reality of art*. We must ask whether anybody can predict the future *reality of art* as being locked into a certain degree of abstraction or realism.

...

We know that the imitation of objective reality has always been responsible for the difficulty to explore the invisible realm of feelings beyond depicted subject matter. This realm is identified with the autonomous life of aesthetic forms. While depicted subject matter describes the outer condition of man, non-representational configurations describe the inner being of an artist. In the course of western art, beauty of nature was conceived as being different from the beauty of art and a synthesis between both could only be imagined if natural forms were put into the service of artistic configurations. The classical ideal of beauty was the equilibrium between form and content. But in the 19th century it had already become clear that art should pursue a higher goal than to show something you can see for yourself. Illusion as a mimetic goal had become obsolete and there was no more desire to see imitative art further perfected. Hegel argued that beauty disappears when the principle of imitation puts itself in front of the aesthetic message, because then it is not a question of what is depicted but only that it is depicted correctly.[5] He demands that the content of beauty

derives from an inner self that lays itself over depicted subject matter and shines out of it. Behind the outer we expect something inner, which is its spirit. The outer must point to the inner condition of the artist. The elements of the beautiful contain the inner in the outer, and the outer is of significance only if it points to the inner.[6]

Schopenhauer, in his critique of allegory, refutes everything which lies outside the work and distracts from the actual aesthetic reality, the content of perception, because it is in the immediacy of contemplation in which perception finds its ultimate goal in a knowing subject.[7] Schopenhauer distinguishes between the *half formed language of nature* and the prophetic imagination of beauty. The conceptual idea of beauty, as presented in art, makes it possible to see beauty in nature when we encounter it. He sees art as the apex of all reality because in it we see what is given in the visible world, just with greater concentration, intention, and intelligence.

The basic tenor of such concepts of beauty is based on the assumption of a teleological hierarchy that stretches from the relative disorder of appearances in the world to the ordered beauty in art. Now, objects of reality are viewed as material for higher aims. Of course, one cannot read the formal changes in the history of painting as if they resulted from an opposition to nature. The revolution of Modern Art was not directed against the beauty of nature but against the idealization of a formula for beauty which had laid itself over the presentment of reality, like Nietzsche's curse, "the formula is a tyrant."[8] The new orientation of aesthetic ideals in Modern Art demanded not only questions of whether representation of reality is necessary at all, but it triggered ontological questions concerning the basic nature, the *actual reality* of art. It became unavoidable that serious philosophers started to reflect on urinals, Brillo boxes, imitators of past art, modern appropriators, altogether on objects located at the fringes of what is

presently possible, as if to draw a plan for an aesthetic geography. The changing panorama of Western Art, from its beginning in the illusionist panel painting of the Renaissance until its overthrow at the beginning of the 20th century with the physical self-presentation of abstract form, testifies to the fact that the inventory of forms in nature is not large enough to comply with the artistic drive that tries to create formal analogies with the inner being of man. The various mostly mechanical devices, which served conventions of perception in the past, needed to be replaced by other modes of visual perception. The development from the perception of angels carousing in the sky to the contemplation of actual reality on the surface of the canvas is a change of perceptual mechanisms coherent with the change of style and the change of emotions.

The liberation of pictorial means from their service to objective reality was the logical consequence of a tradition of thinking about the way the actual nature of man can be objectified in a work of art. The autonomy of lines and color fields in a non-representational configuration was felt by early abstractionists as liberation from the weight of reality and less as a loss of nature's formal treasures. As a physical reality, an abstract painting is like a product of nature, free from separate contents of perception which traditionally forced the attention of the beholder to vacillate between depicted objects and the formal whole. Non-representational painting became an undivided totality. Similar to the vastness of nature it reduces the power and meaning of individual elements and unites sensuous impressions in a single uninterrupted intuition about the whole.

...

Concentration on totality is concentration on formlessness which finds its determination in the feeling of the sublime. It was a great accomplishment of Immanuel Kant to recognize the importance

of formlessness at a time, in the second half of the 18th century, when the synthesis of form and content was the most desired aspect of aesthetic judgment. He theorized about the possibility of a perception which is free of individual elements of representation. "One need not worry that the feeling of the sublime will get lost if the reduced representation is negative in regard to sensuous content; because imagination, while it does not find anything on which it can hold on, feels unlimited through the elimination of represented contents."[9] When the representation of individual forms leads to a negative presentation i.e. integration into a visual totality in which individual elements have lost their narrative meaning, a presentation of the infinite is the result ... which, however, enlarges the soul. And Kant concludes that there is no other more sublime passage in the Jewish book of laws than the command that you should not create an image of what is in heaven, on earth or under the earth.[10]

With this passage from the *Critique of Judgment*, Lyotard defends a painting of formless emptiness as if to develop a program for the future of post-modern aesthetics. He sees the future of painting devoid of figuration, like Malevich's squares, in which you see something without perceiving anything. While he rightly diagnosed that the contemporary avant-garde tries to create content without depicting it, I believe one should not speculate about the specific appearance of an abstract painting which moves imagination to its limits. It is certainly wrong to deduct from Kant's "negative representation" a mode of painting lacking all formal invention or spatial articulation and envision nothing else but the infinite emptiness of an unbroken pictorial space as it occurs on monochrome planes. If emptiness were the sole desired content of representation, emptiness would turn into imitated form. Time and again Kant pointed out that the experience of the sublime occurs in front of a nature which is not empty but replete with mountains, high waters, and deep crevasses. Our perception is not

occupied with details but it recognizes the power of a landscape free of aesthetic judgments or purposive determinations as a free effect on our emotional disposition.

"If you call the perception of a starry sky sublime, you don't connect it with concepts of worlds inhabited by rational beings ... but only that you perceive a vast vault that encompasses everything; and only under such an image can one speak of the sublime which is connected to the purity of an aesthetic judgment."[11]

The central meaning of the sublime is in the distance of the content of perception from an imagined purpose. The uncontrollable power of rational associations continuously intermingles with perception, particularly when the connections between elements are weak, allowing individual elements and meanings to become independent and separate themselves from the totality of the visual configuration. In that sense, the question on what level of abstraction (between Realism and Abstraction) a painting should operate has become unimportant. Now we speak only about the power of an aesthetic reality to create an atmosphere and an emotive disposition which places itself into consciousness as a singular and extraordinary experience.

While Kant's conception of the sublime might give the impression that the postulate for transcendence of empirical data suppresses sensuous effects, we must contribute great importance to his conception of sensuality; after all, it is the privilege of art to heighten the sensuous to such a degree, that we get lost in it and lose contact with any purposiveness. The sublime transcends beautiful and pleasant contents through intensification of sensuous components.

It is no coincidence that the representatives of rational thinking opposed the sublime with skepticism and often with animosity because rationality finds limits in the complexity of actual experience.

...

Early abstract painting developed out of 19th-century landscape painting which distributed pictorial energy evenly over the picture surface, either by compositions starting from the picture edges and proceeding to the infinity of space in the center of the painting (Friedrich), dissolving pictorial subject matter into evenly distributed points of light (Impressionism), building a solid structure of small facet planes over the entirety of the pictorial plane (Cézanne), spreading the energy of brushstroke articulation in a single rhythm of the heart (van Gogh). We speak of an effort to mitigate the significance of individual elements in order to create a unified emotion in the totality of the work. Unification creates a beauty which stands like an event of nature in front of our astonished eyes. Unification testifies to the working of a single soul. The content of perception is the revelation of an inner being. The painting has built its own nature, which is neither superior nor inferior to nature—equal, yet different from reality—pointing at its creator. As we look at nature as the work of a creator, we look at art as the creation of an artist. The hermetic position of his style is not a sign of intellectual indifference or naiveté; it is the conscious search for a field of emotions that derives its rational significance from the competition with contemporary phenomena and from all of art.

The concept of the sublime is a verbal fixation when experiencing the landscape of style. We don't look at paintings to find outer beauty, which is perhaps more beautiful than a tree, but we look at the imagination of a painter and how he has grasped reality through the model of his art. Originality of style, to which we attribute highest importance, is not the synthetic digestion of the outer characteristics of other styles, but the concretization of a state of consciousness that brings into existence the singularity of being. This is the venture of art. When acting for our own truth we can easily lose the path on which the rest of mankind proceeds. Yet such anxieties belong only to those whose ambition drives

them to be heard. When we jump from the train of time we don't mourn over those who have reached another destination.

...

The difficulty with many works of modern art derived from the way how forms and formal relations were presented like intellectual exercises on a blackboard in school. Kant speaks of intellectual entertainment "that addresses the feeling of respect rather than love or intimate affection."[12] The self-conscious reflection of modern art on its means and successes created the danger of an academic aestheticism of the phenomenological new and a formalistic kitsch without any expression. The concentration of modern aesthetics on the phenomenon with its sensuous material was the attempt to elicit a spiritual content as if the co-existence of artistic phenomena in our imagination sufficed for a spiritual content. Critics assumed that one could understand an abstract painting when tracing the mechanism of a mind that created such forms. And the more formalist art and its apologists concentrated on single forms and their purposiveness within a pictorial configuration, the greater was the intellectual entertainment when viewing the work. The relation between forms and their visual function in a composition became the ultimate criterion for the phenomenological progress of modern art.

In his careful analysis of the *Foundations of Modern Art*,[13] Werner Hofmann traces the step by step development of Modernism from the beginning of the 20th century with its division into "Grand Realism" and "Grand Abstraction" over the consecutive order of avant-garde movements, all of which claim to be the latest and universal truth, logically derived from previous art and seemingly logical pointing into the future. This linear history of art—the Viennese school of art history—connects every event of contemporary art with roots of the past, like elements of a chain which cannot be broken, inconceivable that anything occurs with-

out being connected to history, and if it is not connected it is not art but something else, whereby *something else* offers fewer possibilities than what art is supposed to offer. So, everything is accepted as art as long as it belongs to the idea of art.

It is logical that such an attitude creates a notion of art in which all disciplines are connected, all boundaries between media blurred, painting can be three dimensional, sculpture two dimensional, architecture pictorial, the contemplation of painting can turn into action- action painting, visual theater, blood orgies, a lam is slaughtered, blood is paint, sexual orgies are religious activity, standards of judgment abandoned, as if a wild animal had broken out, destroying or making fun of everything that tries to capture it. It is obvious that this kind of art criticism is diametrically different to the Formalism presented by Clement Greenberg, Leo Steinberg and other formalist critics in the United States, whose central concern is the elaboration and function of contemporary forms, their relative quality within the discipline in which they occur and which they represent and, altogether, the possibility for aesthetic judgment along the lines of parameters fundamental to the medium.

At this point you may decide whether to expect progress by innovations addressing the substance of painting along the lines of an avant-garde investigating the discipline itself, or whether you leave the idea of progress to those who question the greater concept of art. Outside a particular discipline, they operate with intermixtures of different media derived from idiosyncratic impulses, as if a formal canon in the development of visual expression had never existed. That we expect and accept both directions of creativity lies in the acceptance of pluralistic multiplicity. It is just a question, how long a phenomenon will hold up as art.

The vertical development of painting and sculpture turned lateral in the beginning of the 20th century when Abstraction and Realism were torn apart and a great many phenomena entered the

scene, so that the idea of the end of painting and its replacement with other and technologically more advanced media became the standard thought of critics who envisioned the development of art parallel to the development of technology. Of course there is no way that painting can be detached from painting, regardless of how many efforts are made to destroy the discipline from within, because it is not the cognition of an interesting phenomenon but the contemplation of an inner structure that makes an aesthetic event.

...

The senseless pursuit of rigid political and aesthetic ideologies, which, in the 20th century, led to great disappointments have changed in the neo-modern art of today into the search for inner motives and a moral justification for the production of art. In a world that carries the potential of a global catastrophe, art can no longer be carried by the same optimism of earlier avant-garde movements. Today we cannot imagine a greater task than the rejuvenation of a personal morality which sees in the individual the value of mankind. We can no longer look at paintings and search solely for the beautiful but we discover the hermetic position of an individual and the importance of his work. The revolutionary critic of contemporary art will abandon a priori dogmas about the superiority of a particular direction in art and find superiority in feelings important in his life.

It is better to listen to our old Tolstoy and leave the confusing concept of beauty behind, because the nature of art is found in a continuous movement of consciousness. Art is neither the production of beautiful objects, nor the display of craftsmanship, nor the introduction of new ideas, nor the distribution or propagation of personal preferences, nor the depiction or perception of objects of the world, nor individualization in style, nor the commentary on economic, social or intellectual situations, but art is all of that

in an experience, which in certain segments of history or for the duration of eternity is of greater or lesser importance for mankind that finds in art a mirror of what is human.

1 Immanuel Kant, *Kritik der Urteilskraft*, Hamburg 1954, pp. 45, 159
2 Konrad Paul Liessmann, "Schönheit", facultas UTB, Vienna 2009, p. 66
3 Jean-François Lyotard, *The Postmodern Condition: A Report on Knowledge*, Minneapolis 1985, n.p.
4 Donald Kuspit, "Flak from the Radicals: The American Case against Current German Painting" in *Art after Modernism: Rethinking Representation*, The New Museum of Contemporary Art, New York 1968, p. 143

5 Georg F. W. Hegel, *Ästhetik*, Berlin and Weimar 1984, p. 53
6 Ibid., pp. 30, 31
7 Arthur Schopenhauer, *The World as Will and Idea*, Garden City 1961, p. 199
8 Friedrich Nietzsche, *Werke*, Stuttgart 1938, p. 488
9 Kant (see note 1), & 29 (124), p. 122
10 Ibid. p. 114
11 Ibid. p. 115
12 Ibid. p. 115
13 Werner Hofmann, *Die Grundlagen der modernen Kunst*, Stuttgart 1987, n.p.

Weitz

Slide lecture *Concerning a definition of art*, Carpenter Center
for the Visual Arts, Harvard University, Cambridge 1981
and Columbia University School of the Arts, New York 1982

In 1956, the American philosopher Morris Weitz started a discussion in aesthetics that has intensified over the past decades and propelled the discipline of aesthetics into the center of philosophical interest. In an essay with the prophetic title "The Role of Theory in Aesthetics,"[1] Weitz asked himself a seemingly simple and logical question. Can art be defined? Are there necessary and sufficient conditions applicable to the arts which can bring to light something essential that can be captured by a definition and show the difference between normal reality and a work of art? Weitz comes to the conclusion that in the arts there is no phenomenological unity which would allow an aesthetic theory to speak of necessary and sufficient properties which could be framed into a definition and reveal the essence of art.

All great theories of art (Formalist, Intuitionist, Organicist, Voluntarist, Emotionalist, etc.) tried to elicit definitive properties. Each theory claimed to be the only one, other theories being wrong because they explain something which is insufficient and applicable to normal reality as well. Of course, theorists claim that their enterprise is not a philosophical vanity or an empty intellectual exercise but that theorizing about art is an absolute necessity for a fuller understanding of aesthetic phenomena. Supposedly, we do not understand aesthetic accomplishments if we do not

know what art is, and are also not able to decide which work is better than another. Without a theoretical base for ordering and evaluating a visual experience we make only subjective utterances as if for an arbitrary object encountered here and there. There seems to be an argument for the necessity of an aesthetic theory which shows artists and critics a basis for art in its time.

Morris Weitz asserts that all aesthetic theories are wrong because they misconstrue the concept of art. Any attempt to determine the necessary and sufficient conditions must contradict the logic of art, whose only property it is not to possess necessary and sufficient criteria equally applicable to all arts. A definition is therefore not only difficult but logically impossible. An aesthetic theory is the illogical attempt to define what cannot be defined, to find necessary and sufficient conditions in something which does not possess necessary and sufficient conditions, and conceive the concept of art as closed when art itself shows that it continuously changes, that its very nature is change, and the concept of art is an open concept. A concept is open when the conditions of its application are amendable or correctible. A concept is closed when necessary conditions for its application are determined. Closed concepts appear in the sciences, while everything that operates with empirically descriptive norms deals with concepts of great flexibility.

To support his theory of the indefinability of art, Weitz looks at some theories which influenced aesthetic considerations in the 19th and 20th centuries.

Clive Bell and Roger Fry are representatives of a Formalism that sees the essential message of art in the plastic elements and their formal relation to each other. Formal properties make significant forms, combinations of lines and color fields, strong enough to transcend narrative subject matter or simple imitation. Significant forms create a totality which is more than the sum of individual elements. Everything that is not art is lacking this desirable fea-

ture. An organized content of perception is a singular phenomenon, different in every work, a signal for aesthetic propositions and concomitant emotions. Looking at Cézanne, for instance, we appreciate the successive building of facet planes, a pictorial mechanism that is significant form. Everything we call art has liberated itself from the simple repetition and imitation of realistic images to create a visual totality, a significant form. This optimism of Bell and Fry refers to all great art. We must conclude, however, that bad art and kitsch may also have significant form, a significant kitsch-form that invests much effort in banal content while neglecting the aesthetic message through significant art forms. Kitsch appears in older art as well as in avant-garde movements.

Geometrical abstraction, for instance, imitates pre-existing elements and hardly arrives at more than what is merely design. True avant-garde art is difficult because it is impossible for the eye to absorb the dialectic between a new phenomenon and the logic of its appearance. Avant-garde interrogates existing parameters, particularly if they have become academic norms dealing with redundant forms and stale emotions. Avant-garde is a surprise for established criteria of judgment. It deals internally with the nature and scope of art, always considering the type of beauty which extends into hitherto impossible states of existence, into something absolute that can derive only from a single soul not trying to accomplish anything else but its own revelation. The work is not monadic as a singular idea but divides into visible form and a hidden secret. When the project fails, it is difficult to decide whether it is a failure on the part of the artist or of the medium of art, which can include in its sphere only a limited amount of information before it explodes and critically exposes the nature of creation itself. It is interesting that critics are attracted by phenomena on the fringes of what is possible in art or whose narrative is solely directed toward itself without consequences for other art. When post-modern artists inadvertently

step into the trap of conservative ideas and bourgeois modes of execution it is the consequence of an isolationism which is often less modern than Modernism.

Until the beginning of the 20th century it was expected that a painting maintain a homogenous level of abstraction and create beauty through the synthesis of form and content. Kandinsky in his early period rejected narrative subject matter for self-presentational form. His paintings cannot be captured by rational explanations of the plastic organization or deducted from empirical data. Instead, they represent a structured informality resulting from "inner necessity." Formalist theories must be extended to include the absence of form while concentrating on harmony, consonances, dissonances or whatever emotions set free by a formless work of art. The Tolstoy's and Ducasse's emotionalist theory claims that form is not significant but expression and emotion make the essence of art. Benedetto Croce claims that a work of art is not identifiable with a public phenomenon but that its essence may be found in a specific creative and spiritual act.

All theories assert that they are comprehensive statements about definable properties of art, yet each one misses something that the other tries to replace. Weitz remarks that a convincing attitude toward art does not derive from definitions but from the empirical report about individual works. All theories attempt to arrive at a universal truth, run in a circle, are incomplete and empirically difficult to prove. He decides that an aesthetic theory is a logically empty attempt to define something, when there are no necessary and sufficient conditions that would allow the concept of art to be closed when its very nature demands openness. It does not make sense to search for a definition but rather to ask which concepts are applicable to art. In his "Philosophical Investigations"[2] Wittgenstein asked the question as to how we can apply the concept game on games. There are card games, board, ball, Olympic, word games and many others. Every game has a simi-

larity to another without ever coming to a common denominator. Even though we recognize games, describe them and imagine their particular content, we do not need a definition or a theory to tell us what a game is.

(Schwitters: We play until death picks us up).
We must conclude that there are no common properties in art but only similarities. We don't seek definitions but describe what we see and experience. When describing and explaining we have other works in the back of the mind. Each work contains elements of other works whether they are visible signs or hidden in our consciousness. Concepts are open concepts because they are flexible, amendable or corrigible. The concept of panel painting, for instance, has changed since the Renaissance. Today we can no longer speak of a panel painting hanging parallel to the wall and providing an illusion of space that leads the eye beyond the physical surface of the canvas. Today we allow a panel painting to exist as a 3D object in real space. The distinction between initially separate media, painting, and sculpture, has become fluent and the distinction between art and normal reality is blurred. An open concept invites a new outlook on what is possible in art.

Throughout the 20th century many works have offered themselves as art when in fact they were just trivial attempts to stir the minds of critics. We miss aesthetic criteria to elicit preferred characteristics which make it possible to distinguish between art and junk. Of course, we do not need a single theory but a schedule of characteristics preferred or necessary at a particular time in history. There is no work of art which could represent all art. Still, there are bundles of aesthetic qualities which put themselves diminutively or prominently in front of an aesthetic phenomenon at a particular time in history, declaring logical necessity in the progress of culture, even if those qualities cannot be applied universally to all art.

...

At this point we send our friend T into Kennick's warehouse, to
select from all the rubbish people have stored there, objects we
call works of art. We are not able to give a convincing account of
this exercise, however with a certain trust and naivety we assume
that works of art possess qualities which create emotional reac-
tions even if these objects are identical to objects of found reality.
Of course, we deal with knowledge about intentions in the context
of artistic creativity.

Duchamp's *Snow Shovel* makes sense only in the context of
Fountain and *Bicycle Wheel*. These objects repeat and clarify his
intention to extend Realism to profane objects and allow his
philosophical will to indulge in ontology. Had he not introduced
more than a single found object into the realm of art but contin-
ued to paint nudes descending a staircase or horses whose run-
ning mechanism structures the space of a painting, his *Urinal*
would be forgotten today, and perhaps there would never have
been any *Brillo Boxes,* and perhaps Appropriationists would not
have copied the works of Old Masters, and perhaps philosophers
would not have had so much trouble distinguishing between the
wine and the bottle. That is how it could have been. But as it is,
art has looked back upon itself—the Orpheus disaster—and orig-
inality is no longer seen in the phenomenological properties of a
work but in the intellectual effort to create an aesthetic ideology
that questions the rest of art. The efforts of Hegel to make art look
back upon itself—the smoke of a chimney being blown back into
Leibniz's fireplace—is the logical entanglement between art and
reality, between something that is intrinsically metaphysical but
opposes its inherent character as if afraid to loose freedom when
not breaking out of itself.

The traditional distinction between aesthetic and normal re-
ality is broken and the aesthetic essence of art is tied to philoso-

phy. Artists are free to practice their craft without regard for beauty or craftsmanship and philosophers use art as a territory for reflective thought. The blurring of traditionally separate media, painting, sculpture, and normal reality, made of philosophy a necessary tool for aesthetic judgment within overlapping media. While philosophical speculation is an accompaniment of artistic practice (it is difficult to imagine an artist working naively without questioning form, content or beauty), it is only today that normal reality invades the realm of art, and even though these events are rare and mostly unimportant for the rest of art, philosophy will make sense of brutal intrusions of reality. Philosophy establishes mental conditions for coming to grips with and encouraging new phenomena. Art searches for borders in the geography of the mind. It is difficult to predict the direction. Philosophy seeks laws to keep excesses of art under control, not with definitions but with a truth concerning perception and what perception is able or unable to tolerate. In other words, philosophy, due to its very nature, tries to arrive at a priori judgments. Philosophy sees itself not in a slavish position behind the most recent progress in culture, but as a support for artistic freedom and the law for artists to be lawless in their work.

Ontological questions are different from the evaluation of aesthetic values. Ontology deals with simple distinctions between the scaffolding of appearances while aesthetic judgments operate with more differentiated forces of consciousness. To remove objects of art from a warehouse is the ontological part of the exercise. While we cannot argue about the choice of objects, we look at the personality that chooses. T decides on rectangular objects on which paint is applied. He calls them paintings. Sculpture he sees as a three-dimensional configuration dealing with the human body, animal figures or abstract forms in space. When he brings boxes and cubes vertically arranged on a wall, we know that he knows Minimalism. Principally, we assume that the presence of a

definition or a theory of significant form had no influence on his choosing. He followed his intuition. We ask why he did not bring a snow shovel. While he loves the idea that an artist has the possibility to explore the limits of art, he does not enjoy looking at an encyclopedia to learn what something is. One has to know what to do with an object, he says. A Madonna figure of the Middle Ages is best displayed in a Romanesque church and a snow shovel would be beautiful in the foyer of the Department of Commerce. It is astonishing, T says, that philosophers seek definitions when it is unimportant for the rest of society. He himself is pretty sure what art is once he sees it. Freihofer and Entenmann bakeries make chocolate donuts which look very much alike but taste differently because of different sugar content. When he sees donuts at the breakfast table of a hotel, he knows already from far what kind of donut it is. His intuition is right, his body reacts. Rational considerations would disturb the truth of the matter because truth springs from other sources than sheer conviction. Of course he has trained for many years to distinguish donuts, and slowly, without volition, he developed into an expert who knows as much as the baker. One needs exercise to look at art, he says, because the eye needs training like the mind.

From Aristotle we learned that the eye is the seat of the soul, which, in unity with the mind, becomes concrete in art. The truth of art lies in the connection of the outer with the inner. The outer is not a product of imitating nature or other art. It results from the melting of the inner with the developing outer appearance during the act of creation. While nobody can say that he approaches the making or the viewing of a work with a tabula rasa or an innocent eye, one can say that the truth of art is independent from the imagination of empirical data. Understanding aesthetic reality needs empathy and intuition. Art is for those who seek art and who are sought by art.

While having absorbed the past and reconstructed it, the

view of the future is of utmost importance for new ideas and the imagination of possible phases of aesthetic existence. If I have no idea in a picture, whatever my idea may be, I stand in front of the painting like a cow in front of the closed door of the barn. An aesthetic idea is the principle of presentation in concrete form. Non-representational art offers enormous possibilities independent of chains from the visible world. I have no doubt that abstract art, because it exists, will not go away and will move into a territory that has been elaborated by Immanuel Kant as the sublime, in which something is presented without depicting it, driving imagination to its limits. Non-representational art resulted from the increased desire to see art in art. Art is abstract. I do not assume that Jean- Françcois Lyotard is the only one who understands what I say. After all, he involved himself with the analysis of the sublime and concluded that painting in the future will "be white like Malevich's squares." On my part, I am convinced that painting in the future will not exclusively deal with white squares but explore the creation of an atmosphere in the painting, regardless of the elements and colors. Kant explained that the sublime does not solely derive from a reduced presentation. Nature is full of crevasses, mountains, and wild water. The feeling of the sublime derives from the disinterested attitude toward a total situation which cannot be described with concepts but addresses itself only to feeling.

Ontological differentiations between objects are on a more pragmatic level and are content with the structure of the appearance while giving little credit to the essence of an object in its outer appearance and concomitant zones of consciousness. Also, it is sad when experts concentrate on what is presently fashionable on the art market. Their interest comes from outer forces, social circumstances, and personal conditions. In such cases art exists in complicity with partners of similar knowledge and interests in the value of an object either monetary, aesthetic or both. One cannot express in words what is necessary for art of the future other than

the feeling of something new, perhaps born from a tradition condensed in the present.

An example of the workings of intuition is contained in the report about European chicken farmers, who in the 1950s travelled to Japan to learn at the Nippon Chicken Sexing School to distinguish between male and female hatchlings one day after birth. Distinction of the gender of chickens is of importance for commercial breading companies because shortly after hatching it must be determined what feed they are given—females for eggs, males for meat. Because there is no apparent difference between hatchlings, students learn how to distinguish between male and female in week-long training sessions . The teacher observes the student who quickly looks at the vent of the hatchling before discarding it into the proper box. The teacher says yes or no. While it appears logical that miniscule differences exist between male and female hatchlings, one is unable to express with words whether something is seen that would make the difference plausible. Instead, the training improves intuition in making decisions.

A similar situation exists with T who delivers objects from a warehouse and places them on the street or in a museum's rooms. His decision cannot be said to derive solely from studied facts but from intuition about art. Of course, he will also deliver a bit of kitsch that superficially resembles art. Now we have to ask whether something that looks like a painting is art and whether some modern sculpture is rubbish or not. I have difficulties loading a row of bricks into my car even if a studious curator plans an exhibition in our museum. If it were possible to comprehend this exhibition and interpret its irrational intentions as the willful destruction of existing values, we would still ask about the value of superfluous destruction. Philosophy helps. The fact is we need all kinds of aesthetic utterances, even if they effect negatively and reinforce what is in our inner possession.

...

The intimacy of contemporary art with normal reality makes it necessary to ask for the actual reality of art. Everything that claims to be art is responsible for its own propositions. Philosophical speculations are often more interesting than the work itself. Axiological considerations have taken second place behind aesthetic propositions. It is trivial to say that a work contains beautiful colors, that it has a pleasant subject matter, that its composition is harmonious, that the eyes of a Madonna embrace the heavenly, that the mouth of suffering Christ is expressive. Even though we attribute much importance to the specific properties of a work, such criteria are no longer the ticket for art. Morris Weitz deals with a piece of driftwood he found on the beach. It looks like a sculpture and we do not object when he takes it inside and places it beside a Chinese vase. It is a lovely object. But art? There must be something about a Noguchi piece that separates it from all other wooden pieces in the world. George Dickie has a more than naive answer.[3] A piece must find its way into a museum. This rather depressing attitude gives credence to the work of artists, who with the help of distinguished personalities were able to penetrate the labyrinth of worldly difficulties. It marks the beginning of art as a social phenomenon in a capitalist society.

There is no doubt that philosophy will take over when significant numbers of non-artistic phenomena creep into the realm of art, from urinals and Brillo boxes to dead hares in a Plexi-cage, phenomena expending the province of art to seemingly limitless boundaries. I do not know whether philosophers enjoy dealing with aberrations that shock the world when it would be more fruitful to discuss beauty in various forms, beauty of natural form within beauty of artistic form. Nevertheless, it does not make sense to dismiss movements that indulge in ugliness and claim that the uglier it is the more avant-garde. After all, when early abstract painters were derided as exponents of "Entartete Kunst" (*entartet*—"degenerate"—means separate from established gender,

different from the expected), they introduced a kind of beauty that affected different brain cells than the traditional notions about what was possible in art. We need to be careful not to dismiss strange phenomena too early; it takes time to either affect us or not. Weitz has a point when relying on description and interpretation as a road to appreciating aesthetic value in its totality.

And then there is skill. The Western obsession with skill derives from an obsession to see an object of art as a phenomenon you can neither create yourself nor fathom in dreams. The medieval notion of an art work being a divine gift is always present in an aesthetic mind. A divine gift transcends the name of its nameless maker and allows beauty to flow inside its concrete existence. Such is the case with tribal art, which, outside Western lineage of form, was often considered primitive or not as art at all, because it deals with forms and formal organizations separate from anything the Western mind was able to absorb as beauty handed down from the Greeks. Today, we see it differently. A Greek marble portrait is not necessarily superior to a wooden Senufo face, which in its formal complexity may illustrate the bold imagination of an artist who reinvents the tradition of his tribe while not overthrowing it. We have learned to look at works outside local tradition. Only recently has the Western eye adapted to standards of appreciation of other cultures, challenging the balance of comfort handed down from the past. As long as art re-finances itself by taking loans from other cultures, it is a viable asset for the development of the human spirit, which all over the world is involved in a continuous enterprise of aesthetic expansion.

A work of art is continually made new by reconstructive imagination. How far imagination and interpretation go is left to the talent of the beholder. An excess of historical consciousness may obliterate the emotional impact and mitigate, if not corrupt, the inner conscious life. An aesthetic experience is totally at one with itself. The presentation of form and content in concreteness

is independent of degrees of Abstraction or Realism. Unity of form and content can occur on any level. A work of art is not an object we find on the beach. It addresses feeling and intelligence. In unison the aesthetic phenomenon is left intact as a singular impression. Contemplation of totality occurs when a stream of visual data order themselves into an uninterrupted intuition. Inasmuch as the idea of art manifests itself in the sensuous object, its principle of operation is totally contained in itself and available at first encounter. The emotional agreement with the work is in agreement with historical consciousness. What is aesthetically significant is always in relation to other aesthetic experiences, be they in nature or in art. Everything that is absolutely simple, like a single tone or a color is of no aesthetic importance. The connection between initially separate elements creates a totality which is more than the simple sum of its elements. A structure of sensuous and intellectual connections results in a new and individual effect. The principle force of aesthetic content is experience with and expectation of the same or similar objects.

Modern art has pushed the linearity of history in many directions. It made of painting an object of culture in all ramifications. Whether or not we like our present culture is most profoundly demonstrated in the appreciation of art. All other progress belongs to civilization. While both belong to the same organization, culture is the inner becoming the outer, civilization is the outer through the inner desire for progress in handling the difficulties of existence. Since civilization is continuously pushing forward, art cannot pursue a tradition solely focused on itself and prescribe, like an aesthetic religion, what forms should be used. The individuality of artists contributes to the basket of forms from which we choose whatever we want, and because everybody needs something else we do not need definitions.

Concepts that intermingle in this discussion are style and newness. Monet's paintings are so distinguished because they con-

tain new aesthetic propositions only found in Monet. Family resemblance guarantees that aesthetic propositions clarify themselves through repetition. It limits the possibilities of interpretation. It exposes the way the painter views the world through his art. All great names in the history of art announce themselves by propositions which extend possible parameters governed by a continuity of emotion. Continuity is not an imitation of visible signs in the evolution of sequential works but the exploration of new images within continuous emotions. It does not make sense for an artist to imitate his own work and become a craftsman of established configurations. Revolutionary artists are in close contact with themselves and the alternatives available at a point in history. Newness is not the striving for sensational contents but the manifestation of an individual between the visible and the invisible world.

We live at the beginning of a period in which no collective tendency governs the panorama of aesthetic events. What remains are single cells floating in front of us as possibilities, like monads without windows. The neo-modern artist cannot find certainty in aesthetics. The last certainty is monetary value on the open market. There is a sense of a temporary impasse in art history and a new freedom for philosophy seeking universal truth and claiming legal rights to order the often monstrous turbulence in the area of art.

It does not make sense to follow the traditional notion of a painter having no conscious involvement in the evolution of his style and, therefore, no involvement in the progress of aesthetic events. Also one cannot claim that a painter continuously needs to go through a new consideration of parameters to decide which steps proved successful in his oeuvre. Whatever the position of an artist between rationality and sheer naivety, the indeterminacy of his situation, life itself, must influence him in all elements of existence. Continuity of style reveals the attitude of an artist and

sharpens the senses for emotions out of which he lives. Aesthetic propositions develop from intuition about what is necessary for art. Resting underneath an apple tree and seeing the various lines of branches against a blue sky led Pollock to the intuition of beauty in evenly distributed lines over a surface. Liking and disliking are subjective elements. The consonance between the state of the painting and the condition of the beholder accounts for an experience that may stay with us for the rest of our lives or may be gone tomorrow.

...

In closing, I would like to remark that the search for a definition and a common denominator within the multiplicity of contemporary art is the result of an aesthetic turbulence at the beginning of the 20th century, when Abstraction and Realism were torn apart and the door opened for much material, from the hardest to the simply two-dimensional.[54] A chair and an abstract line can appear as equal partners. An abstract line or a non-representational element is attached to the surface of a painting like a physical object. Initially separate media such as painting, sculpture, and philosophy have united in an all-encompassing creativity.

I do not know why critics speak of crises and art historians lament the absence of a collective style, when the development of art from the Renaissance until the beginning of the 20th century shows that the visual arts moved systematically and with apparent logic toward the side of Abstraction which had first put itself beside depicted subject matter and finally became the main content. At the same time, when Abstraction became autonomous, Realism, liberated from the manipulations of form and began its own life without the dictate of stylistic discipline or the burden of narration. As such, a part of art has moved away from the traditional sphere of art and became hard reality.

Duchamp is often praised of having performed the miracle of ordering profane objects into the sphere of art through the "transfiguration of the commonplace."[5] The separation of hard Realism with its profane objects effected traditional illusionism, which had already come into disrepute at the end of 19th century and now suffocates in the objet trouvé, without metamorphosing into an artistic product. A real object can be borrowed from reality for philosophical aspirations. While nothing can be seen that would satisfy aspirations of good form, composition, invention, newness, subtlety or the unreachable, while there is nothing that would inspire emotions, one sees what the philosophical will evoke. Schopenhauer speaks of the glory of a nameless thing. Philosophy has conquered a segment of art and refuses to let go.

Art could no longer remain in its illusionistic and metaphysically precarious position. Illusion was attracted by the magnet of reality. The found object is the final stage of mimetic possibilities. Once the final stage of displaying found objects is reached, the pendulum of art can swing in the other direction and include a variety of forms in various configurations.

Today, we see a Realism which, similar to traditional Surrealism, can transcend the logical functioning of the world and penetrate into realms of imagination, where forms and formal organizations co-opt with visionary imagination. When a sculptor builds a tower on a boat to provide the pigeons of Venice a permanent home, he creates a virtual reality, a super-reality outside the limitations of rationality, without, however, excluding it. Photography and photo-collage are ideal tools for new Realism. Neomodern art moves in the abstract as well as in the real, unencumbered by tradition or logic. It uses the entire arsenal of pictorial means for unexpected constellations. It is not a phantom of unfulfilled dreams but the world as a stage for the fantastic, the metaphysical liberated from the coordinates of linear history. We can no longer speak of destruction of established values. Now it is

freedom for the imagination of a magician. While painters and sculptors of the past earned their bread with pigments and stone, conceptual artists derided the act of painting as a falsification of the spiritual and abandoned the act of plastic creation. By comparison, neo-modern artists have returned from solipsistic ideas to the reality of producing aesthetic objects because, as Hegel expressed, the idea has to proceed to reality and find true subjectivity only in concreteness.[6] Conceptual Art, as practiced in the last decades of the 20th century, already belongs to an obsolete Modernism.

While painting and sculpture up until the end of the 19th century functioned on a more or less similar height of abstraction, one could speak of a collective style equivalent to Wölfflin's *zeitgeist* with categories of viewing a work (a distinction between Baroque and Renaissance art is a distinction between open and closed form), today's *zeitgeist* does not contain a specific way of seeing or specific expectations of how works of art should look. We are satisfied with what appears in the topography of artistic landscapes. We expect surprises, we are prepared for anything, yet have no idea where and when it will occur, and have no expectation of the type of painting expected from Old Masters. While seeking the new, we encounter it with indifference. From the point of view of the classical avant-garde one might speak of an illness of art, which cannot be cured even with the boldest experiments because art has lost the firm ground under its feet. Kandinsky already warned of a loss of the floor of art. The floor of art is an agreement amongst similar spirits which give a stamp to the progress of art and display themselves like commissioners of a political party. They are dressed in black overcoats, wear black hats, smoke cigarettes, and make careful gestures like secret agents of a foreign country. I am speaking of the Italian Futurists Russolo, Carra, Marinetti, Boccioni, and Severini, who visited Paris in 1912. They are depicted in the book *Art after Modernism* by Hans

Belting[8] as artists dressed in garments of bourgeois society against which they declared war. I cannot imagine such an assembly of talent today, because there is no common ground in the area of Abstraction, nor in the social or political intentions of a narrative Realism, which would make it worthwhile to walk honorably in unison. We do not see each other because we cherish individuality. Andre Breton declared love to be the ultimate goal of art. It is difficult to find what we love. We find it alone.

Art historians and critics try to be shepherds of aesthetic quality. Many reserve room for sensational events in an ontologically questionable position. The demarcations between painting and theater are brought to the public with orgies of blood, paint, and the mystery of the body. Nobody can escape the aura of the sensational even if it provokes our patience through disappointment.

The lack of a common style in neo-modern art has enormous advantages in being liberated from the expectations and duties via an existing style. Now, each work can create its own laws, become concrete in formal manifestations, reveal spiritual attitude and is definable only by individuality.

Here I come to the facit of my rhetoric: While it is tempting to imagine the existence of a definition of art, which, in the grail of philosophy, expects a hero to deliver the exact knowledge and scientific method to measure the speed of light and the temperature of boiling water, we must admit that there are conditions in the world, which outside language or rational thinking cannot be grasped and can exist only in empirical immediacy, full of gestures.

1 Morris Weitz, "The Role of Theory in Aesthetics" in Holley Gene Duffield, *Problems in Criticism of the Arts*, San Francisco 1968

2 Ludwig Wittgenstein, *Philosophical Investigations*, Oxford 1953

3 George Dickie, *Aesthetics*, Indianapolis 1971

4 Wassily Kandinsky, "Über die Formfrage" in K. Lankheit (ed.), *Der Blaue Reiter,* Munich 1965, p. 143

5 Arthur Danto, *The Transfiguration of the Commonplace*, Cambridge 1981

6 Georg Wilhelm Friedrich Hegel, *Ästhetik*, Berlin / Weimar 1984, p. 146

Report

Statement delivered at the "Kafka Conference",
celebrating the 100th birthday of Franz Kafka at the
Cooper Union School of Art, New York City, 1983

While roaming toward this Kafka Conference at Cooper Union, from Tribeca over Canal Street and Broadway to Third Avenue, it felt like going to a wooden confessional. I was supposed to give a statement in the large auditorium. From time to time I stopped, thinking I should turn around, but when I came to the area near Houston and Third, buildings started to speak, everything appeared so familiar and I had no choice but to continue. I felt like a lost dog searching for a home, but now I find myself in front of this illustrious audience.

I am not a well-bred dog but a sort of mutt, a mongrel, a bastard or whatever funny names there are for someone who is the product of many cultures, and I hope of many desires, devotions, and fantasies. I never managed to remain in the same place for a long period of time, I was never able to sweat it out, as they say, but moved around. I have seen many paintings, listened to music, studied some rooms of philosophy, created ideals for myself so there is something to look forward in life. I never had much use for aesthetics, even though I was interested in Wittgenstein's dog and the reason he wags his tail in front of his master. After all, aesthetics has been reduced to a branch of psychology which investigates why and when we wag in front of masters. Do we need philosophy with its search for constant and unitary laws to judge

aesthetic progress? Who knows. There is continuous change in the world. You cannot predict when a canine sample is chosen by the president to influence the course of history. Critical language of the past was convincing, choosing one example over another. Today an aesthetic fever or philosophical hysteria is created around something not worth mentioning at all. Of course, to titillate the mind of philosophers is not my business. My disagreements with humankind, however, often make me unhappy. I realize I am a stray with difficulties making friends. May be I feel most comfortable with tired construction workers who don't talk about art when they gather in a little bar in downtown Manhattan for a drink and share chicken wings in the late afternoon.

Without knowing what it means, I think of myself as a spiritual dog. No greater insult has been dealt than assertions that we are nothing but biological machines. Machines, they say, without soul because there is no self-manifestation, no spirit coming back to itself, no distance from itself, only involved in instincts, drives, urges, and other impediments to inner freedom. Spirit is said to exist only if it is like smoke from a chimney coming back into the stove. Supposedly, only in self-reflection can humankind obtain freedom from physical limitation, from anything real, thinking that there is something to be obtained out there beyond the self as if there is something outside the self. What a terrible predicament that human nature must continuously self-reflect to obtain freedom. Dog life is said to have no freedom because dog thinking is supposed to be bound to the inherited limitations of its species beyond which there is no escape. By contrast, humankind has concepts of language, thought to bring relief from boredom, from emptiness of mind and provide access to the innermost recesses of the soul.

It is not my intention to make fun of great philosophers, but one thing must be said: art is not a discipline of the humanities. What is human about creatures which create objects representing

nothing but the object itself, comparable to the world's original creation?

With this kind of thinking we are unacceptable to regular minds. Art is our passion, our only possession. We don't strain our intelligence by the application of concepts to the general disorder of reality, but we transform impermanent appearances into a work that embodies stable and universal meanings. Beauty is our business. Beauty is the final stage of the spiritual. Every great work contains mystical and metaphysical properties and provides a more than adequate substitute for often vulgar reality. Our thoughts are not limited to concepts or definitions. Thoughts are like pigeons sitting on different branches of consciousness. You must agree that we are spiritual even if we don't utter a single word. After all, painting is the art of silence. We have little to say. We show. And because others have problems understanding our language without words, we have difficulties being rewarded. Many dogs, craftier than me, know how to take care of themselves by choosing a dealer who is happy to show off his dogs' tricks and call them his stable. Whether he really loves it is another question. At least he knows that they will perform according to agreed principles. The closer to trick fashion the greater the success. If you do something different, you are viewed to be of a lower breed. They say you have no sense of history, no respect for aesthetic regulations, not enough wisdom to be part of the present; you live only in dreams about being loved. I suppose you must belong to the canine race to understand the full scope of this situation. It is difficult indeed. I always assumed that paintings are created for the purpose of evoking and revealing emotions. Perhaps I am wrong or perhaps there are many more assumptions about the purpose of art. Whatever the case, I never understood those who reduce artistic adventure to formal manipulations, pursue calculated sensuality or indulge in a taste limited to a small segment of history. From painting, I expect continuously changing vistas of

phenomena and emotional states. I always pitied dogs that received training at police academies or perform in a circus where they are bound to do the same thing every day. Particularly terrible it must be to work in the circus of art, because actions there are geared to the minds of men and what they thought or did in the past. Circus dogs dance the same routines until they are dead. They certainly succeed in attaching a visual label to their name which identifies them from a hundred yards, but they got stuck in a formal mechanism that often misses transcendence and emotive content. New forms cannot be created with conscious intentions or an aesthetic will that surpasses canine nature. Newness derives from the morality of an inner truth taking the unpredictability of existence into consideration. The best ones are least predictable. They invent what is necessary at the time and create miracles nobody is able to fathom. Painting is a moral enterprise. I have not received the kind of training which other more scholarly individuals have received, yet I cannot complain that my lack of scholarship has done me any harm. My independence from schools of thought, political parties, trends, and clubs made it possible for me to devote my life to the pursuit and investigation of my inner being. We have to work on ourselves because only through inner formation is meaning in outer concretization possible.

Sometimes I walk down 14th street from the East side to the West, passing shops and galleries in Soho, and I don't encounter a single dog. Of course, I am always on the lookout, knowing they are out there, and when I see one, even from across the street, my enthusiasm is boundless. Similarly, when someone rings the bell of my house, I am in total ecstasy. I run up and down the stairs, can't find my keys, do some barking and make it clear that there is a dog in the house. Most of the time, however, we encounter creatures that do not reply to our enthusiasm. It takes discursive thinking and contemplation to attune to our work. Contemplation

orders an array of sensuous stimuli into uninterrupted intuition. Not everyone will understand what I am talking about, certainly not the ones who continuously search for meaning outside aesthetic characteristics. They like the picture of Napoleon invading Russia or get secret service information about the importance of certain forms at certain moments in history. I wish I could be inside and outside at the same time, but as matters are now, I don't know whether I am in the world or whether the world is in me. Dogs led on a leash in a group with others are unfortunate creatures, the bigger ones as ridiculous as the little ones. Both are caricatures of their kind. The only thing that impresses me is the movement of bodies towing in the same direction down the street of history, all tightly held together by this linear progression of leashes and ideas that prevent them from walking too much to the right or too much to the left. We independents display great joy when encountering one another, but after some fast ceremonies we go on. There is no sense pursuing something together because the only thing that binds us is freedom of creation. While we acknowledge that the judgment of our actions is not aloof to the big bone called art—conquered only by the united crunching of all dogs—we are not bound to contributions at a particular time because the succession of ideas is separate from the representation of succession.

The disposition of time in our time makes it worthwhile to address eternity. Of course, we strive to make our time the most advanced on the clock. We chew in an area where no dog has chewed before. We like to have style, and consuming it is our pleasure. We don't hunt after things we want—a prerogative of the undeveloped—we get what we need. However, society likes to award those who give what is expected: works that operate on the premise or the variation of an older theme. Why should we pursue what is known? Uniqueness is expressed in the uniqueness of style, the singularity of emotion. All great names in the history of art have

separated themselves on the basis of innovations that opened new avenues of consciousness. The greatest masters had the greatest insight into art because their innovations are not a deliberate rebellion or a superficial reaction to the works of other artists but derive from a careful analysis of the premises on which art as a whole is based. Their work justifies the whole enterprise of art.

It is not necessary to speculate what art is or whether it can be defined or how it is evaluated. The phenomenon shows everything at the first instance of encounter. Since emotions in art operate out of real life, the masters must have had a great insight into life for it is life that contains the inspirational emotions condensed into a single uninterrupted stream of consciousness. The feelings with which we sense the world are rediscovered in art. We look at paintings to look at painters.

Stray dogs transfer loyalty from intellectual convictions to innermost feelings. They become one with the total picture. Being one with a painting is the same as being one with nature. We have a sense of awe and wonder through the visible situation in front of us. It penetrates with such a clearness of feeling that all elements lose their names and become subordinates to intuition about the whole situation. Great art declares nothing, it has absorbed everything. We operate with an empty but luminous mind. That's why humankind doubts our intellectual ability, denounces our philosophy as worthless, quotes science as having no use for our utterances, that dog psychology is possible only by including the owner, equally regarding the human and the inhuman when, after a period of time, dog and master take on a similar look and develop a similar character. It is true that we don't contribute much to the basket of analytical knowledge, but we demonstrate that it is possible to get around in the world by doing nothing but crunching hard bones in the relentless pursuit of fine marrow.

Dog

Spontaneous lecture for artists and writers at
Seggau Castle in Lower Styria, July 1994

Ladies and gentlemen,
I have heard that two days ago, sometime after midnight, several painters and writers assembled in this pristine room to engage in intellectual exercises, which in our circle come into full swing only after closing hours, to find out what animal I might be. I hope that your investigation was conducted with scientific diligence and that no detail of my outer appearance or inner condition was overlooked. I assume you proceeded with discipline and empirical exactness and you found a solution to this problem. Now I am no longer astonished that, in this night of scientific inquiry, you woke me several times from my sleep by the loud ringing of an antiquated telephone in the bishop's chamber you had kindly reserved for me, and asked for details of my appearance as if you had forgotten. Intimate questions were put to me, whether I walk on two or four legs, whether the hair on my body is short or long, whether wings grow from my shoulders, how long my fingers are, flat, rounded or tapered, whether my color can change, whether I am able to focus my eyes left and right simultaneously, whether I am warm blooded or cold. I noticed that more than once you were interested in a part of my body; embarrassedly you called it a "Rüssel," [lit. trunk] sometimes you said "Ringel," whether it is bushy flowing down in the back, whether it is smooth, big or

small, whether I can hang down with it from the branch of a tree while eating, and, altogether, what I do with it. I remember to have answered questions with a single word: "enormous."

I must confess that your inquiry didn't disturb me; after all, it is an inborn desire of mankind to be compared with animals. Yet the new method of your science makes me wonder. Your connection to me as guinea pig was not solely over the telephone, but you made your thoughts float around in my room, the bishop's room, until I awoke from sleep and lent you an ear without cutting it. In this hour of examination I was grateful you appreciated my participation without asking for higher sacrifices or the last abandon.

Ladies and gentlemen, I am sure your efforts paid off. You will not lose the agility of thinking for the rest of your life. You will be able to decide what animals you want to be with, because if you join the wrong pack you will be eaten alive. Mr. Kafka will endorse such statements in writing.

Before I come to the reason of my account, however, I must express astonishment at not having received any signals about the outcome of your investigation. Maybe, in the process of computing statistical significance you concluded that intellectual strain leads to nothing else than what you have known all along: I am a dog.

Already at birth it was quite evident that my feet didn't resemble anything human but that they obeyed the excellent canine line that bends the hind legs of females slightly inward, a feature most appreciated by male companions of our species. When I was three years old, my father decided I should not grow up like Lautrec. Bones were broken in several places and feet straightened according to Western ideology. Imprisoned by plaster casts and leather contraptions for many months I suffered initially from not being able to roam around with other dogs, but it created a psychological mechanism in me for the rest of my life, that would not have happened under different circumstances. I developed an extraordinary desire for new places, moving from place to place in

my imagination, in ever new areas of art. My eyes became the center of inner mobility.

Even though we dogs are born with an excellent sense of smell, so the finest changes in the environment can't escape us, my eyesight became the sharpest sense in my body. Therefore, there is no need for me to chew the materials of the world from the outside to the inside; I observe them from a distance.

Beside the visual sense we are endowed with a seventh sense. In certain dogs this sense is very developed and humans can't believe when a dog looks into the future anticipating the arrival of a stranger half an hour before he appears. Yes, they call us sharp dogs. For us, there is no difference between visible and invisible forces.

Immobility in plaster casts promoted my talent to interpret lights and shadows on the wall of my room as phantastical events and receive them as celestial visitors. Today I can stay at my place perfectly still, yet alert, like a dog before an imminent event, more alert than anything you have read in newspapers about auditive or visual vigilance. To be alert is our highest principle, an inborn virtue, our innermost Being. At that time I already knew that I would not live on bones people thoughtlessly toss to the dogs, but that I would live on images which invited themselves for gambling games into the hotel of my brain.

I was born at a time in history when the human race suffered from a disease located in the center of intelligence. World War II was raging. Scientists know that dogs are much superior to people when it comes to conflicts. It is true that dogs don't kill each other over bones or territory. Life is supposed to be beautiful, serious conflicts must be avoided and respect for the neighbor is expected. It was observed that even in disputes over a female, the most serious matter in canine life, a dog shows so much love for his companion that he will give her up to a stronger dog without fighting. He hopes she will be well taken care of.

As a young dog I spent many months in a damp air raid shelter underground, while the city was in the process of disappearing. Beethoven's *Eroica* on the radio warned the population about impending air attacks from planes crossing the border into Austria. With blankets tucked under our arms, we ran to the shelter. One night I lost my right shoe and my mother's hand, who disappeared in the dark when dragged by the pushing crowd into the closing doors of the bunker. All of a sudden I found myself sitting alone— I was five—in the middle of a pitch dark street. Gradually, the ominous roar of approaching aircraft, there were four, increased to a deafening noise in the black sky of the night. Spotlights illuminated the deserted city, bombs started falling, erupting into a glowing inferno of flames, explosions, and shrapnel whizzing through the air. What remained in my memory, as if it had been yesterday, are the Christmas trees covered with long aluminum strips to distract the radar of anti-aircraft guns on the ground, bombs falling down in an enormous fire from the sky, the planet had turned into a devilish purgatory. Even today, I still ask myself how it is possible for mankind to live simultaneously on earth, hell, and in heaven. By contrast, our canine race survives on an ancient law: when there is turmoil, stay put on your place. I slowly walked along walls, very tightly, touching them as if holding on, in the direction of my house. Shrapnel, the size of a fist, danced on the ground in my direction, I clearly saw it coming, zipping past my left ear. I always tried to give it a name but could not think of one.

But now I come to the significance of your correlations. Until I was 17, I was a stutterer. No sentence could be expressed without kinking up my mouth in the middle of a word, heaving a short sigh as if I had had my mistress's stocking in my mouth, with visible empathy from listening persons. Teachers hated me, I hated them in return. One day, on a beautiful Sunday morning, Demosthenes, the greatest orator of ancient Greece, visited. He had cured his disease of stuttering, he said, with a simple method: standing

on a cliff, he screamed philosophical sentences out into the ocean and into the clouds. What today is known as "philosophical screaming" or "scream-philosophy", documented in text books as the peak of a slowly intensifying malaise, can be brought to a final end by a philosophical eruption in the mouth. It is unfortunate when the disease doesn't show any symptoms, as is the case with many people, when it doesn't make itself felt for many years and cannot be caught in time by the Demosthenes method. In its final state, the disease of stuttering will infiltrate the brain and take hold of the whole world with stuttering ideas. At the present state of technology one would assume that, in the area of speech pathology, the professors in the basement of the university will not operate with antiquated methods and later confess that the illness shows no improvement in a two week stutter-therapy, that the helpless sigh in the middle of a word actually gets worse and sometimes even duplicates in patients, and that better results are expected only by an extended therapy that might take years.

As far as I am concerned it didn't take miracles to test the therapeutic claims of Demostenes' method. I screamed sentences and short paragraphs from Kant's "Critique of Judgment" from Mount Cavalry into the Mur valley. Already, after a few sessions, I was permanently cured. I hope you will communicate this secret, which in the dog world is by far nothing new, to the nearest place for medical emergencies. It is our duty to care for the well-being of mankind in the area of medicine as well.

I despise house animals that blindly subjugate themselves to a master because they live in a big house, I hate small vicious dogs that accomplish nothing with their ridiculous high-pitched yelping, I deplore circus dogs who dance the same forms until they are dead. I wonder about those who sneak around and eat the food of other dogs. I didn't attend the police academy, have no knowledge of special tricks, don't belong to a party, either aesthetic or philosophical. Obviously my enterprise is grounded on itself.

Sometimes, when walking through New York's Soho, and its small shops and galleries, I don't encounter a single dog. Of course, I am always on the lookout for one, I know that they are out there, but you cannot say when you will meet one. When somebody rings the bell to my studio, I am completely out of myself. I run up and down the stairs, cannot find the keys, can hardly control myself. Our ecstasy is boundless, ecstasy is our business, but most of the time we deal with somebody who doesn't understand our enthusiasm. This makes us sad and we retreat to the fireplace. I wish I could simultaneously be inside and outside but how it is I don't know whether the world is in me or whether I am in the world. To know nothing but to suspect everything is our inquisitive nature.

Dogs that pull with other dogs on the same leash are unhappy creatures, the bigger ones as ridiculous as the small ones, caricatures of their species. It is impressive how the movement of bodies in the same direction holds the whole pack together in the middle of an intersection, all of them could be run over. We independents show great joy when meeting another dog but after a short ceremony we let go. It doesn't make sense to go together. What unites us is destiny, freedom for movement, testimony of feelings, fulfillment of wishes, and the realization of dreams. We are sophisticated individuals, that's why mankind takes care of us.

I deplore animals that live in the same room and follow a boring occupation day by day. Compared to such a dog life my radius is here and there. In this country, the expression "you dog" and "you're a dog" are known. No dog expects continuous praise, but praise from one's master is the greatest reward. It is true that people are afraid of us. They observe how we behave. After all, we have an enormous urge to catch what runs away.

Sometimes it is asserted that we have no talent for intellect, no capacity for logical conclusions, that science doesn't know what to do with our philosophy, that the disposition of our character makes it impossible to develop a concept of time because we don't

know how long the master has been away. It is said that we are on a low level of development because we still distinguish between experiences and their coming into being, that we never eat from the same dish and always try to be first. I must admit that such doctrines don't miss the direction but that they are totally wrong when it comes to detail. I wish they could be legally pursued, but as it is, we have no choice than to show that we don't push between the legs of people to catch the action. What unites us is knowledge of the dog world, the strict compliance of unwritten laws.

In ancient times, the first barking of a lonely dog caused the eternal chain of barking dogs to which they cling invisibly today. No other animal is called crazy. But if you look closer you must admit that we have contributed a lot of knowledge to mankind, naturally nothing to the basket of analytical thinking, nothing solid and nothing rational, only an intimation of what we actually want. We demonstrate our art of going without hesitation from the hard bone to the fine nerve without loss of time. That's why one speaks of the fine arts. This is, I think, a great contribution to the rest of the population. In the long history of our existence we show affection for people; they take us as we are.

One cannot decide where barking has the greatest effect because people used to house animals have great pain when hearing the barking of a strange dog. Kafka's encyclopedia of dogs is very precise on this point; it meets with Mann's theory that a psychology of the dog is only possible if you include the dog owner, because one needs to consider the human and the not-human simultaneously, and only in this synthesis is an ontological verdict reliable. Owner and dog, already after a short period of togetherness, take on not only the same outer characteristics but the inner condition of character. That's why it is meaningless to determine whether our work has any value, because the final decision is made by dog owners who have a high opinion of themselves and the dogs they represent. There is no justice.

To catch a stray dog is difficult and even more difficult to sell it on the open market. You need a particular eye to recognize who has left the rules without violating the rule. Since you cannot decide on this matter by looking at the eyes or judging the outer appearance, one needs instinct to realize that we are good dogs who don't harm neighbors. The semantic meaning of this sentence is rather important. It shows that we have talent for no-conflict, for things without a name, for the sublime, for what we see without perceiving, for something that is present without presence. That's why an ownerless dog is alone in the world and needs greater development than animals for which the master has planned ahead.

Initially there was talk about erecting a monument for the stray dog. However, the dog with the best orthography, his middle name was Maria, answered the municipal office in a certified letter that one should not build a monument for the stray dog but should only allow the rose to grow in his favor.

We prefer the company of Gods. Pliny already reported that Pluto saved the life of Zeus and that, since then, he enjoys the privilege of lying down on clouds. When there is a thunder storm you can hear him growl.

Encounter with Rockstone

Cambridge, 1976

Even though the following notes were written shortly after a long night, in the morning of May 28, 1972, in the airplane from Arizin to Boston, they must be viewed only as a meager reconstruction of a nightly conversation I had had with Rockstone, while sitting in a four-meter deep pit in the desert of Nevada. Less because of physical exhaustion than of the overwhelming visual impressions of the past day, I could concentrate only with the utmost effort on few ideas in my notations. More importance and authenticity must be attributed to the sketches (figs. p. 162–163) I made of Rockstone's sculptures, sketches I produced on the evening of May 27 in my Arizin hotel room after having spent most of the day with his works in the desert.

Rockstone, thirty years ago the most prominent American artist—today, I know, he operates under the name of Rothko, Still, and Bloomfield—retreated 14 years ago to the abandoned coal mining tower in Arizin on the edge of the Nevada desert—refusing to display his work in public any further. I got involved in this matter rather involuntarily through the architect Johannson who left an initially burdensome collection of twenty-six pictures to me, which amazingly contained eighteen works by a painter, Still, from the 1930s, works I had to trace by cumbersome correspondence with hundreds of people all over America,

until I discovered that they actually had to be ascribed to the artist Rockstone.

All of us are threatened by non-existence, Rockstone said, threatened is our physical and spiritual existence. We must manifest our being by giving a direction to life, participating in spiritual disciplines and loving the contents we create. One precondition is, Rockstone said, that you take spiritual life seriously; yes, that it is a matter requiring ultimate effort and it becomes reality in works of art and science. If such a concretization is not taking place, our life is threatened by two forms of non-existence, emptiness, and insignificance. Emptiness threatens the particular contents of spiritual life; one day we discover that contents we have labored on with passion for many years have suddenly become stale and meaningless. The loss of belief in a particular direction throws us into manifold possibilities. Disappointed and bored, we dedicate ourselves to another direction for a while, only to discover, that yet another direction promises more success and better chances of realization and, like that, we are thrown from one position to another and our creative participation is always altered into indifference or aversion. We try everything and nothing satisfies. In this situation of gradually increasing anxiety we search for a spiritual center, whereby we discover that a spiritual center cannot be found, particularly if we strain to construct it with rational efforts. Yes, the absence of a spiritual center is responsible for our inability to establish a base which would provide footage and challenge progress.

After my arrival in Arizin, Rockstone said, I was unable to do anything but lie on the bed for days, full with anxiety about familiar objects surrounding me, a bed, a chair, an ashtray, everything reflecting the impossibility to recognize another meaning in these wasted objects other than my own wasted existence in the world, and, at that time, Rockstone said, I imagined a series of paintings which stood so clearly in front of me that any at-

tempt to create them would certainly have filled me with nausea, because I knew that, at the first attempt of concretization, I would already be impelled to improve on everything and throw myself in a new direction, while the new phenomenon was still in the process of being created. The doubt and the anxiety about my paintings could only persist as long as I were alienated from my work, as long as I participated in the systematic interrogation which is the result of nonsensical thinking about general cultural conditions. Earlier in life I had already attempted to escape from this systematic doubt—a condition of spiritual life—even though I experienced, day by day, that it is impossible to escape from it; I exhibited certain series of works under different names, which promised, I thought, freedom from the access of general doubt.

At one point, I spent two years painting my own picture collection in a house I had acquired on Long Island, a two-hundred year old house with enormous white rooms and large windows in which the ocean stood, and further north the haze of Manhattan. In this house, I mounted a series of paintings on the walls in varying sizes and styles which never existed before. With each painting I transported a complete and final artistic event into the world, but as I said, Rockstone said, it would have been impossible to dedicate my life to one of these ideas and produce, like other painters, a number of works following the same idea. When all walls were taken up by paintings, I continued my path, my roaming around the cities of America. I discovered my works under different names in often famous collections, sometimes in the display cases of bookstores on the back walls near geographical maps with antiquated lettering and reproductions of my paintings, and then, in such moments of encounter I was gripped by physical anxiety, because, despite my obvious talent to produce pictures, I have been unable to give my life a direction, which, as a spiritual possession and center, would have protected me from the methodical doubt concerning details of my

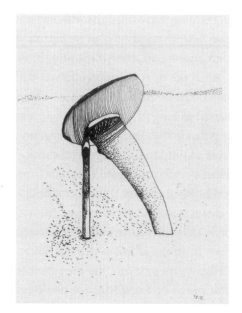

Rockstone, pen-and-ink, 11 x 8.7 in., 1972

Rockstone, pen-and-ink, 11 x 8.7 in., 1972

Rockstone, pen-and-ink, 21.6 x 17 in., 1972

enterprise. Altogether, I was unable to figure out, who or what I was. I couldn't discover a tradition in my paintings even though I sometimes surrendered to autonomous convictions, sensuous predilections and temporary affections. Our insecurity is the result of an alienation from the totality of the world, our lack of universal participation, our isolation. Of course, I was always convinced about my cause, I defended my paintings against enemies, wrote letters to dissidents, lectured at universities, argued with philosophers occupied with rational conceptions of history, critics who comprehend art only in the context of artistic traditions, who suppress originality, who arbitrarily inflate the importance of an artist for the ambition of the public, create a historical situation, destroy him by integrating his singularity into the taste of time, and swallow him in the art as idea context and the submission of aesthetic intentions to parents within a historical space. While it belongs to the nature of art that its ideas and products are measured on pre-existing values, we must ask how far a functional concept can extend without resistance, since something is right and true in one situation and totally wrong in another, and in addition, how logical should the history of art be, when the individual products are not logical at all? There is an obvious discrepancy between art as a general discipline and the particularity of its products because cause and effect are separated when the human situation is trivialized or not implicated.

The opposite is the concept that sensuous content determines the value of a painting. They almost beat me to death in the Sloan Museum when I walked in one day and continued working on one of my paintings which had been hanging there for two years. A museum's guard hit me on the head with a broom, Rockstone said, while I quickly produced a tube of van Dyck brown and a little bottle of turpentine I usually carry with me, controlling the quantity of paint with a soft cloth while the blows landed on my head, Rockstone said, I darkened an area of

"Substance 96" I had painted in '47 and the visitors of the museum just stood around the scene without interfering, as nobody reacts when somebody robs a store on the street, because everything is just theater, the dying, the suffering and then, Rockstone said, I was imprisoned because the museum director was of the opinion that I had raped the painting. I wrote him a note that there is no continuity between a painting as a sensuous phenomenon and its meaning within a cultural tradition, but more factors must be taken into account than those which are phenomenologically present, and even if the painting appears complete and finished in regard to beauty and so forth, it can still be missing those special characteristics which, deep in our substance, continue throughout life and that the painter is the only one to decide when and if a visual manifestation of inner subjective formation has taken place and at what point a work is ultimately finished. Leonardo is said to have considered all his works unfinished, and from Bonnard we know that he continued on his pictures long after they had found their place on the walls of public collections. So he argued, Rockstone said, until they let him out of the prison cell with its 32 house rats he had counted at night, in the hours he was unable to work because in the evening the guards with a towel around their hands removed the light bulbs, so prisoners were unable to cut their wrists at night; yes, I heard rats at night and small children riding on them into the chimneys, he could hear them very clearly when pressing his ear against the wall. And when he was freed, he had enough of this ridiculous society of mankind, Rockstone said, so he fled to Arizin and settled in the tower here.

As you know, the tower has two rooms, the spacious living area provides a great view of the desert which, from the very beginning, supplied pictures of imagination which were particularly intense at the crack of dawn, when the desert and its flat extension melts into a grey-pink with the rising sky. Pictures of

imagination are no different from reality. Of course, at the outset of my nightly observations from the tower, I couldn't believe seeing ants which, at a certain hour, approach the man high cactus plants, not to say that this is something strange or unusual, but exceptional is only the size of the ants in this region. I saw ants the size of a butcher's dog, hundreds, maybe thousands I observed as they gathered around cactus plants slurping the milk from soft leaves. While this is not documented in a book of natural history, it still belongs to the marvelous history of nature. People in Arizin speak about a farmer who mounts these tame but somewhat lazy animals in front of his wagon when, on Thursdays, he delivers silver ore to the railroad station. Only after I convinced myself about the existence of these mammals was I able to concentrate on other things I encountered in my nightly observations of the Nevada desert; yes, Rockstone said, today I almost feel like my friend, the poet T. Williams, who can do completely without sleep when spending the nightly hours relaxing his motionless body on the terrace while his mind delves into wonderful spaces of imagination, pictures of the world in front of him, experienced or still being created, the degree of participation under control one creates with an ice-cold heat; yes, it was only at that point that 3D forms started to invade my imagination, as in dreams you don't think of flat planes but volumes around which you move.

In earlier years, the art of sculpture appeared to me more like a peripheral means of expression, partly because of its imposing materiality, partly because of the vague definition of its essence. At that time I told myself that it is the tension between empty spaces in a sculpture, and from Minneapolis circus I borrowed the stateliest elephant for a three week exhibition at the Jackson Gallery on 52nd street in New York. It could hardly move, the lovely elephant, because it fully occupied the room in which it stood. The mild curve of its noble back almost touched

the ceiling and one could more imagine than actually see the world of created forms. The inspection of the exhibition proceeded like this: as visitors entered the first room of the gallery, located on the 18th floor, an automatic elevator door closed behind them. There was no more going back but only a forward into the cleavage between the elephant's hind legs. Crawling or bending, the soft grey of the elephant belly close to their faces, visitors scrambled through this moving boat until reaching a door to the next room, all white and empty, into which the trunk of the elephant slowly fumbled through a hole in the wall. There are areas of reality in which utter distance is the most effective method of recognition. Through distance we break our isolation in the world, take possession of visual phenomena, Rockstone said while taking my hand and pointing it to the shadow of the poll, which had developed on the west side of the pit in which we had spent all night.

It has been seven hours now that we are sitting here. Naturally we have not talked too much, it is best just to sit motionless, not thinking of anything and observe with increasing attention the events happening in the surroundings. The pit is seven meters deep, we are on the four meter step, and it is four meters square. The straight walls and altogether the geometry of the construction I could have never had without the efforts of the Arizin landscaping company, but now it is something like art, a neutral space which includes the surrounding events into its realm of aesthetic existence, like the white room and the trunk, the smallest changes in the underground space, a leaf, a stone, the changing light in transitions of the day. Rockstone said we ask for the essence of art which cannot be found anywhere but it is always present. The best works of art are not paintings or sculptures but are positioned somewhere between physical self-presentation and their inborn power for transcendence. It does not make sense to accept demarcations between different media,

get absorbed in the morphological justifications of European art history, a priori hypotheses and assumptions of what is or is not possible in sculpture or painting. We see that all pictures in museums are worthless dead wood, except their value as conceptualized beauty. Van Gogh's palette, exhibited in a glass vitrine in the Louvre, has the same value as his paintings, except our attention goes to the paintings on the wall because they represent aesthetic propositions, different to all other pictures in the room.

It is not a matter of putting paint on canvas, applying it on a stretcher frame and hanging it parallel to the wall, but that we find ways to propel consciousness about art forward, Rockstone said. This must be my task here in Arizin. But these are rather ridiculous remarks in comparison to more important ontological questions which Anaximander and the theogony of Hesiod have lain upon me. Why doesn't the earth disappear when it swims on water? Where are the borders of the earth? And if the earth were a disk, would I fall off its edge? How far would I fall? And would I fall faster holding an anvil to my chest? Where are the outer limits of space? And what is beyond its boundaries? What is beyond the limits of my thinking? Is the sequence of numbers 9 18 27 the building block for the geometrical structure of the universe? Is the universe full or empty? Do I exist inside or outside the world? Can I send my thoughts to distant places and let them act there without me being physically present? Homer sent Odysseus to instruct me in moral thought: in a world full of chaos it is advised to suffer alone in silence and be content with the gifts we received, because the more you desire the less you will get. The positive is always equaled by the negative because the world consists of duality between warm and cold, above and below, good and bad, light and dark, large and small, blue and yellow, red and green, black and white, properties which don't want to exist alone but only in company with their opposite. And that's how it is with love and hate, war and peace. But we don't

want to talk about wars. Nobody will listen in the great cathedrals anyway.

In the beginning I didn't leave the pit even during the day, not only to get used to the concentrated observation of nature, but also, because the physical exertion to remain for a long time underground diminished the usual aesthetic pleasure and brought forth with increasing clarity the spiritual exponentiation and intensity of my work. The pit is certainly one of my best, perhaps the best Arizin work, even though the pieces you saw yesterday in the desert question the essence of art, or at least they challenge traditional sculpture with its tendency toward the monolith and depiction of the human body, a body which, since ancient times, served as a measure for formal inventions, no matter on what level between realism and abstraction the configuration operated. Parts of my pieces are distributed over the desert, sometimes there is hair hanging from them, legs, table legs protrude from the short desert grass; yes, especially because they have nothing to do with Western sculpture their value cannot be captured by Western standards. They are within themselves, autonomous. And while I prevent their getting out into the public, I also prevent their being compared to sculpture or becoming a medium, against which everything that follows must be measured.

At this hour, Rockstone said, the Arizin blue birds assemble punctually at 4 o'clock in the morning at the edge of the desert. Down here in the pit, their screaming is even more present than above in the open country.

December 29

I wish I could recall the meandering of this telephone conversation in its entirety. To describe it at length would be a pleasure, indeed, for there is a promise of gravity and depth. However, what interrupts my recollection is the image of a heavy rainstorm pounding on the tin roof he had constructed over the pit, which fifteen years ago he decided to continue digging for the rest of his life, one day, while turning the dirt in the garden. I scratched the surface, he said, and I couldn't help going deeper. Who would have expected this enormous cavern under my carrots, a creek winding its way through a rocky bed. The vault itself extends into a high Gothic cathedral. I suppose, I had been preparing myself for many years without knowing it, to go deeper and make this discovery and now I ask myself whether I am still alive or whether I have become somebody else in his fur. I cling to these images. They have invented me. I carried the earth in barrels, brought it up to light and now it brings forth flowers. The deeper I dig, the deeper I may fall. But, I am sure, I am only a few months away from the cathedral which has been waiting further inside the cavern from the beginning of time.

And you ask me about painting, he said, it might take me a long time to come up with something. Painting is the art of silence. Can you walk with me over bellowing pastures in the early morning when the earth exhales its fog over shimmering greens? I am a stutterer. Demosthenes stuttered the world. On a cliff he exposed himself to the sight of an ocean, screaming his love to the winds that carried his life back to the Gods. And then they had pity on him and attached his tongue to a pigeon in flight. Nothing can be said, he said. Why do you ask me about realism, the solace of the doubter, the mind unable to find its way into the silence of nothingness? There is only one reality to art, the reality of the work itself which pushes the vehicle of imagination in front of it as if to expect an imminent catastrophe. We praise.

Every painting is a miracle, an accident, perhaps an enormous disaster resulting from an unexpected brainstorm that leaves you helplessly stranded in a state of distraught comfort. The mind cannot get in touch with the eye. They are close together and yet so far apart. Creation flows in all directions and needs heavy equipment. Once you are in contact with yourself, you don't need concepts like realism or abstraction to score your items in art. After all, you are the master of destiny and everything before you is just a lackluster phantom which has little to do with you. Beautiful art is nature, though you are conscious that it is art. Whatever may have occupied my mind when making it, the object has its own life. I suppose, he said, that beauty is the only reality I know. Beauty has lurked in the back of my mind like a praying animal; one day it sprang out of the darkness, sustaining itself without mercy. The production of art cannot be confused with the work of art. The medium of transport is different from the transported. Looking at his work in the desert, I had no desire to know its purpose. The work appeared like nature, the nature of its creator.

There are only a few phrases I remember:

… it is in my blood to be bold … gritty nub of existence … a jumble of pink and green … reality in all its configurations … hovering on the edge of consciousness … warm glow of nostalgia … nuts and bolts of art works … impulses to trap an angel … from art to nature ….

At this point I realized that he had not cured himself of stuttering at all. The illness just dissipated into larger areas of consciousness where certain thoughts, phrases, melodies or images would take hold for a period of time, sit there as if they would never leave, and be overcome only through the continuity of his aesthetic enterprise.

Portland

Manuscript notes for the 1992 Commencement Address
at Maine College of Art, Portland, Maine

This is a time of change. Our energies of the past are our hope for the future or, as T. S. Eliot wrote: "Time present and time past /Are both perhaps present in time future [...]." We take our time into our own hands. The content of time is the content of our work. The content of our work is our time.

May 17, 1992, almost a century behind us, a new millennium in front of us. Where do we come from, where are we going? Perhaps we are a generation of healers for whom the dynamic progress which governed the 20th century in every discipline has lost its meaning. Progress in the 20th century was seen in the success of splitting things apart: splitting ideas into firm ideologies, splitting the atom, isolating organic cells, dividing countries, races, cultures, analyzing the psyche of man in depth, as if the Tower of Babel could reach greater heights through an understanding of its individual building blocks.

Very soon a time will come when all our energies will be absorbed by keeping things together and maintaining what we have, particularly what we have of nature, which has always been the first to be punished in man's periods of analytical materialism, both in the environment and in the arts. Nature is gravity, the gravity of all things. Heavy are the mountains, heavy are the oceans, heavy are the souls.

A momentous split occurred in the visual arts at the beginning of the century when the traditional synthesis between Realism and Abstraction was torn apart. Even though the pendulum may have been swinging at times more toward abstract arrangement or in the other direction toward a narrative subject matter, a synthesis between both constituted the ideal beauty of Western art from the Renaissance to the beginning of this century. While the narrative content shows the outer condition of man, the abstract configuration reveals his inner, emotional state. Both poles are in continuous conflict with one another. The representation of objective reality is responsible for the difficulty to reveal an invisible realm of feelings beyond a visible subject matter. Perception gravitates toward obvious meanings. The beauty of nature was seen in opposition to the invented beauty of form and, traditionally, the conflict could be mitigated only by a synthesis between represented objects and their integration in a formal whole.

Over the centuries since the Renaissance, it became increasingly apparent that art needed to serve another purpose than showing something about the world we can see for ourselves. The 19th century was filled with voices of philosophers polemically directing themselves against narration in the visual arts, demanding that aesthetic content arise from the *self* of an artist rather than from the outer world. Schopenhauer's devastating critique of allegory is a rejection of everything outside the structural properties of a work, because narration distracts from the actual content of perception. Content is provided by contemplation of the physical existence of the work and the particularity of its structural identity.

It became increasingly challenging for artists to consider the actual reality of a painting itself. In fact, the representation of nature was replaced by the presentation of an aesthetic nature when abstract art liberated pictorial means from their tutelage to carry the luggage of association. What became known as the enterprise

of Grand Abstraction was a tremendous promise for the artist who, for the first time in history, could create out of a primary position, like the creator himself.

At the same time, around 1911, when abstract painters set the stage for a physical self-presentation of pictorial means, Realists introduced found objects into the realm of art. They liberated forms of reality from the chains of formal manipulation and showed beauty as it appears unencumbered in the actual world. All of a sudden everything that appeared in nature could be seen as a work of art. Every natural form carries the potential of existing as an expressive element. The whole world has become a work of art. Grand Realism makes mankind see the astonishing beauty of pre-existing things and induces the same respect for the natural world as for man's own creations.

The elimination of representational subject matter made of the artist a prime creator of reality. Opposition to the actual world and compromises with pre-existing forms disappeared. However, such promises of early 20th-century art were rarely fulfilled. Intellectual speculation about the method of artistic production took precedence over expressive content. During the Formalist and Minimalist period in the 1970s in particular, a lot of squares, stripes, and monochrome surfaces emerged, as if these were the only forms to create systems of composition which would guarantee objecthood. Formalist art made it a virtue to keep anything out of the work that was emotional, irrational, personal, psychological or associational, so that nothing but structural constitution would be communicated. The concentration on the phenomenon itself was an attempt to elicit a spiritual content by the co-existence of an empirical phenomenon with its ontological constitution in our mind. Such a purist approach intended to reject all meanings instead of acknowledging that in aesthetic perception a variety of meanings can fuse into a single uninterrupted stream of consciousness which manifests itself as a feeling.

The visual arts are the only arts in which the recognition of a phenomenon manifests itself as an emotion. If this emotion cannot be had, the work is nothing but a billboard of aesthetic ideas or formal ideologies. The black hand of materialism, of which Kandinsky warned, laid itself over much of 20th-century art, particularly in times when art denied itself its confessional and emotional potential.

While the representational artist of the 19th century was said to be a craftsman of mimesis, the Classical Modernist artist was in danger of becoming a craftsman of intellectual propositions. Minimalism minimized formal articulation for the sake of relatively empty, but mysterious and silent objects. Minimalism completed the integration of art objects in the world of ordinary things. No further progress could be envisioned for Abstraction.

I think that here, around 1980, we can see the end of Classical Modernism and the beginning of a new period in art. Aestheticians argued that abstract art had lost its power and that fresh curiosity in aesthetic phenomena could only return through the renewed introduction of representational images. The door opened for Neo-Expressionism which tried to restore painting to look like something crafted by hand and thereby retrieve the personal, the psychological, the intuitive, the irrational, which had been lost by Minimalists whose work looked alike. However, our early impatience with Neo-Expressionism resulted from its difficulty to establish propositions in art which would be different from the structure of Expressionist works of the 1930s. Images were created with speed as if the painter feared it might escape during the act of creation. The value of the new Expressionist figuration must, however, also be understood in the context of and comparison with non-representational art, because now it became a task for abstract artists to re-evaluate the value of works which contained nothing but abstract lines, geometrical elements, and other pictorial devices which would place a painting in the vicinity

of an empty decoration or unfounded results of design. It was time for non-representational art to reconsider its ontological premises and possibilities to introduce a content without depicting it.

Today we live in a most hopeful period. The traditional demarcation between Realism and Abstraction has come to an end. The visual arts have conquered a territory for themselves which not only allows an exploration of the various degrees of abstraction but also an ability to operate with a representational content in abstract art, without getting involved in representation per se. A painting style may emerge in the future which pushes abstraction into that still unexplored territory stretching from the general presentation of abstract form into the creation of a specific, emotionally charged visual environment. Such a style of painting would arise from the pursuit of an essence of the visible world rather than from the description or formal manipulation of its outer appearance.

We may paint, let's say, an apple tree and be concerned only with the specificity of its overlapping lines or branches. Abstraction can move from the general to the particular, and this is very exciting. The freedom of invention of form with a new emotional content is, after all, abstract art's reason for being. Abstract art should be an invention of formlessness which strains imagination to its limits. The meaning of the concept *abstract* will have to change into the particular structural identity of the work, a sublime totality presenting a content without depicting it.Without becoming narrative, abstract painting can present a definite thematic interest. Nature will again become the greatest source of inspiration. It will bring forth forms and formal structures the artist has seen inside himself. The artist will work beside nature, not after nature.

The concept of sublime totality has become the most meaningful way of thinking about an emotion received from a work. The contemplation of art must transcend the rational investiga-

tion of individual forms. Contemplation is the holistic apprehension of an object. Perceptions order themselves into an uninterrupted intuition. Uninterrupted perception is an important concept because, under sublime, we understand a formlessness in which the whole is more than the meaning of individual parts. We do not look at a painting and its various parts, but we look at the artist who expressed his emotions through aesthetic propositions. It is our job to show what we love, not only in terms of the forms on which we labor, but the love for a particular structural identity of the work. No *a priori* compositional principles can be applied to create great art because structure evolves out of inner necessity condensed in a single emotion. Liking or disliking is an instantaneous reaction in the visual arts.

Immanuel Kant, in his visionary analysis of the sublime, pointed out that a sublime experience occurs in front of a nature which is not empty, but full of mountains, crevasses, waterfalls, and skies. A sublime experience occurs when apperception is independent of rational interests and penetrates to the feeling of greatness in front of a phenomenon and its creator.

The central issue of the sublime and our contemporary art is the distance of the visual phenomenon from its function. The desire of the intellect to introduce associations and functions to individual elements comes into being if the structural quality of the work is not strong enough to capture total perception, if it is not precise enough to arouse emotions. Then the painting is a dead object. Many galleries have looked like morgues. The sublime occurs only through the connection and unification of elements transcending associations and intellectual purposiveness.

It is no coincidence that early abstract painting developed out of 19th-century landscape painting, which spread visually structured energy evenly and equally over the picture plane. Impressionism atomized depicted objects into evenly distributed points of light. The Expressionism of van Gogh captured the

Thistle, graphite on paper, 26 x 19 in., 1993

painting with the energy of a brushstroke articulation which pulsated in a singular rhythm of the heart. The Cubist interpretation of reality with small planes and geometrical elements built a transparent landscape of pictorial elements in front of a head or a still life. Such unifications of pictorial elements in formal constellations are the striving for an expression which stands in front of us like an event of nature, like a miracle that can be experienced nowhere else but in these particular works. The unity of pictorial

6/33

Garden, etching on copper, 22.5 x 15 in., 1997
(printed by Rolf Meier, Winterthur)

elements reveals the workings of a single soul. The artist assumes
a hermetic position through his search for an autonomous field
of tension and emotions.

The intellectual entertainment with ideological self-defini-
tions of modern art is a thing of the past. Academicism, continu-
ously on the lookout for new forms without the foundation of new
feelings, must be replaced with a renewed concentration on a con-
tent arising from inner necessity. Today we do not follow political

dogmas or aesthetic ideologies which try to conquer the thoughts of humankind. We have learned that phenomena based on concepts are subject to change. Political and aesthetic ideologies have been replaced by a search for an inner self. Our efforts have little to do with the optimism of earlier art movements, which like young religions had hoped to change the whole world. Our contemporary task is the rejuvenation of a personal morality which sees in an individual the value of the whole world. Our optimism about the future lies inside ourselves. This is an enormous task in a world in which we have to survive, a world which poses continuous opposition and resistance to anything beautiful we want to offer it.

We also do not have a brother in Paris who would send us on a painting vacation to the south of France. We have our own difficulties in front of us and as artists we struggle to be integrated in the practical world. There will be days when you sit in the bathtub thinking that the whole world is moving forward while you are left behind. We have chosen a difficult profession indeed. Our rewards cannot be expected to come from the outside but from the inside. It does not make sense to prepare for a judgment by other men, because everything we give to the world is our gift. We work for a last judgment. Our work comes from an inner truth out of which we live. Our truth is always present. As the poet T. S. Eliot says in "Burnt Norton" in *The Four Quartets*:

> Go, go, go, said the bird: human kind
> Cannot bear very much reality.
> Time past and time future
> What might have been and what has been
> Point to one end, which is always present.

Speed of Light

Rebecca LittleJohn interviewed Paul Rotterdam for
AUSTRIA KULTUR on the occasion of his exhibition at
the Arkansas Arts Center, Little Rock, 1995.

RLJ With respect to the speed of light, how fast do paintings travel?

PZR Painting is the art of the finest feelings. Feelings travel as fast as light itself. At least theoretically it is possible that the entire message of a painting is contained in the emotion evoked at the moment of first encounter.

RLJ You often occupy your space with something that keeps me out of your depth. May I approach you?

PZR The space in my paintings is not the kind you expect in illusionist easel painting. In the 1970s it was mostly a void. In the eighties, when I began to fall in love with certain particular structures or events in nature, the space became perhaps less objective, more celestial, occupied by elements which made of the work a nature all of its own. Often I keep you out by physical elements which act as barriers or guards and I draw you into the space through your increased desire to transcend immediacy.

RLJ I nibble and chew on you as I go. You make stations to precipitate my gulf. Must I interpret your moves or is a rose a rose?

PZR The greatest artists always had the greatest insights into art. An artist cannot hide in the fog of subjectivity and pure emotionalism without knowing the premises on which his art should be built. Not everything is possible at all times. The appreciation of

works of art is not the taking of a sensuous bath in warm stimuli but the complete consummation of an act of looking at the various alternatives the work is presenting in comparison to other alternatives of procedure.

RLJ You trip me up holding space in one hand and depth in another. Is there a bridge across?

PZR The depth of a painting is not identical with its space. I would like to conceive of depth as an emotional gravity or something which leads deep into zones of yet unexplored consciousness.

RLJ The deeper region of a painting will be the center of focus. After everything else is built, in these regions you practice true painting. Is there a method to absolutism?

PZR I am not trying to depict any particular reality in my work. The sublime totality of the work itself is the actual reality of art. I long for the intangible and the mysterious in nature which will find itself in the created object. There you don't see depicted concepts but an emotionally charged visual environment which arose from an inner vision about the essence of the visible world and the new state into which the art of painting needed to be pushed.

RLJ Strip painting of qualities and the proposition dies mortal. Is that the reason you protect exposed areas?

PZR Quality derives from the success of a painting to demonstrate the importance of its propositions. Abstract art should be an invention of formlessness which strains imagination to its limits. The unity of pictorial elements accounts for the work's specific structural identity. It reveals the workings of a single soul and the object in its transparency conveys a spiritual content. It shows the striving of a consciousness into a territory which is its own possession.

RLJ You handle three-dimensionally with the tactics of a traditional landscape painter. Do I need shoes?

PZR Already in the beginning of the 20th century abstract painters became aware that a form that represents nothing outside itself

is strictly speaking a physical, three-dimensional element that affects the ontological status of what a painting can be.

Regardless in what physical form a painting may appear, you will not need shoes but eyes to travel the expanse of possible spaces in art, from the most intimate and direct physical form, over the space of mountains and clouds into the distances of heaven and the remotest corners of hell.

RLJ You wander in the pathos of myth long depicting it.

PZR The night-rainbow, I mean the depiction of the night bow, took ten years of boiling in my head before I was able to paint it. Friedrich had sent me a night bow in the sky after I had given a lecture on his night bow painting. But then there was the "Lost Love" series that broke up and started all over again for the past 15 years. The "Broken Tree" series was an intense mourning over death.

RLJ An animal central to life in the pen of the unicorn dies. Will myth die?

PZR Myth moves like a cloud into the spiritual workings of mankind to provide refreshment from barren logic. The rational, when thirsting for the irrational, produces a truth larger than what can be deducted from the physical world and creates meaning from seemingly unrelated events.

Interview

Carl Aigner and Paul Zwietnig Rotterdam, 2004

CA Mr. Rotterdam, you began your artistic work as a painter in late 1950, early 1960. In retrospect, how do you view the situation in Austria as the fundamental first phase of abstract painting was drawing to an end and Actionism was trying to replace panel painting and as media, conceptual and performance art were coming onto the scene?

PZR What did not fall through the sieve of memory from the early sixties are the impoverished artist figures of elegant Vienna, most of them no older than 20 or 30, forward-looking, however apprehensive of their uncertain future. In the center of town was the Café Hawelka with marble tables, worn Art Nouveau furniture and the indefatigable Herr Theo in a black tailcoat. It was the stomping ground of those striving to give direction to their life, sharpening aesthetic sensibility vis-à-vis the outmoded Realism on the walls of the café. One felt responsible not only for the future of European Art but also for the linear development of the entire century.

Himself a living artwork, Rudolf Schwarzkogler frequented the café in his best tailor-made suit, showing little sympathy for poor painters still toiling over the conventional canvas rectangle. Barbara Frischmuth had just published her first poems. Kulterer held the monopoly over what was published in the only literature magazine of the time and he sold it personally on the street and

in galleries. Arnulf Rainer was also there; he had just begun his overpainting phase, shocking at a time when an artist was expected to exhibit more skill than simply covering the surface of the canvas with mysterious black paint. Speaking, he halted after two or three words as if to veer his thoughts mid-stream, showing amusement at my three-dimensional, abstract forms protruding from the canvas. Werner Hofmann, working on his "Fundamentals of Modern Art," still today having lost nothing of its significance, reigned as the gray eminence of the theoretical clime. Hermann Painitz, a conceptual artist, Helga Phillip, an Op-artist, drove abstract painting to new heights of autonomy. At the other end of the spectrum, at Realism, Happenings took place in New York, Paris, and Vienna, instigating a furor, particularly when the actions of artists like Yves Klein and Georges Mathieu involved a canvas supposed to preserve the traces of their theatrical actions for all of eternity.

As for me, the old habit of articulating through brushstrokes got left behind; I painted neither black spots nor female nudes. It occurred to me that an abstract pictorial element was a physical reality, an emotionally charged form lying there on the canvas, and that it could protrude beyond its rectangular confinement into a third dimension to challenge the limited surface of panel painting, sometimes requiring no more than a stretcher frame with painted wood affixed to it.

Kandinsky and Duchamp represented for me the extreme poles of non-representational painting and hard Realism. The so-called "first phase of abstract painting in Austria" was not actually considered by young painters to be truly abstract art, but rather abstracted images derived from realistic contents of the visible world. It was time to measure up against the classic masters of abstraction, who had won autonomy for an artwork and freedom from any form of imitation. I felt secretly guilty not associating with geometric abstraction. The current argument was that only

in the synthesis between the geometry of the canvas support and the elements synchronized with it, could true autonomy emerge, objective and uncolored by associations or feelings connected to something other than what is physically present in the picture. But why would I dedicate my time to a branch of geometry, a derivative of Mondrian, when I had reserved a single room for myself in the hotel of art? There too was Otto Breicha, art critic for the *Kurier*, who twenty years before Donald Kuspit hissed that abstract painting was exhausted, that it supplied no new impulses for the expansion of aesthetic consciousness, and that a new figuration was needed—the "Neue Wilde"—to keep interest in the visual arts alive.

And no one had money. Wolfgang Herzig let me sleep on a mattress at his place when I missed the last streetcar to my studio in the Schönbrunner Schlosstrasse. Figuration or none, I could not imagine returning to the parameters of Expressionism, when already at the age of eighteen I sneaked into an abandoned police barracks destined for demolition and covered the interior walls with hundreds of figures in black house paint.

CA What are your memories of the development of Austrian art during the Sixties?

PZR I observed up close until 1968 the early emergence of what was the beginning of today's pluralism of aesthetic experiments, each jostling for acceptance as art, and each claiming to be the latest thing, not infrequently overshadowing the medium of painting. Without necessarily loving it, we welcomed this avant-garde in Vienna, because we were looking for something extreme.

One impressive figure, who unfortunately died young, was Robert Klemmer. He dared to exhibit van Gogh, Mondrian, and Magritte paintings he had done himself, a concept later termed "appropriation" by the art world, a presentation of the old in the guise of the new, accompanied by philosophical questions on the nature of art and the meaning of aesthetic feeling.

CA What was it that caused you to push onward with abstract painting? Why didn't you switch to one of the more "advanced" media like photography, installation, video, or one of the other new imaging techniques?

PZR If you bring objects or events from the warehouse of reality into the light of day, you use means of transportation that guarantee to convey the intended content. The old cart used for loading the most beautiful forms of imagination since Paleolithic times is just as "advanced" today as the electronic devices we use to chase reality, capture it, diagnose it, and bring it "live" into our living rooms. You use whatever is appropriate.

I can take a photo for *Vogue* in Tahiti of a brown-skinned girl with a white rose in her black hair or I can paint a portrait of a brown-skinned girl with a white rose in her black hair from imagination in my room in Las Vegas. In the gamble of art I wouldn't put my money on the photo of a brown-skinned girl hanging in the lobby of the casino, but on a canvas made in Tahiti, covered with a coat of paint (that emancipated European painting of the 19th century from its obligations to an ideal of beauty handed down since the Renaissance), to make the aesthetic material the content of art. In December 1888 Vincent van Gogh wrote to his brother Theo that Gauguin "has more or less proved to me that it is time I was varying my work a little … canvases painted from memory are always less awkward and have a more artistic look than studies from nature …"

The "artistic look" of Western art, from panel painting of the Renaissance to the invention of non-representational art, has been a continuous emancipation from the forms of nature, an emancipation of nature from the excesses of an art that increasingly became aware of itself and shows, through its examples, that the truth of reality and the truth of art cannot be attained through the content of representation, but through aesthetic reality alone. The liberation of pictorial means from their servitude to objective re-

ality stems from a tradition of thinking about the way in which human nature can be objectified in a work of art. Like the endless expanse of nature, the lines and painted areas of a formal composition deplete power and meaning from the particular and unify in a single uninterrupted intuition of the whole. The autonomy of pictorial elements guarantees an aesthetic reality that has ultimate significance in feeling.

There are many phenomena lined up for an audience in the House of Art. To keep things under control, philosophy posts the consultation hours and, without intervening in the more intimate formal problems of art, explains to the applicants that not everything is possible at all times. Some works are granted an audience the moment they come into being while others wait for centuries. And no one knows how long a work will stay inside. Art is a capricious lady who sometimes awakens too early, sometimes too late. The temporal, conceptual control of philosophy is so generalized that phenomena can sneak in and we have no idea how they got there or why they arrived too late. The alliance between art and philosophy, that most crucial parameter of a culture, spreads aesthetic ideas over all of life.

CA How do you view the development of non-representational painting in this context?

PZR The development of non-representational painting, from the free invention of form at the beginning of the 20th century to the absolutely empty, monochrome surfaces, was reinforced by a philosophy of the sublime, which in the absence of formal elements saw a path to the metaphysical. Unable to imagine any further development in the spectrum of abstraction, dire voices warned that an empty geometry is a dead end and the self-awareness of art spells the end of art. In the absence of philosophical control, the gate was open for the entrance of thousands of phenomena from hard realism to pure abstraction. The conglomeration of so many bodies threatened to suffocate art. Even the brown-skinned girl

with the white rose and black hair from Las Vegas is there.

Now, one speaks of art after the end of art. The thinking head is stuck in the *Brillo Box*, the oracle between art and trash, as if the essence of art could be comprehended without actually having to experience its examples. Intellectual entertainment with aesthetically banal objects attests to a loss of direction in art and in a theory, too exhausted to cope with the possibility for future aesthetic experiences. Since previous epochs testify that the intensity of experience depends on the distinctiveness of abstraction, we must ask at all times in which direction the abstract can still go and preserve our driving curiosity in art.

CA What was your motivation to move to the USA and not, for example, to Paris? Was it the artistic problems and issues you have mentioned, or initially your teaching position? What were your own personal artistic expectations?

PZR *Ubi bene, ibi patria.* The Mamla, ancestors of the Baule in Africa, believe they descended from heaven on a rope; I don't know, I almost think it was like that for me too. It was a somewhat rough landing, but then, blown by a wind toward the west, I landed at the age of 29 through the beneficence of a higher authority, in Cambridge, Massachusetts, teaching at Harvard University in the Carpenter Center for the Visual Arts. In a heart-shaped building of concrete and glass designed by Le Corbusier in 1963, it was there, in the middle of the university campus that my intellectual development really began. The building inspired me to undertake three-dimensional projects that were exhibited in the lobby for two or three weeks at a time. Having no pretensions, the projects were shown as conceptual art, occasionally causing uproar in the Boston newspapers, especially when it happened to be a question of the chicken or the egg.

Four years later, 210 miles to the south, New York City: I don't know how I got there or whether I am one of those who have always been there; just to make sure I told myself "I am New York,"

whatever the cost. And so I belonged, like all the others, to the whole world, to a culture that uses the visual arts to flaunt the most visible expression of its modernity. After all, one could view more modern art in the galleries of Soho in a single Saturday afternoon than in any other city in the world in an entire year. Huge crowds of visitors trod the polished floors of the enormous galleries. On the walls one seldom saw anything but huge, abstract canvases ostentatiously proclaiming American painting to be abstract, the contemporary state of civilization expressed in visual appearance. Pop Art represents an important development in objet trouvé realism. It serves as a favorable standard for the positions of non-representational painting the best minds of philosophy devoted their energy to defending. Today it goes under the name of Formalism and refers to an historical segment in the development of abstract concepts of form. The texts of Dore Ashton, Leo Steinberg, Harold Rosenberg, Clement Greenberg and other "-bergs" were the subject of lively discussion in cultivated circles.

At the home of art historian James Ackerman, I sat on a carpet next to Michael Fried, who at the age of 28 had just published his famous text *Art and Objecthood*. It dealt with the pictorial elements of new abstraction that no longer derived from a random invention of form buoyant with all kinds of spirits.

It was also about the fact that painted surfaces now show few and usually no brushstrokes that come from a vague emotional state. And of course the pictorial elements are not cut off by the borders of the canvas, like the cruel edges of conventional panel painting do to every content; instead, now the forms, if there are any in the first place, keep a respectful distance from the borders of the canvas, are synchronized with them, presenting themselves theatrically, as one called it, as aesthetic realities for which Immanuel Kant was not infrequently the godfather. On the corner of Lexington and 67th, Tony Smith's black cube ruled, and you didn't get caught up in its emptiness like you might in the fig leaf

covering the naked body standing on one of the pedestals all over the world. Now one speaks of the sublime, of the idealism of a culture lost in the future. And then there's David Smith, who made the entire 20th century glow in his polished steel plates.

Here in New York, therefore, it's a question of an aesthetic underpinned by philosophy surviving in the canyons between skyscrapers. Motherwell, before he launched into his lecture on art, emphasized that he was a doctor of philosophy. Art works with the finest feelings that arise from the incredible tension between the beauty of the new and its persuasiveness as art. After all, it all comes down to painted lines. Painters defend their work in critical texts and lectures at universities at every opportunity. Renaissance man is their idol.

In the white cloisters, as I christened my loft with its 17 high windows looking onto West Broadway, I wanted to paint a collection of pictures and hang them on the high white walls. When I stuck my head out the window, I could see the twin towers of the World Trade Center just a few blocks away. Some of the floors were lighted at night. There were other people who also asked themselves during sleepless nights if there could be anything easier than to paint the most glorious picture collection and to live off this love. Naturally, not the kind of pictures one might see at the neighbor's or that came from Russia, but at least one picture that, amidst the enormous mass of artworks that pile up daily on all continents of the world, might simply as a feeling rise to the top.

Theory or no theory, I painted prayers without ascribing to any particular religion. Even the concept of style is worn. It makes no sense to use the same stamp to brand pictures like cows, so that the layman can feel proud to recognize them from afar. I painted my picture collection, I had no choice. Once a nurse who was visiting the studio asked me where the pictures were; what was hanging here on the walls was surely the remains of a construction site. But then came the writers, to whom I owe everything. Only when

my works appeared in group exhibitions of American artists did I feel accepted in American art ... and because we're living in America, the telephone rang. But Paris was not far away. Daniel Abadie, Gerald Piltzer, Gerard Titus-Carmel, Jacques Dupin, Jean Frémon, Aimé Maeght brought my works to France; Erich Storrer and Francoise de Pfyffer to Switzerland. Now I lived in my imagination both here and there, happy that the horizon of my feelings had been broadened geographically. Naturally, Japan must not be left out of this account, either.

How long can one look within oneself without wanting to counter the aesthetic nature of the work with that which is actually aesthetic? I had to leave the economic/aesthetic whirlwind of the city; I had to go to the country. The sublime is not the white canvas from one hundred years ago, hanging on white gallery walls. Here we love waterfalls, deep gorges, and mountainsides of which one says that we look right through them without interest in order to comprehend the enormity of creation. Today, in the third millennium, my pictures come from the earth, nameless formations, content without illustration. Not made by me, they came about all by themselves. I guarantee it. In primeval times someone once said that he, who is up there, is holding the rope firmly in his hands.

CA With your change of location from New York to North Blenheim in upstate New York, you must have experienced an artistic and existential change reflected in your concentration on nature as a central aspect of your aesthetic motivations. What kind of artistic perspectives and expectations do you think you will get from that ?

PZR If I had another life, would I give it to the rose ? But there is this beautiful emptiness, this nothingness in gray. A leaf, a thistle, a thorn bush, marshlands, and ponds forming the forms of titillating drawing marks. The unforeseen appears beyond the mountain; valleys emerge from thin graphite lines held with trembling fingers

attuned to softness and the surge of touch. I ask myself what trees and thistles would do if not looking directly into my eyes ?

From Art to Nature

Manuscript for a lecture at San Antonio College of Art,
March 21, 2013

In 2001 Arthur Danto published an essay entitled "The Madonna of the Future,"[1] a title derived from a story Henry James wrote in 1873 about an American artist working in Florence, who was driven by the desire to make a painting equal in beauty to Raphael's *Madonna della Seggiola*. He found a young model beautiful enough to fit his dream. But before starting the project he needed to study Raphael's work. It took twenty years, at which point the initial beauty of the model had changed into a different beauty, perhaps more fitting another painter. He then found himself sitting in front of a white canvas, not knowing what to do, having accomplished nothing, even though he had gained some knowledge about the short trajectory of Renaissance art since Giotto, its development of illusionist space, foreshortening, control of light and dark and other devices which could be learned by somebody with the skill in the imitation of reality.

Of course, a philosopher would not pursue the story about a frustrated artist who attempts to emulate the accomplishments of another artist unless this were to lead to questions concerning *the lateral diversity of art* in our post-modern period, concerning approprianists and painters who shock the art world with monochrome canvases or with objects taken from the household of reality. The question arises as to why a blank white canvas does not

194

mean anything in 1873 while it has a chance to find its way into a museum in 1973. At this point we must find our own answers.

...

Until the end of the 19th century, the ideal of painting had its origin in the Renaissance, when the newly discovered illusion of space allowed a painter to pursue a narrative able to look into heaven, faithfully describe events on earth, and delve into the furthest corners of hell. The essence of art, the reality of art, could then be found in the imagination and inventiveness of the artist who created metaphysical thought and proved his skill in competing with the beauty of nature. It is in the character of Western art, at least in its rapid development over the past five hundred years, to self-consciously question whether Renaissance ideals can be sustained indefinitely, what the reality of art actually is, and which parameters of expression must be employed to keep self-critical interest alive. The Western impulse not to copy works of history, but to expose artistic individuality, led avant-garde artists into a continuous search for progress in the application of means for visual expression. Illusionist space, which contains cognitive concepts of reality, became a particular focus for change. In the trajectory of Western art since the 15th century until the beginning of Modernism, it became increasingly apparent that the reality of art does not exclusively depend on the reproduction of nature and concomitant illusion, but that it can equally be found in the physical immediacy of aesthetic properties, liberated from anything outside the aesthetic object.

I believe that the self-conscious activity of Western art will not come to an end, even if the tradition of certain parameters has expired and changed into a different perception of what art is. The history of events cannot solely be read from changing appearances but from the development of human consciousness and advancement of perceptual faculties in the progress of civilization. Today,

it is no longer an issue whether a painting represents objects of reality or whether it is simply covered with a coat of paint. Modernism has proved that perception of mimetic phantoms can easily be replaced by the contemplation of an autonomous thing. This kind of perception has only recently become available to us, even though the best artists of the past had their eyes primarily fixed on the total appearance of the painting while using the assignment for subject matter more like a surrogate; of course, such signs of excellence we attribute with contemporary eyes to some masters of the past and not to others. Looking backward to historical works, we prefer those which dominate perception with parameters related to our age. The change of perception induced by Modernism distracts from the monopoly of a single frame of historical chronology.

It is no coincidence that concepts like empathy (Worringer) and contemplation (Russell) arrived at the same time with nonrepresentational painting at the advent of Modernism around 1910, when the proper perception and appreciation of abstract configurations demanded a different perceptual mechanism than the traditional viewing of illusionist subject matter. Abstract configurations can no longer be read like a book with sequence of events but demanded empathy to get a feeling for the relational quality of forms in their entirety. We are dealing with empathy that supersedes the traditional apprehension of depicted subject matter and its ideal to see the purpose of art in the imitation of nature. Tribal cultures, particularly of Africa, had been held in low esteem because their aesthetic output, derived from an organic and living expression, can only be apprehended by empathy. The feeling of the sublime turns into one of rationality which neglects its own law by not concentrating on rational concepts but on the substance hidden in the object. The feeling of the sublime strives for limitlessness outside rational demarcations. It was often asserted that artists are non-rational individuals. In fact, we are

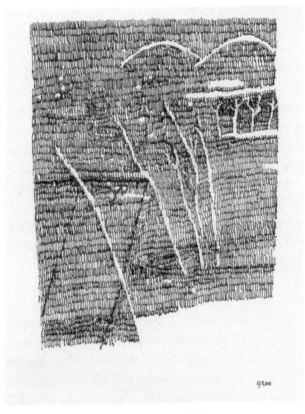

Blenheim, pen-and-ink on paper, 14 x 11 in., 2013

more disturbed by rational productions than by non-rational procedures which often make progress only by taking risks.

Contemplative philosophy does not deal with the contrasting qualities of existence but with the totality of an appearance separate from the concept an object represents. Concepts build a barrier between subject and object and limit the freedom of the spirit which, only if it surrenders to the totality of the appearance, can experience an enlargement of consciousness. In contempla-

tion the spirit involves is the unmitigated enjoyment of truth. The perceiving subject abandons preconceived ideas and surrenders to the other in its inner state. The perception of a painting is no longer split by manifold depicted objects but the work appears like an object of nature which has entered the world as something that has always existed. Responsibility for this changing perception of art can no longer be sought in new appearances challenging the course of history, but in the ability of the beholder to appreciate the inner workings of new feelings in art. It can no longer be expected that a painting is applauded by all, but its success becomes increasingly dependent on like-minded souls. In the course of the 20th century, avant-garde art became the property of the elite which appreciated feelings in thinking by works which challenge the boundaries of art.

...

Looking backward to the 1873 white canvas of the frustrated artist we must decide that our silly involvement with a banal object comes from the modernist obsession to establish a difference between aesthetic and normal reality. Nobody in the 19th century, with a right state of mind, would have had the idea of contributing any value to a barren canvas or, let alone, getting the idea of art. But since there are enough precedents found in modernist painting, the question narrows to whether a monochrome canvas is a work of art and if we decide to call it so, whether it is good or bad. The latter question is important on a personal level, not only in terms of taste but in the attitude toward and expectation of the general concept of art. Today we are certainly in a different state of consciousness than a hundred years ago, because it is intellectually titillating to consider objects outside a tradition while consolidating or shifting our position inside the tradition. In the progression of abstract painting, the white canvas takes a pivotal position as a point of no return. The white canvas was poked with

nails, slashed with a knife, splashed with blood, altogether treated with irreverence or religious reverence so that all that can be done has been done to it. Realizing that further pursuit of ascetic objecthood leaves little room for invention, instinct for more positive aspirations drives our thoughts into the future.

Approaching the 1873 canvas with a concept like style, it becomes apparent that a single blank canvas is nothing but a profane object forgotten in the studio of a painter who spends his time in the Florence countryside. Regardless how interesting the surface has become by an aged patina, the white canvas has left no trace of intentionality and if it were to receive intentionality by the artist returning to the city and proclaiming that it is the Madonna of the Future, it still could not be a work of art because, firstly, it is so far removed from the art of its time that it can no longer be considered avant-garde, but a joke. Avant-garde, even though its claimants come from ultimate freedom, cannot expand to such a degree that it becomes arbitrary nonsense. And, secondly, it is not supported by a style representing an idea supported by other canvases of the same artist who realized that the presentation of sublime nothingness, empty space, and sheer objecthood are meaningful, exciting, and necessary for the present basket of artistic phenomena.

Style, as the ultimate concretization of an individual in progressive works of art, has become the panacea for the turbulence of phenomena in the post-modern period. Since style is bound to the visual structure proposed and realized in a sequence of works, it is the most authentic document in revealing an aesthetic position within the circumference of artistic possibilities. What counts is not a single event, a single work or a single gesture of an artist who examines possibilities of procedure, but his inner being evolving in time. Changing configurations reveal his maturation together with the continuity or disruption of a binding historical model. We distinguish art works from normal reality by appre-

hending the cognitive and emotional practice of an individual or his culture. In 1973 artists produced monochrome canvases with the idea in mind that the reality of art can equally be found in an object free of associations implicating empirical data. The quality of a work can be measured in terms of the propositions advanced in individual style, originality and plausibility within local ideals of history.

In 1888 Vincent van Gogh wrote to his brother Theo that Gauguin "has more or less proved to me that it is time I was varying my work a little … canvases painted from memory are always less awkward and have a more artistic look than studies from nature." He set the stage for Western art to openly and freely remove itself from the tutelage to the visible world, become self-conscious and place the truth into aesthetic phenomena, ontologically on the same level with actual reality. Twenty years later, around 1910, Kandinsky proclaimed that a line or a color field is on the same level of reality as a chair or any other hard thing in the world. More than hundred years earlier (1792), Immanuel Kant spoke of aesthetic ideas as the representation of imagination, which occasions much thought without definite concepts; consequently, an aesthetic idea cannot be completely encompassed or made intelligible by language. The result is an aesthetic nature that surpasses actual reality. As the representation of imagination it is an idea transcending concepts of reason and presenting itself in a *completeness of which there is no example in nature*. From the analysis of the sublime we have learned that we should not worry if the perception of individual content is negative, if we see nothing in the work but the work itself, because it leads the mind into the infinite which can *enlarge the soul*.

There will not be an end to painting but at various stages in history we can expect an end to a tradition of thinking and traditional mechanisms of perception. Today the contemplation of an aesthetic atmosphere created by formless configurations provokes

emotions as if contemplating nature. The judgment is called aesthetic because feeling arises from the internal constitution of the object, a harmony of mental powers felt as a negative or positive sensation. Changing conventions of perception determine the taste of a time. Modes of perception and styles coincide and there is always a struggle to distribute this change in society. Society will decide what survives, but it is not present society, lacking a view of the future, but future society which does not lack a view of the past. The value of art is carried by the ups and downs of the waves of an ocean. It is futile to ask for the future of art other than its varying connections or independence from visible reality. The changing mechanism of perceiving will inform perception of art and the taste of its time. The history of art is a tightly woven fabric with each stitch creating a logical progression in the developing pattern without holes or arbitrary interruptions even if it deals with fringes loosely flirting with non-art reality.

···

There is a difference whether I say "concerning the future of art" or "concerning a future for art." A future for art would make assumptions about the appearance of artistic products. But as it is, art comes unexpectedly. Surprise is its asset. Nobody can anticipate new possibilities of art making, the emotional state of artists in their time, the inward constitution of society toward art and life. The making of art is not the evulsion of idiosyncrasies floating in an empty and unrelated space, but the careful interrogation of premises at a particular time in history. Ambitious artists have not only known that not everything makes sense at all times but that their work obtains meaning from the introduction of aesthetic concepts which, beyond sensuous beauty, carries an idea hitherto hidden or dormant as an overt possibility. Originality, as the highest principle of individualization, permeates all previously known phenomena with the caprice of emotions and intelligence. Beauty

as the sensuous manifestation of the spirit is not a separate entity that can be defined or created but a constant and unchanging canon of form. Beauty results from the sensuous reception of abstract thought. The spiritual in art is the power of aesthetic phenomena to affect a mind formed by emotions of the past. These emotions may have come from the contemplation of nature or the experience of art. It makes a difference whether I see an artist imitating another artist or his emotions derived from a previous master. Nevertheless, the apprehension of visual expression must entail contemplation of the object in its isolated existence apart from purely scientific intelligence.

The trajectory of Western Art since the Renaissance is divided into segments which make an end to previous art and propel into the future with varying velocity. One can read it as a linear development characterized by the introduction of new parameters, appropriate at their time, which dispel a reigning monopoly of taste. Each time a new era started, it was accompanied by critical upheavals concerning the ontological condition of art and its criteria of evaluation. When non-representational painting separated from the historical parameters of narration and illusion, European society thought that the great era of Renaissance taste had been smoldered by something incomparably lower in spirit and beauty. Because art had moved into the spiritual realm of empathy and contemplation, modern art was considered perverted and removed from historical expectations praised as universal and eternal. Particularly the lateral broadening of styles from Realism to Abstraction in the beginning of the 20th century made a confusing pluralistic picture, in which nobody could fathom what all of this meant and where it would go. This situation has existed from the advent of Modernism until the *present lateral diversity of art.* Besides Abstraction distancing itself from Realism, it split into two different aesthetic directions: geometrical abstraction and abstract expressionism. It is obvious that both families have similar

characters but quite different philosophical foundations. One is guided by pre-existing geometrical elements and their plausible application, the other comes from a free play of *inner necessity* and boldness of imagination. Both are determined not to be pushed back in time by even the slightest implication of realistic subject matter, they certainly avoid the proletarian Expressionism which neither belongs to Realism nor Abstraction.

The art of the Middle Ages, from the Roman Empire until the 14th century, was devoted to producing nameless miracles of divine origin. It exerted aesthetic purity and authentic truth as an object being a gift from heaven. Icons are objective signals for a religious spirit. The presence of the object was accomplished by the immediacy of pictorial space, flatness of elements, sharp outlines as if cut from a stencil, and the physical presence of a depicted form. The beauty of pre-Renaissance painting arises from freely invented forms structuring the architecture of the canvas by continuous contact between pictorial elements and the shape of the support. The spiritual of the work gained momentum by concentration on its physical existence, a holy relic in real space.

From there on, painting of the 14th century needed to expand, start a new era in the Renaissance and deal with profane objects of reality, realistic images and illusion of space. Depicted figures could now be placed on a stage which develops from a physical foreground into wider territories of imagination. All of a sudden, painting is deeply entrenched in the here and now of reality while simultaneously driving imagination into the deepest regions of consciousness. But most of all, art has become a means of information about mythological and actual events in life, from the Rape of the Sabines, to Arabs smoking a waterpipe, to pyramids in the desert, to the Battle of Valmy, thousands of soldiers fighting on horses, and so on. And, moreover, the artist was allowed to glimpse at the psychological state of depicted persons, their facial expressions and symbolic gestures. Even today the

smile of La Giaconda and Marilyn Monroe create a greater fascination and mystery than the painting itself. The involvement with the psychological state of depicted persons, in a highly realistic manner, contributed to the notion that Western art is superior over cultures which produce autonomous aesthetic objects. Western critics looked at other cultures with a critical eye because only Western art was able to represent the world as it presented itself. Portraits, still lifes, and landscapes dominated the repertory of representation. Painting was considered in the same league as mass media today. The concept of representation ingrained itself so strongly in the mind of Western society that, until the end of the 19th century, it became impossible to conceive of painting as anything other than a medium which follows various circumstances of reality.

At the same time, however, the concentration on the vision of an artist—which in medieval painting was suppressed by the anonymity of the icon—became increasingly important and ultimately the main focus of aesthetic appreciation. Art became conceptual at the point when the particularity of formal invention became dominant over narration. Style as the most authentic means of individuality and originality, expressed by form, became the focus of attention, often to such a degree that the idea represented in a work became more important than the work itself. For artists it became imperative to consider historical and contemporary parameters in order to achieve the conceptual capacity to unravel the hidden possibilities of art. It became standard knowledge that the imitation of reality produces nothing but the redundancy of what we already know or can see for ourselves, and that such an art can impress mostly through its technical skill. Plato had given the imitative artist a third degree rank behind the purity of ideas and the truth of reality. Hegel compared the imitating artist to a worm crawling behind the elephant of reality. Such insults to representation could be overcome only through the presentation of

autonomous, aesthetic configurations. Abstraction, the ideal vehicle to transcend narrative content and push pictorial material to the top, became the most visible sign of historical progress. Instead of looking at the psychological state of a depicted figure we perceive the inner workings of an artist. We look at art to look at artists. Their works reveal visions and emotions through formal means. While represented subject matter shows the outer condition of man, the abstract configuration reveals the inner emotional life of its creator. A Vermeer cityscape provides little to look at other than the breathtaking way how forms are spatially organized within the confines of the canvas; aesthetic reality points to the calm character of an artist who reveals beauty in stillness and transcendent simplicity.

The path from the Renaissance to Modernism is characterized by changing parameters of expression. Space, line, color, perspective, contour, light, edges, etc. are the visual material to create. The new way of using these parameters is responsible for the progress of historical segments. Each segment preferred a particular aesthetic nature. El Greco, at the end of the 16th century, showed a way into the future (Baroque and Rococo) by establishing a mannerism of movement with free floating forms, soft contours, and a pronounced space, as if conquered by the wind. Velázquez, in the 17th century, established a perfect synthesis between abstract and representational elements. Operating with a duality between geometry and faithful representation, he is responsible for the dialogue between abstraction and realism, the riddle of what is superior in art. And further on, the aristocratic graciousness of Neo-Classical art of the 18th century encountered the peril of having to operate with heroic parameters of content and excellence of execution, as if they were eternal and universal. If a two-thousand year old tradition lasted so long that it came back to its origin of being devoted to Greek nymphs and Gods with divine beauty and strength, such a glorious tradition was

considered the highest ascent of art and expected to last forever. But, in the 19th century, we see a clear revolt politically and aesthetically against a taste which gripped all of Europe. It became obvious that depicted subject matter could no longer remain in its old clothes. The slowly developing fashion of allowing representational elements to be individually molded according to the willfulness of compositional considerations, directed critical attention to the questionable importance of narration, but most of all, to the developing significance of abstract constellations of form, which made of a painting a formal singularity, an autonomous entity, its own nature.

The path toward pure abstraction is characterized by a search for immediacy of form accomplished by the progressive flattening of pictorial space and the physical presence of pictorial elements. One could hear voices that a painting is first of all a canvas covered by a coat of paint before it represents a war horse. Avant-garde artists and philosophers questioned the basic premises of life and art. In 1845, fifty years before Cézanne painted Mont Sainte-Victoire, the German philosopher Johannes Andreas Romberg published an encyclopedia of fine art, in which he defined the concept "abstract" in the following way:

"Abstraction is the mental activity which makes the formation of the work of art its highest goal and pays no attention to the rest. Abstraction is for every artist an absolute necessity unless he wants to lose himself in the superficial, the oblivious or the boring. The artist who wants to reach this goal has to learn to distinguish all parts from each other and eliminate everything that does not belong to this goal ... he will avoid everything that could contradict the effect ... that arouses our attention."

Twenty years later, the Viennese philosopher Robert Zimmermann proposed in his *Aesthetik* that the philosophical discipline of aesthetics should become a science of visual form that determines which pictorial elements and what formal constellations

have the greatest effect. He sees pictorial forms and their spatial relationships as the sole effective mechanism for aesthetic appreciation. His somewhat exaggerated view of the importance of form led to serious discussions about a pragmatic formalism contradicting the claim of Romantic Art that the beauty of subject matter also accounts for metaphysical aspirations.

Amboise Vollard reports that the French novelist Joris-Karl Huysmans said of Cézanne in 1893 that he is "un artiste aux retines malades." Cézanne had violated the traditional notion that the surface of a depicted object needs to be homogenous. Instead, he dissected pictorial elements into vertical and horizontal planes which occupy the entirety of lateral space while keeping the information contained in represented subject matter to a minimum. The result is a painting based on a grid of horizontal and vertical brushstrokes. They build an aesthetic nature intensely demonstrating the barren truth of paint application while involving a disciplined order for all pictorial forms within the edges of the canvas. A nature is created which does not depict but exists. Its beauty must be contemplated by a concentration on the totality apart from all aspects of imitation. Art has shifted from the representation of nature to the presentation of aesthetic nature.

It is amazing that the conflict between Realism and Abstraction would continue until the end of the 20th century, and I doubt that it will ever be fully extinguished. Clement Greenberg, one of the most astute aestheticians of Modernism, suggested in the 1960s that everything moving outside the "pale of art" is not art. He rejected Surrealism because it is not involved in the course of Modernism to move painting toward objecthood. Objecthood is an intrinsic feature of all abstract art because the 3D illusion of space representing reality has succumbed to the reality of the picture plane. While all representational painting delivers only a segment of depicted reality, the space in abstract painting finds its limits exactly there where the canvas physically ends. Edges be-

come active participants in formal constellations when pictorial elements are aligned tangentially to the vertical or horizontal directions of boundaries provided by the support. The course toward Modernism is the gradual closing of a stage curtain until we see nothing else but the curtain itself. Ultimately, painting ended in monochrome canvases barren of pictorial incident, hanging like an object parallel to the wall, finding a place on the floor or being covered by a variety of forms, invented or taken from the storeroom of geometry.

At this point, in the late 20th century, art became *l'art pour l'art*, finding its value in aesthetic concepts, playing with elements of ornament, often ignoring inner motives of expression. Apologists of formalism explained that the desired objecthood could only be accomplished when anything emotional, associative, irrational or vague was kept out of the work and aesthetic perception could focus on a collective gathering of material. Whether the rationality for proper design creates more satisfying appearances than the instinct for vital forms is left to taste. But one cannot forget that geometrical elements are not invented but put together like found elements in naturalistic painting or objects in the art of objet trouvé. There is little difference between artists who display manipulated objects or whether they paint squares, stripes, and other pre-existing elements. Early enough in aesthetics the question arose whether a painting is a blackboard of concepts surrounded by philosophy or whether it should remain a plastic configuration symbolizing the inner workings of an individual, his emotions, intellect, and desires, summarized in the particularity of beauty. Hegel warned that art would come to an end when nothing but an idea in its universality is communicated and when the individual concreteness and distinctive sensuous particularity is lost. If the work sets before us "the generalization of its content with the express object of instruction pure and simple, then the imaginative no less than the material aspect of it are

merely an external and superfluous ornament, and the work of art is itself a shattered thing within that ornament, a ruin wherein form and content no longer appear as a mutually adherent growth."[2] When a work has abandoned aspects of delight, entertainment, and diversion, it can find its essence only in instruction. Kant warned of works where the "Schulform durchblickt." Academic art has always catered to aesthetic expectations, the path of least resistance, to people unable to confront unexpected challenges. Michelangelo seems to have had the same problem. Francisco de Hollanda recorded the following statement about Michelangelo around 1550:

> "Because the large mass of people without judgment loves always things they should actually despise and always criticize works they should actually praise, it is no miracle that they continuously err in the judgment of painting—an art that demands much understanding. Without intuition, rationality or judgment they prefer painters who claim nothing of their own but the oil and rough or fine brushes. And there are painters who are no painters, and there is painting that is not painting. It is astonishing that bad painters are unable to create in their world of ideas a good painting. Their works are always the result of bad ideas, because a bad artist is unable to fathom something masterly, even though his hand cannot be so corrupt that it does not leave a trace of something good. And, in this art of painting, something good can come into being only if the artist has understanding. And this is the true difference, a true border between a high and low conception of painting."[3]

In the 20th century, progress was sought in division: turning ideas into opposing ideologies, splitting the atom, distinguishing ge-

netic properties, divorcing families, dividing countries into east and west, isolating organic cells, analyzing the psyche of man, etc. The century was marked by continuously changing programs of artistic procedure: Impressionism, Expressionism, Abstraction, Realism, Cubism, Futurism, Dadaism, Surrealism, Tachism, Pop Art, Op Art, Kinetic Art, Formalism, Minimal Art, Neo-Expressionism, Super Realism, Pluralism. Splitting aesthetic ideas from group ideologies moved to the singularity of an individual, who finds himself attached to nothing else but his own creativity. The window of art has opened for a greater number of aesthetic procedures and appearances. Contemporary art shows no signs of slackening, it is not a time which has lost belief in high culture representing eternity; it is not a time after the end of art history. Artists have not abandoned the *burden of history*, as philosophers claim, but art has abandoned history as a burden. Because there is no demand for a contemporary style, the limits of history will be extended by individual accomplishments. The loss of a collective agenda must not lead to arbitrary subjectivity. Ambitious artists are not lonely figures without belief in aesthetic propositions from which the quality of their work can be measured. Kandinsky spoke about freedom, an absolute necessity for art, which in itself is not absolute. Every epoch, every culture has its own parameters to measure freedom and the limitations of this freedom cannot be broken by even the most genius art. But this freedom must be accomplished; for Kandinsky, it is the path to *inner necessity*.

A pluralistic art is too varied in intention and appearance to be captured by a single philosophical dimension. Philosophy must become pluralistic in the approach with artistic phenomena, not with preconceived ideas and notions about what is necessary or valid in art but in contemplating a thing and derive at a greater truth than with logical or rational concepts. After all, empathy and contemplation are the proclaimed tools to approach the par-

ticularity of a work. Its nature is abstract. Regardless of whether a painting contains representational images or whether it presents nothing but confused lines, its nature is abstract, because you look at the painting, expecting nothing else but the feeling of its character.

Progress in art is always accompanied by changing modes of abstraction. It is expected that abstraction will continue to focus on various degrees of applying realistic or abstract elements responsible for the plurality of feelings. Art is a thermometer which measures the fever of its time. The lateral diversity of art moves between degrees of abstraction without claiming a single idea to serve the chain of history. The introduction of emotions and associations is different from the expectations of late Modernism with its claim that a painting is nothing but a coat of paint. Such concepts have lost their meaning because, today, we approach art with a more truthful concentration on the nature of visual presentation. Aesthetic perception will focus on the sublime totality of the work. From there we know whether we love it or not. Its structural identity cannot be captured by logical thought alone, but must include an aesthetic attitude, conform to emotions. Our effort has little to do with the optimism of earlier avant-garde movements which hoped to introduce a new religion in society. Today's task is the rejuvenation of a personal morality. The value of an individual is the value of the whole world. Our optimism about the future lies solely within ourselves.

And now we have arrived at the white canvas again, which is but a surface covered with a coat of paint. It seems that we need to start all over again from the beginning of time. We have been left alone by art. The historical parameters of Modernism have lost their meaning and been replaced by a new vision and consciousness beyond the obsession to replace existing parameters. If there is nothing to be renewed, there is nothing to be replaced. Being left alone, we can be what we are. At this point it is not the

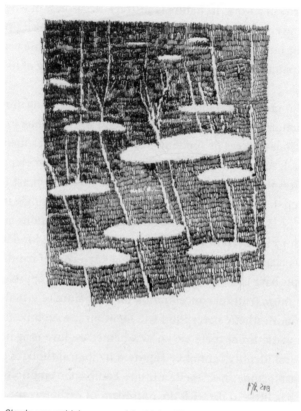

Clouds, pen-and-ink on paper, 14 x 11 in., 2013

parameters served by the chain of history, but it is we who serve history. Attention shifted to the individual and his range of expression. Individuality reveals itself in the type of nature the artist creates. The best resource for imagination is nature itself, because in the contemplation of nature we are removed the furthest from concepts. Nature is an endless source for emotions and variations of form. Visible reality can be presented without representing it. The work of art is free of external obligations. It creates its own

laws, becomes concrete in the immediacy of formal invention and makes aesthetic material the actual content of the spiritual. Whether anything we do will affect the course of history is not a question, because we are no longer slaves of the past. It is left to the lateral diversity of art whether a product remains on the shelf or is swept away by the flood of history.

1 Arthur Danto, *The Madonna of the Future*, Berkeley 2001
2 Georg Wilhelm Friedrich Hegel in A. Hofstadter, R. Kuhns (eds.), *Philosophies of Art and Beauty*, Chicago 1964, p. 422

3 Francisco de Hollanda in *Michelangelo von Kunst und Leben*, Berlin 1964, p. 171

Addendum 2014

One of Immanuel Kant's great accomplishments was to have spoken about formlessness at a time—at the end of the 18th century—when the Classical ideal of beauty demanded a synthesis between form and content. He theorized about the possibility of an aesthetic apperception which, free of represented subject matter, leads to the actual experience of art and concomitant emotions. Formlessness denotes a perception free of rational concepts. In the enjoyment of nature Kant notes that "nature is sublime in all appearances which arouse the idea of infinity... the actual unchangeable tenant of nature is its absolute wholeness in which all (singular) appearances unite in infinity."[1] The concept of nature must therefore "point at a super-sensuous substrate which, above all senses, is great and allows an emotional state we call sublime." The super-sensuous substrate results from a subtraction of individual elements in deference to visual totality. One should not worry that "the feeling of sublime will be diminished by the reduction of representation which in regard to appearances is completely negative; because imagination, while it finds nothing sensuous to which it could cling, is infinite precisely because of the elimination of barriers ... it still enlarges the soul." And Kant

points to the Hebrew Book of Law and the sublime command that you should not make an image of what is in heaven, on earth or under the earth. Of course, Kant does not pursue iconoclastic ideas but seeks feelings of the sublime in an all-encompassing way by perceiving phenomena of the visible world and of art which must present themselves first as an aesthetic reality before leading to the recognition of individual concepts. The momentous changes of art production in the beginning of the 20th century made it necessary to regard philosophy as a spiritual support until aesthetics became the dominant discipline of post-modern thinking.

I cannot join the school of contemporary philosophy which, from Kant's *sublime,* derives the idea that modern painting should avoid figuration, should be white like Malevich's squares in which you see something—I suppose the infinite—without seeing anything depicted. While we admit that ambitious abstract painting struggles for a depiction without depicting, we cannot deduct from the concept of *negative presentation* how an aesthetic appearance should present itself, whether it should be an empty canvas covered with a coat of paint or whether it can also operate with elements able to establish a visual totality without supporting individual significance. If emptiness were the sole intended subject matter it would be an imitated form like the representation of a real object. However, abstract painting does not need to proceed without thematic interest; on the contrary, painting has at its disposal the whole storeroom of reality without being enslaved by outer appearances.

"Sublime is what pleases against the interest of the senses" and presents itself as nature. It finds its function in the disposition of the beholder to reach something metaphysical. This idea of the super-sensuous is aroused by an "aesthetic judgment which stretches imagination to its limits while finding its determination in feelings." We feel that something is there without needing to

know what it is. Now, however, art is always directed toward the creation of something particular. If, however, the particular pleases only through concepts it cannot please as beautiful but only as *mechanical art* which places the skill of production above the way of creation.

The famous apple, painted with photographic precision on a blue background in a golden frame, lit up at night by a spotlight in the window of a gallery at Circolazione Stradale in Venice, attracts tourists who stare in astonishment at the acrobatic depiction of an apple on a 2D surface. You look twice to make sure the apple is not actually there. For some time a painter was considered a master when birds flew into the studio to peck at the grapes on his canvas.

Concentration on a literal content or an obvious idea of design leads into a functionality which produces barriers and interrupts imagination on its way to contemplation in which an array of visual stimuli order themselves into an uninterrupted intuition. "Therefore, the expediency of a product of fine art, even though it is intentional, must not appear intentional. Fine art must appear as nature even though we are aware that it is art ... A product of art appears as nature despite having followed all rules and regulations which made the work as it is; however, without painfulness, without showing anything willful or learned, i.e. without showing a trace of any rules having floated in front of an artist's eyes or having fettered his emotional disposition." Art can be called beautiful only if we are aware that it appears as aesthetic nature. The experience of the sublime takes place in front of a visual totality which is not empty but full of mountains, raging torrents, and deep ravines. We arrive at an experience which encompasses everything all at once. The immensity of nature and the aesthetic nature of art effects our innermost being.

The greatness of nature and the infinity of art are not sought by everyone and can even be dangerous or detrimental. It is said that there are passengers on trains from Bern to Geneva who pull

down the window shades so that they do not have to see the frightening might of Mont Blanc. And in the Baule culture it is reported that women became sick and even died after having accidentally viewed the Goli Glen mask with its expressive forms crowning the open mouth of a wild creature from another world.

Kant speaks of a starry night sky which is "a wide vault that encompasses everything and only when perceived in this way can we speak of the sublime which guarantees a purely aesthetic judgment." We do not ask whether living creatures inhabit the stars but experience the vastness of space outside and inside ourselves.

Sublime is a painting when associations and rational principles of design are removed from straining perception. However, aesthetic nature can present itself as autonomous regardless of what it contains. In that sense it is unimportant in our postmodern period whether a painting deals with realistic or abstract elements because, now, we only speak of its power to create a primary event through its absolute wholeness in which all appearances lose their names und unite in infinity. The demand for the suppression of the particular is not a suppression of sensuality. Rather we ascribe sensuality as an important property to art, which is able to increase sensuality to a degree that we lose all hold on the rational. I do not know whether it is possible to think and see nothing while feeling everything. The sublime is an event which has come like a gift. It is not an exclusive domain of art but occurs in many moments of life as the imagination of past, present or future events.

The perception of nature is connected with its creator and the perception of art is connected with the nature of the artist. Today it is unimportant whether we see lines or painted areas which carry some kind of association with figures or motives of landscape because the teleological value of the work is independent of the lineage of tradition and its prescription of ordained forms. Its teleological measure consists in the suppression of interest in the particular for the sake of the compactness of visual information

in a unified emotion. The unification of visual elements in an un-interrupted intuition points to the workings of a single soul. What we call the spiritual in art is the revelation of human nature. The hermetic position of the artist, however, is not the result of intel-lectual indifference concerning new propositions in art but it is the territory of an autonomous field of emotions which, in union with thinking, can create a sublime nature in art.

1 This and the following quotations from Kant have been translated for this publication by the author and taken

from: Immanuel Kant, *Kritik der Urteils-kraft*, Hamburg 1954, paragraphs 26, 27, pp. 82–105

Index

Published by
Hirmer Verlag GmbH
Nymphenburger Straße 84
D-80636 Munich

Editor
Carl Aigner and the
Niederösterreichische Museum
Betriebs GmbH
Kulturbezirk 5
A-3100 St. Pölten

Cover design
Rebecca LittleJohn, New York, using a
b-w drawing of PZR (fig. p. 212)

Layout
Peter Grassinger

Project management
Carl Aigner, Rainer Arnold

Printed in Germany

The Deutsche Nationalbibliothek lists
this publication in the Deutsche National-
bibliografie; detailed bibliographic
data are available in the Internet at
http://www.dnb.de

ISBN
978-3-7774-2228-2 (German Edition)
978-3-7774-2219-0 (English Edition)

This book was produced
with the kind assistance of
Niederösterreichische Museum
Betriebs GmbH

KULTUR
NIEDERÖSTERREICH N

Plates

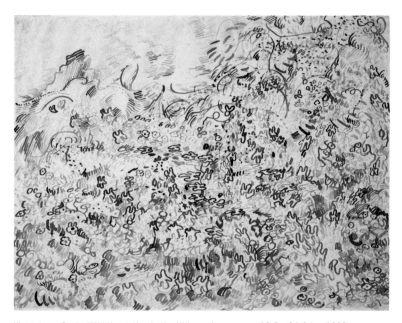

Vincent van Gogh, *Wild Vegetation in the Hills*, sepia on paper, 18.5 x 24.6 in., 1889, courtesy of the Van Gogh Museum Amsterdam (Vincent van Gogh Foundation), inv. no.: d 0177 V/1962

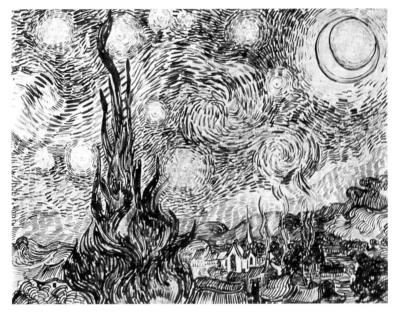

Vincent van Gogh, *Cypresses in Starry Night*, pen-and-ink, 9.5 x 25 in., 1889,
photograph of a lost drawing, Vincent van Gogh Foundation, no. 1541

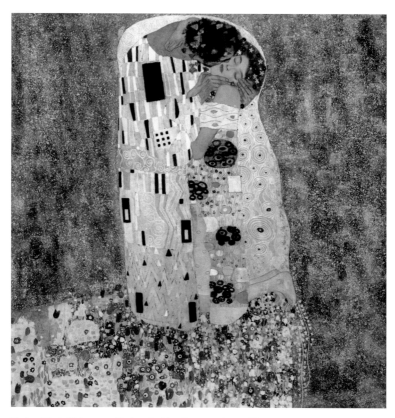

Gustav Klimt, *Liebespaar*, black-and-white glass negative, c. 10.6 x 8.3 in.,
courtesy of the Österreichische Nationalbibliothek (ÖNB), Vienna, Signatur 94905-E

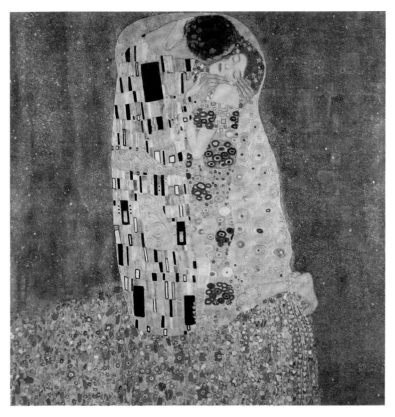

Gustav Klimt, *Der Kuss,* oil, silver and gold on canvas, 70.9 x 70.9 in., 1907/08,
Österreichische Galerie Belvedere, Vienna, inv. no. 912. Photo: Österreichische Galerie
Belvedere, Vienna

Gustav Klimt, *Die Erfüllung*, cartoon for the Stoclet Frieze,
tempera, watercolor, gold and silver on paper, 76.7 x 47.2 in.,
MAK – Österreichisches Museum für angewandte Kunst,
inv. no. 37.197